From El Greco to Goya

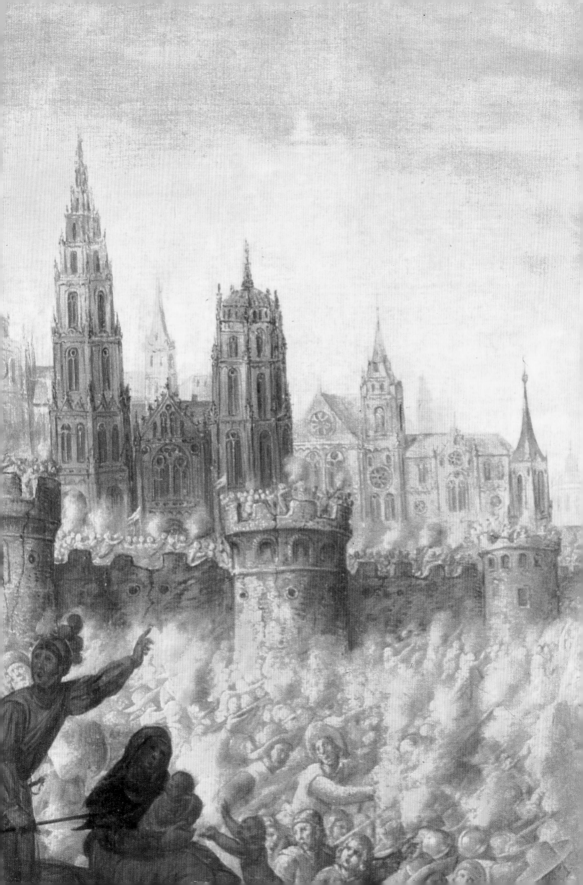

From El Greco to Goya

Painting in Spain
1561-1828

Janis Tomlinson

PERSPECTIVES

HARRY N. ABRAMS, INC., PUBLISHERS

Acknowledgments

My scholarly debts are many, and are acknowledged in my bibliography. I would like
to give special thanks to Jonathan Brown, Gridley McKim Smith, and Edward Sullivan,
colleagues and friends whose scholarship on painting in Spain has set a model for my own.
At Calmann and King, I would like to thank Lee Ripley Greenfield for her encouragement
from the beginning of the project, Susan Bolsom-Morris for her sleuthing talents in tracking
down photographs, and to my editors, Jacky Colliss Harvey and Kara Hattersley-Smith, for
their prompt responses and advice throughout the preparation of this manuscript.
This book is dedicated to Davey, Laura, Jack, Julia, and Eric.

Frontispiece ANTONIO DE PEREDA *The Relief of Genoa*, page 93 (detail)

Series Consultant Tim Barringer (University of Birmingham)
Series Director, Harry N. Abrams, Inc. Eve Sinaiko
Senior Editor Jacky Colliss Harvey
Designer Sara Robin
Cover Designer Judith Hudson
Picture Editor Susan Bolsom-Morris

Library of Congress Cataloging in Publication Data

Tomlinson, Janis A.
 From El Greco to Goya : painting in Spain 1561-1828 / Janis
Tomlinson.
 p. cm. -- (Perspectives)
 Includes bibliographical references.
 ISBN 0-8109-2740-3
 1. Painting, Spanish. 2. Painting, Modern — Spain. 3. Spain —
Kings and rulers—Art, patronage. I. Title. II. Series:
Perspectives (Harry N. Abrams, Inc.)
ND804.T66 1997
759.6'09'03—dc21 97-7681

This book was produced by Calmann & King, Ltd, London
Printed and bound in Hong Kong

Harry N. Abrams, Inc.
100 Fifth Avenue
New York, N.Y. 10011
(212) 206-7715
www.abramsbookks.com

Contents

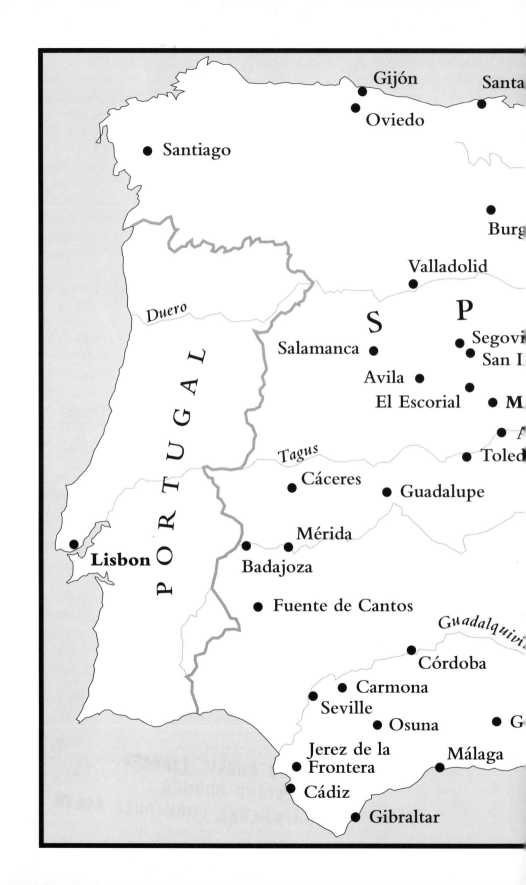

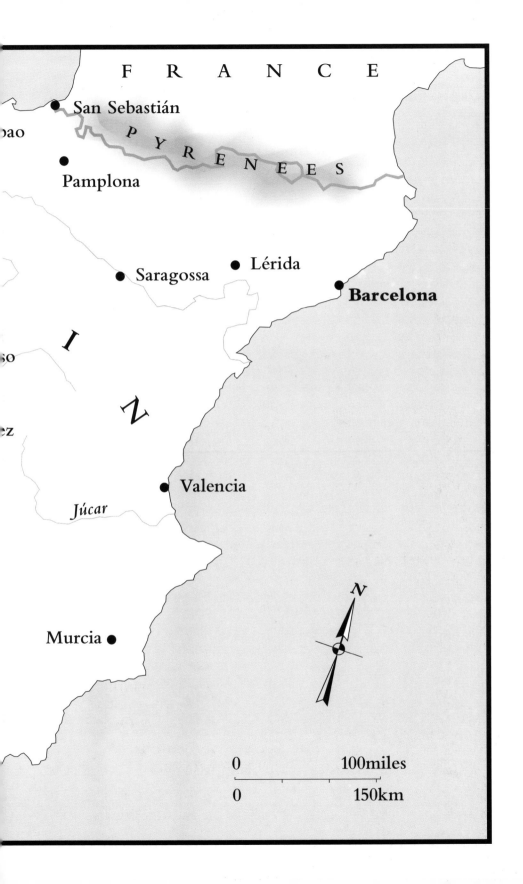

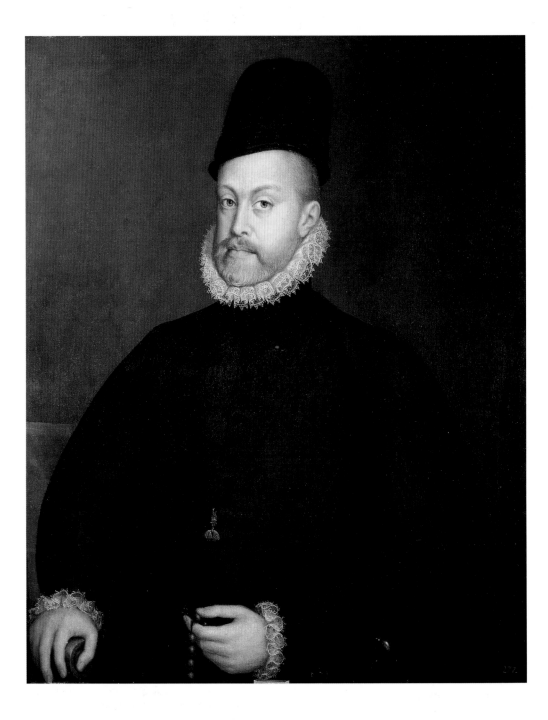

Introduction

1. SOFONISBA ANGUISSOLA
Philip II, c. 1575.
Oil on canvas, 34³/4 x
28¹/2" (88 x 72 cm),
Museo del Prado, Madrid.

Wearing the Order of the
Golden fleece and with
rosary in hand, the king is
depicted as both majestic
and devout. The portrait has
only recently been attrib-
uted to this Italian artist.

By their marriage in 1469, Ferdinand and Isabella united the
Spanish kingdoms of Aragon and Castile. Ferdinand,
heir to the throne of Aragon, was also king of Sicily
and Sardinia and became king of Naples in 1504 through diplo-
macy and military success. Isabella ruled Castile, which at that
time also controlled the principality of Catalonia, so the union
of Aragon and Castile neatly explains the formation of modern
Spain. Yet the story of the Spanish nation and identity is in fact
far more complicated, as is the definition of "Spanish" art. The
title of this book, which focuses on painting in Spain rather than
on any fixed notion of Spanish painting, is intended to acknowl-
edge the problematic nature of that frequently used term.

After the unification of Castile and Aragon, the territorial
definition of Spain continued to change. In 1580, during the reign
of Philip II (r. 1556-98), Portugal was annexed. But the union was
not a happy one, and if the concept of a nation has to do with the
voluntary will of a people to belong to a nation, Spain at this point
did not qualify. Under Philip IV (r. 1621-65), Portugal and Cat-
alonia rebelled against the central authority of Castile in 1640. Por-
tugal won its independence, and at the outset of the eighteenth
century Catalonia again defied Castile by supporting the Aus-
trian contender in the War of the Spanish Succession waged after
the last Spanish Habsburg, Carlos II, died in 1700 without heir.
But these domestic rebellions represent only a part of the tribu-
lations of the Habsburg monarchy.

The territorial gains of the Habsburgs within the wider European theater and the presence of this Austrian dynasty as rulers of Spain can be attributed to Maximilian I of Austria (r. 1493-1519; Holy Roman Emperor 1508-19), who in 1497 arranged the marriage of his son Philip to Joanna, daughter of Ferdinand and Isabella. The son of Philip "the Handsome" and Joanna "the Mad" was Charles (1500-58), who became the duke of Burgundy, the king of Spain (as Charles I), and ultimately the Holy Roman Emperor (as Charles V). His dominions included Burgundy, the Netherlands (including modern Belgium and Holland), Austria, Naples, Sicily, and Sardinia, in addition to his Spanish territories (see map pages 6-7). That empire shrank with Charles's abdication in 1556: although he passed his Spanish, Italian, and Netherlandish territories to his son, Philip II, the lands and title of the Holy Roman Emperor went to Charles's brother, Ferdinand I (d. 1564), and subsequently to his nephew, Maximilian II.

The sheer size of Charles's empire made a bid for European supremacy feasible and clearly threatened the rulers of France and the German territories. From 1520 to 1659, Spanish Habsburg rulers were successively engaged in military confrontations against the Turks, the German princes, the Dutch, the English, and the French, not to mention the rebellious Catalonians and Portuguese. Habsburg rule in the Netherlands – the severity of which grew in direct proportion to the perceived threat of Protestantism in that area – led to a revolt that originated in the 1560s and was only resolved (with the independence of the Dutch United Provinces) in 1648. The wars took heavy tolls, not the least of which were economic. Although Spanish colonies in the New World had sent back vast amounts of wealth, income from this immensely lucrative source and also from the heavy taxation of Castile was soon exhausted. That many of Spain's wars were religious as well as political helps to explain the determination of the Habsburgs in the face of what seem, in hindsight, extremely unfavorable odds. Charles, as well as his son Philip II and great grandson Philip IV, were militant in their defense of Catholicism against the threat posed by the Protestant Reformation. In defense of God, there was no room for compromise.

The Spanish kings ultimately did admit defeat in the political sphere, signing in 1648 the Peace of Westphalia that acknowledged the existence of the United Provinces of the Netherlands. The war with France ended with the Treaty of the Pyrenees of 1659, which also proclaimed the union of the two countries with the marriage of María Teresa, the daughter of Philip IV, to the French Bourbon King Louis XIV. This marriage explains

the Bourbon succession to the Spanish throne in 1700. Although challenged by the Austrian Habsburgs, the succession of the Bourbon Philip V (grandson of Louis XIV and Philip IV's daughter, María Teresa) was in the end proclaimed. The 1713 Peace of Utrecht – ending the War of the Spanish Succession that had involved Spain, France, Austria, Britain and the Dutch – again guaranteed that Spain and France would never be united under one ruler.

Painting in Spain or Spanish Painting?

Given the complexity of a national history that has been considered here in only the most general terms, we may well ask, when did "Spain" begin and what does "Spanish" mean? Spanish art is popularly considered a manifestation of national history and character, a concept that links such disparate paintings as elegant if austere nobles and devotional images. The choice of title for this volume reflects a belief that, like many other nationalist frames in art history, "Spanish painting" is an anachronism that only imposes a restrictive homogeneity upon the subject. Should we consider as "Spanish" those Italian artists who played such an important role in decorating the royal palace and monastery of the Escorial? Probably not, but they remain crucial to the development of painting in Spain. A shift here to painting in Spain, away from other books on Spanish painting, is not always more inclusive; and it has led me to give short shrift to the work of the important painter Jusepe Ribera (c. 1590-1652). Although born in Spain, Ribera was active in Rome, and Naples: the Spanish rulers of the latter were among his most important patrons. At the same time, I have broadened my consideration of painting in Spain by extending the subject into the eighteenth and early nineteenth centuries, when Spain was ruled by the Bourbon monarchy. The preference of the first Bourbon monarchs for non-native artists further complicates any simple notion of national identity and so is often overlooked, as discussions of Spanish painting often jump from the late Baroque painter Claudio Coello (1642-93) to Francisco Goya (1746-1828). Although the hybrid careers of the French and Italian artists who worked in Spain do not fit nationalist pigeonholes, this does not justify their exclusion.

Two portraits of monarchs who ruled Spain illustrate the complexity of the issue. The first depicts the second Habsburg king, Philip II; based on the age of the sitter and costume, it can be dated to around 1575 (FIG. 1). It exhibits traits that can readily be qualified as "Spanish": the somber palette, the stern expression, the rosary held in the right hand seem to illustrate the ascetic religiosity that

art historians continue to identify as essential to the Spanish character. Yet the portrait has most recently been attributed to an Italian and – even more anomalous – a woman, Sophonisba Anguissola (1530s–1625). A very different extreme is seen in the portrait, painted in 1743 by Louis-Michel van Loo (1707-71), of the family of Spain's first Bourbon king, Philip V (r. 1700-46; FIG. 2). Again, it is the work of a "foreigner" painting for a Spanish Bourbon court that willfully rejected the austere formulas of Habsburg portraiture, replacing them instead with a colorism and bombast rarely associated with the concept of Spanish painting. The background, a sort of stage set, is fanciful and complex, the colors brilliant, and the sitters proud to pose in their ostentatious surroundings, gathered around the matriarch, Philip's second wife, Elizabeth Farnese. The aging Philip V sits, somewhat cowed, to the left.

No simple, unified notion of Spanish painting can encompass both of these works. Moreover, such nationalist notions were irrelevant to sitters and artists alike. Although Philip II was raised in Spain and spoke Spanish (in contrast to his father, Charles V, who grew up speaking Flemish), his artistic tastes turned toward the Netherlands and Italy, as proven by his acquisition of painting by the Netherlandish masters Roger van der Weyden (1400-64) and Hieronymus Bosch (c. 1450-1516), and by his patronage of Titian and his apparent preference for Italian painters at the Escorial palace following the death of his Italian-trained court artist, Juan Fernández de Navarrete (1526-79). In contrast, Philip V

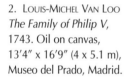

2. LOUIS-MICHEL VAN LOO *The Family of Philip V*, 1743. Oil on canvas, 13'4" x 16'9" (4 x 5.1 m), Museo del Prado, Madrid.

Elizabeth Farnese, the second queen of Philip V, dominates this portrait of the family of Spain's first Bourbon monarch. With its large scale, formal setting and brilliant primary colors, the work marks an intentional departure from the traditions of Habsburg portraiture.

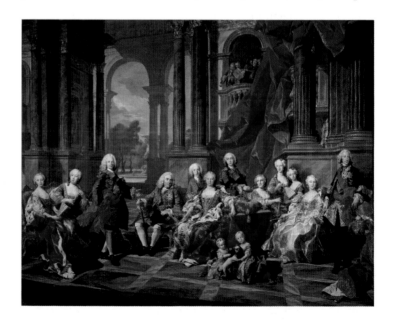

may have spoken some Spanish by the time his family portrait was painted, but the dominant language at the Bourbon court was French; Elizabeth Farnese, his second queen, was Italian. The artist of the portrait was French and a member of the Parisian Académie.

Patrons and Painters

One determining factor of painting is patronage, and in Spain this was largely either religious or monarchic (and sometimes both). At court, portraits of the royal family and courtiers were always in demand, and court artists might also contribute to the decoration of the many royal residences in and around Madrid. Beyond the portrait – mainstay of all court painting from Philip II through the early nineteenth century – a range of works was commissioned by Spanish monarchs. Philip II was patron of several mythological paintings by Titian known as the *Poesie* that illustrated stories from Ovid's *Metamorphoses* and featured sensuous female nudes, as well as the patron of the highly orthodox altarpieces that filled the austere interior of the basilica at the Escorial. His grandson, Philip IV, commissioned in the 1630s a series of subjects from the Flemish painter Peter Paul Rubens (1577-1640) and his studio, scenes of recent Spanish victories for the Hall of the Realms in his Buen Retiro palace in Madrid, as well as Diego Velázquez's (1599-1660) masterful paintings of actors and jesters. Under the Bourbon monarchs, the royal tapestry factory of Santa Bárbara of Madrid inspired some of the most memorable genre scenes of the late eighteenth century, painted as cartoons to be woven as tapestries depicting life in contemporary Madrid. After the sixteenth-century reforms of the Catholic church had inspired a renewed interest in the use of images, religious commissions ranged from altarpieces narrating the lives of Christ or of the saints; to more iconic, devotional images that isolated a single figure to inspire meditation (such as *Christ on the Cross*); to series of "portraits" of the Apostles, known as *Apostolados*. Monasteries expanded this repertory further by including in their decoration series of paintings illustrating the lives of their founders.

Less is known of private patronage. Although scholarship since the 1970s has revealed the bounty of still-life painting in Spain, its patronage and provenance is often untraceable; the same is true of landscape and genre painting. Rare are the artists known to have worked outside of the patronage system: the still-life painter Luis Meléndez (1716-80) began in the 1760s a series of small still lifes without a secure patron, and three decades later Goya broke out of the patronage system by undertaking small-scale paint-

ings and etchings for a private market. Although several small academies were formed in Madrid, Seville, and even Saragossa from the seventeenth to the mid-eighteenth century, until 1752 there was no official academy, as in Italy and France, that might encourage artistic canons, taste, or patronage.

In Spain as elsewhere, patrons could be fickle. An artist's success was relative, and largely dependent upon matching the patron's requirements, whether of an individual or a committee. El Greco's (1541-1614) paintings did not satisfy the demands of the commissioning committee (or chapter) of Toledo cathedral or of Philip II at the Escorial, but he nevertheless found many patrons who did appreciate his style. During the first decade of the seventeenth century, Francisco Ribalta's (1565-1628) stark renderings of Christian themes seemed to please the Patriarch Ribera in Valencia. After the Patriarch's death Ribalta continued to paint religious subjects, but took a startling turn toward a much greater naturalism – a turn that has not yet been fully explained. Before Bartolomé Esteban Murillo (1618-82) became a major contender in the 1650s, Francisco de Zurbarán (1598-1664) received accolades and the patronage of numerous monastic establishments in and around Seville, yet his venture in the early 1630s into mythological and historical subjects for Philip IV in the Hall of the Realms did not earn him any further commissions at court. And if the work of Francisco Rizi (1614-85) and Juan Carreño (1614-85) was highly regarded in Madrid during the 1660s, their altarpiece for a monastic community in more provincial Pamplona was accepted only after a local artist could defend its virtues.

A Changing Spain

Given the chronological breadth of this book, it is best to emphasize at the outset the changing context for painting in Spain from around 1560 to 1828 by outlining briefly some major currents that affected patrons and painters alike. Popular identification of Spain as a land of stark castles in arid landscapes, and of a populace cowed by the powers of the Church and the cruelty of the Inquisition verges on caricature, in taking as historical constants factors that were in continual flux. Although the Inquisition tended to flex its muscles during periods of social unease, many of the traits contributing to its infamy in fact predate the period discussed here. The first *auto-da-fé* (trial of faith) of the Spanish Inquisition was held in Seville in 1481, when six *conversos* (Jews who had been forced to convert to Christianity) were burnt at the stake. Eleven years later, in March 1492 (two months after the con-

quest by Christian forces of Moorish Granada), Jews were expelled from the Peninsula; a decade later Moors also were forced either to convert to Catholicism or to leave Spain. Paralleling these laws was a growing concern with *limpieza de sangre* (purity of the blood) that defended racial discrimination on the basis of heritage. By the 1550s, *limpieza de sangre* was requisite for entry into religious and military orders, as well as universities. This exclusion was given the force of law through the efforts of the antisemitic archbishop of Toledo, Martínez Siliceo, and in 1556 gained the support of the new king, Philip II. Those who supported the doctrine justified their stance by crediting Jews with the heresies (that is, the Reformation) that were then rampant in France and Germany. But traditions often far outlived their motives, and *limpieza de sangre* remained a requisite for state office until 1865.

Throughout his reign, the emperor Charles V had fought the spread of Protestantism in northern Europe. That battle was brought home during the early years of the reign of his son, Philip II, as Protestant sects were discovered in the late 1550s in Seville and Valladolid. Intolerance grew, as the Inquisition found renewed support in a monarchy that now feared the spread of heresy within Spain herself. Retribution was swift, as *autos-da-fé* in both cities burned at the stake fifty-nine of the accused. In 1559, Philip II recalled to Spain all who were then studying abroad, with the exception of scholars at the universities of Rome, Bologna, Naples, and Coimbra. Also in 1559, the Index of prohibited books was issued by the Spanish Inquisition. The Spanish monarchy clearly perceived its role as being that of protector of the Catholic faith against an array of almost interchangeable enemies, by they Moors, Jews, or Protestants. Wars fought by the Spanish and their allies against Turks and Protestants outside of Spain were mirrored by the domestic policies of the Inquisition. The longevity of these concerns is witnessed by the final expulsion of the Moors in 1609; and even in the religious tone assumed by those who two centuries later attempted to protect Spain and her faith against the incursions of the "antichrist" Napoleon.

Spain should not be identified, however, as a land held in an intellectual backwater and surrounded by religious superstition, all due to the Inquisition. This point of view can be traced to the hostility to Spain of French eighteenth-century Enlightenment writers, particularly Voltaire, eager to set the rational, philosophic luminescence of France against the presumed obscurity of Spain. In fact, in sixteenth- and seventeenth-century Spain there was a great deal of open political discussion, noted by many contemporaries; universities, too, increased from eleven in 1500 to

thirty-three by 1600. And Spain's strict adherence to Catholicism was certainly not exceptional in the Europe of the sixteenth century, when Catholic religious leaders convened three meetings of the Council of Trent (1545-63) to denounce Protestant reform and confirm the Counter-Reformation. This movement had been growing since the 1520s, inspired by a wish to reform the Catholic church and to counter the rise of Protestantism. As Holy Roman Emperor, Charles V had played an essential role in convoking the Council, and it is not surprising that his son Philip II was a staunch defender of its decrees, published in 1564.

Those Tridentine decrees served to redefine the Catholic faith in the face of rising and militant Protestantism throughout Europe and had an important impact on painting in Spain. They emphasized the importance of the seven sacraments (Eucharist, Baptism, Confirmation, Penance, Anointing of the Sick, Matrimony, and Holy Orders) in contrast to the Protestant recognition of only two: Baptism and Communion. The sacraments, and particularly the re-enactment of Christ's sacrifice through the celebration of the Eucharist, became a recurrent subject in painting after the Council of Trent. Equally important to religious imagery was the Council's recognition of the veneration of saints, the cults of relics, and the usefulness of images. This inspired a revival of interest in the depiction of saints, and a new concern that images accord with the accepted iconography, or be replaced. Although these beliefs colored religious painting in Spain through the eighteenth century, they are most fully expressed in the monumental palace, basilica, and monastery complex built by Philip II at the Escorial, northwest of Madrid. Not only did the decoration of the basilica feature the images of saints and its high altar celebrate the mystery of the Eucharist; the Escorial itself was a monumental reliquary, with over 7,000 relics collected by the king. Philip's concern with doctrine did not obviate his concern with aesthetics, as he patronized painters of the Italian *maniera*, such as Federico Zuccaro, who eventually came to paint at the Escorial, as well as masters of the Venetian school including Titian and Veronese. But religious paintings by these artists upheld Tridentine decrees.

The monarchic alliance with the Catholic faith was a salient feature of the Spanish court that continued after the Bourbon succession to the throne in 1700. The Bourbons, too, were good Catholics and patrons of several religious establishments. In Madrid, these included most notably the Church of the Visitation (or Salesas Reales), on which work began in the 1750s, and that of San Francisco el Grande, a project that continued from the 1760s through to the 1780s. Yet these were not the dominant, or most

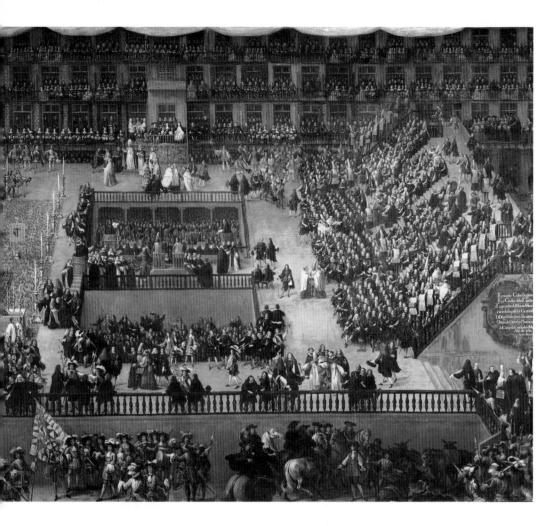

memorable, undertakings of their reign. Soon after arriving in Spain, the Bourbon monarchy began a quest for a court portraitist and also undertook the building or renovation of royal residences, so that they might meet the standards of worldly luxury to which the French court was accustomed. To meet the demands of decoration, the Bourbons founded the royal tapestry factory of Santa Bárbara and the porcelain factory of the Buen Retiro in Madrid. The new rulers kept abreast of trends in France and Italy, and soon introduced into their palaces small rooms, or cabinets, that might display the genre scenes of the Flemish painter David Teniers the Younger (1610-90), already well represented in the royal collection, or require new small-scale paintings, such as the genre scenes of the French artist Michel-Ange Houasse (1680-1730), or the still lifes of Luis Meléndez.

In contrast to the Habsburgs, the Bourbons came to power

3. Francisco Rizi
Auto-da-Fé in the Plaza of Madrid, signed and dated 1683. Oil on canvas, 8'10" x 14'4" (2.7 x 4.4 m), Museo del Prado, Madrid.

The inscription on this large canvas betrays the documentary function of this image, to commemorate the *auto-da-fé* celebrated in the main square of Hapsburg Madrid in 1680, attended by Carlos II, his queen and the queen mother (at the center of the image).

when the Catholic faith within Spain was secure; their wars with other nations were political rather than religious. Although the French kings were Catholic, they found the Spanish Inquisition an alien institution, and as the century wore on, would bring its powers under their control. Upon coming to the throne, Philip V refused to attend the *auto-da-fé* held in his honor. He soon capitulated, however, and did attend the ceremonies in the early 1720s that accompanied the final wave of violence against "judaizers" suspected of harboring Jewish sympathies or of secretly practicing Judaism in Spain. The Inquisition was not abolished until Napoleon's brother Joseph Bonaparte assumed the Spanish throne in 1808. It was reinstated after the fall of Napoleon with the restoration of the conservative Spanish Bourbon Ferdinand VII in 1814, and again abolished in 1820, briefly restored in 1823, and ultimately abolished in 1834. Its powers nevertheless waned during the course of the eighteenth century, *autos-da-fé* became increasingly rare, and execution by fire almost unheard of. Only in very general terms might its diminishing authority be attributed to the influence of Enlightenment thought: in fact it probably was largely due to the unwillingness of the Bourbon rulers to share power.

Two paintings, created about a century and a half apart, illustrate the changing attitude in Spain toward the Inquisition. The first, by Francisco Rizi, documents a five-day-long *auto-da-fé* held in Madrid on 30 June 1680 (FIG. 3). Its main victims were Portuguese *conversos* accused of judaizing. All the balconies and stands of Madrid's Plaza Mayor are filled with spectators who watch the trial of the accused, identified by their tall hats and tunics or *sanbenitos* – the hated yellow garment imposed on those unfortunates accused by the Inquisition, who were, in practice, guilty until proven innocent. At the center of this panoramic view sit the members of the royal family – the Queen Mother, Carlos II, and his first queen, María Luisa. The artist clearly assumes an objective and documentary point of view, offering a panorama in which audience, royalty, the accused, and the accusers are given equal weight.

Almost 150 years later, Francisco Goya isolates the central portion of Rizi's painting: the trial of the accused (FIG. 4). The activities of the Inquisition now take place in a cavernous space removed from daylight and from normal society. The surrounding crush of monks seems physically to oppress the accused in their *sanbenitos*, who bow under the burden. By the time Goya painted this scene, the Inquisition had little real power, and was soon to be abolished. His scene is not intended to be read literally; it is, rather, a meditation on the dark forces that color modern perception

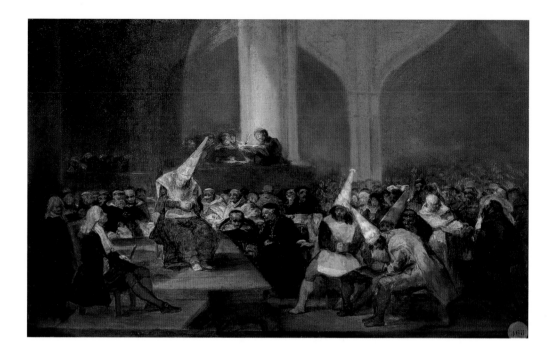

of Spain. Emphasizing the Inquisition in this way, Goya assumes the stance of an outsider before the events of Spanish history, a perspective informed by the French Enlightenment view of Spain as a land of oppression and superstition. His ability to distance himself from his subject – in contrast with Rizi, who can only accept and report – attests to his own modernity, as he contemplates Spain's history and also contributes to the construction of that past in historical memory. For this reason, he is the last artist considered here, and his death provides the end date for this book.

In surveying painting in Spain from 1561, when Philip II chose Madrid as his capital, to Goya's death in 1828, it is best to assume no constants. The monarchy, institutional authority, and patterns of patronage all underwent significant changes. An awareness of these changes is essential to understanding the range of painting to be examined here, which challenges reduction to a single "Spanish" tradition.

4. FRANCISCO GOYA
The Tribunal of the Inquisition, c. 1816. Oil on panel, 18¼ x 28¾" (46 x 73 cm). Royal Academy of San Fernando, Madrid.

In contrast to the earlier painting by Rizi, Goya's scene of the Inquisition is largely invented, as it brings the *auto-da-fé* (celebrated outdoors) into a cavernous space, made claustrophobic by the hordes of clerics, who dumbly watch the proceedings.

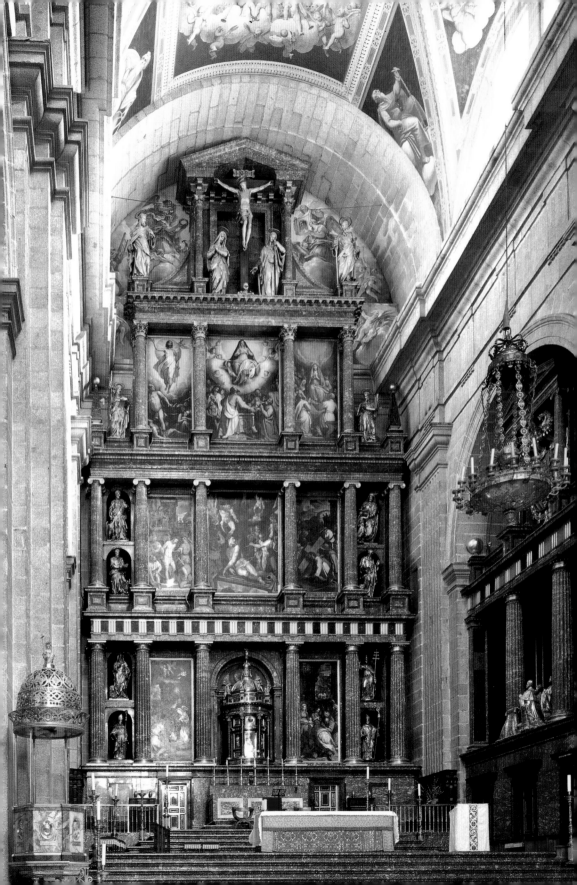

ONE

Painting at the Court of Philip II

5. The High Altar, the Escorial.

Combining architecture, sculpture, and painting, the high altar stands as the focus of the basilica, providing an elaborate and monumental framework for the tabernacle.

In thinking about painting in Spain, several artists come to mind: El Greco, Velázquez, Murillo, and Goya. Yet the history of painting does not end with such lists, since no artist works in a vacuum. Velázquez is best understood in relation to his patron, the Habsburg king Philip IV, and Murillo's images of gentle madonnas are often interpreted as antidotes to the tragic decline and hardship suffered by Seville in the later seventeenth century. To understand why El Greco ("the Greek"), whose identity would become inextricable from his foreign birth, found his way to Toledo by 1577, it is essential to realize that Spain at this time offered great opportunities for artists, largely because of the patronage of Philip II.

In 1561, Philip II, who had ruled for five years, decided to bring his court from the city of Toledo to Madrid. Why he made this move remains a matter for speculation, yet it is clear that the winding, narrow streets of Toledo, and its medieval buildings and infrastructure could not accommodate the expanding retinue of Philip's court. In contrast, the yet undeveloped capital of Madrid, whose name derives from the Arabic *mayràs*, meaning underground springs, offered an abundant supply of water and opportunity for expansion around the Moorish fortress, or Alcázar, that dominated the city.

The establishment of a settled court at Madrid reflects the domestic agenda that would characterize Philip's reign. His father,

the Holy Roman Emperor Charles V, had spent much of his reign in northern Europe, fighting to control the spread of Protestantism and to secure a Flemish-based, central European empire. However, the Habsburg territories in central Europe had passed to Charles's brother, Ferdinand I, who also inherited the Imperial title. Upon assuming the Spanish throne, Philip II was thus able to turn his attention to an empire that looked westward, to the expanding territories of Spain in the New World. Unlike his father, Philip did not leave Spain to command military campaigns: such engagements were largely left to his subordinates, such as the Duke of Alba, sent to the Netherlands in 1567 to suppress the rebellion against Spain, recalled to Spain after a failure to gain a strong territorial foothold in 1573, and sent out again to conquer Portugal in 1580.

Philip's principal residence was the Alcázar of Madrid, originally a Moorish fortress (destroyed by fire in 1734) that overlooked the Manzanares River. He is nevertheless most commonly identified with the monastery and palace complex of the Escorial (FIG. 6), some 27 miles (43 km) northwest of Madrid – the major artistic accomplishment of his reign. This identification of the monarch – already engraved in visual memory by royal portraits in which he is dressed entirely in black (see FIG. 1) – with the austere presence of the Escorial runs the risk of encouraging a one-dimensional characterization of Philip II as "the monastic king." This romantic notion of Philip ruling a vast kingdom from a monastery is misguided. The week preceding Easter was always spent by the court at the Escorial, as were other occasional church feasts, yet winters there could be harsh, while summers brought the threat of malaria. Madrid therefore remained the center of Philip's kingdom.

Philip took the Catholic faith and the rituals of his religion very seriously, but he was not a fanatical recluse, as is sometimes suggested. As a young man he enjoyed outdoor activities (like many Spanish monarchs he was an avid huntsman), and music was a lifelong passion. His love of nature led him to be greatly impressed by the formal gardens that he saw on his travels in the Low Countries (1549-51), which he tried to translate in his royal residences at Aranjuez – on the Tagus River, about 35 miles (47 km) south of Madrid – and the Pardo – about 6 miles (10 km) from Madrid – the Casa de Campo (or gardens, across the Manzanares River from the Alcázar of Madrid) and Valsaín outside of Segovia. After unsuccessful attempts to train Spanish gardeners, he imported Flemings to keep up the royal grounds. Philip had also been impressed by the Flemish style of brick archi-

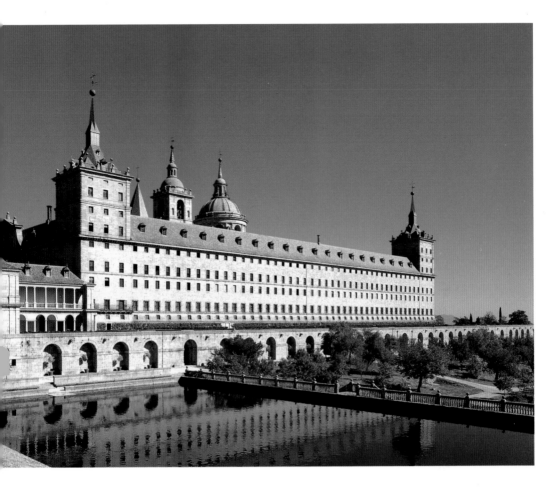

tecture with slate roofs, which he imported to Spain, employ-
ing such slate roofs most notably at the Escorial. As has been men-
tioned, he collected the paintings of Flemish artists such as Roger
van der Weyden and Hieronymus Bosch and was also an impor-
tant patron of Titian, the foremost Venetian painter of the day,
from whom he commissioned religious works as well as mytho-
logical paintings. These included subjects such as *Diana and Actaeon*
(1556-9, today National Gallery of Scotland), taken from Ovid's
Metamorphoses: the paintings feature idealized female nudes, and
probably adorned the king's private apartments in his various res-
idences. Philip read widely, as evidenced by his personal library
that by the time of his death contained 14,000 volumes. That library
was housed in the Torre Dorada (or Golden Tower) added by
Philip to the southeast corner of the Alcázar during the first decade
of his reign. At the foot of the tower was the Garden of the Ambas-
sadors, which also offered a secret passageway to the 4,000 acres
of gardens known as the Casa de Campo, across the river.

6. The Escorial

Begun by the early 1560s,
the monastery and palace
complex dedicated to St.
Lawrence in the village of
El Escorial became the
monument most closely
associated with Philip II.

Portraying the Court of Philip II: Alonso Sánchez Coello

The art of court portraiture links generations of artists, from Alonso Sánchez Coello (1531/32-88) to Francisco Goya (1746-1828); this is not surprising, since portraiture remains the genre most essential to court art of all ages. More than an exact likeness of the subject represented, the court portrait in fact filled two main demands: to please its sitter and to serve as visual testimony of monarchic power and dynastic lineage. When marriages were arranged between royal houses, portraits were sent to represent the future spouse. And when families were divided by distance, portraits offered a comforting surrogate. Thus in 1561 Catherine de' Medici, queen of France, sent her portrait to her daughter, Elizabeth of Valois, Philip II's third wife; when King Philip III, traveled to Valencia, the court painter Pantoja de la Cruz (1555-1608) provided a series of portraits of the royal family, as well as one of the king for the queen. Marriages themselves might be commemorated by portraits, as were coronations, other ceremonies, and even pregnancies.

Portraits painted by Sánchez Coello for the court of Philip II introduce formulas that would become standard in court portraiture throughout the reign of the Habsburg dynasty, with figures posed formally against sparsely furnished backgrounds. The elaborate laces and brocades of the royals' costumes are precisely rendered, as are the individual physiognomies. The precision of Sánchez Coello's style reveals its Netherlandish precedents, for he had trained with the Flemish painter Antonis Mor (1519-75), who had entered Philip's service after meeting the future king in Brussels in 1550. Confronted with an atmosphere of increasing religious fanaticism (and an increasingly effective Inquisition), Mor left Spain in 1560, reportedly because he was suspected of Protestant sympathies. With his departure, the role of court portraitist fell to his student, Sánchez Coello.

In contrast to Mor, Sánchez Coello sometimes deviates from the single figure format, offering figures or background details that provide a glimpse into court life. Sánchez Coello's portrait *The Infanta Isabel Clara Eugenia with Magdalena Ruiz* (FIG. 7) offers more than an objective representation of Philip II's second daughter ("*infanta*," "*infante*" for the boy, means "princess" or "prince") by Elizabeth of Valois. Recent scholars have detected a variety of hands at work here, suggesting that the composition and faces were by Sánchez Coello, but that the hands and much of the intricate costume design were executed by assistants. Such collab-

7. ALONSO SÁNCHEZ COELLO *The Infanta Isabel Clara Eugenia with Magdalena Ruiz*, c. 1585-88. Oil on canvas, 6'9¹/₂" x 4'3" (2 x 1.3 m), Museo del Prado, Madrid.

Although Sánchez Coello's highly detailed style did not suit the large-scale commissions for the basilica at El Escorial, it does record the elegant dress and accessories worn by such members of the court as Philip's daughter, Isabel Clara Eugenia. Married to the Archduke Albert of Austria, Isabel later ruled the Low Countries from 1599 until her death in Brussels in 1633.

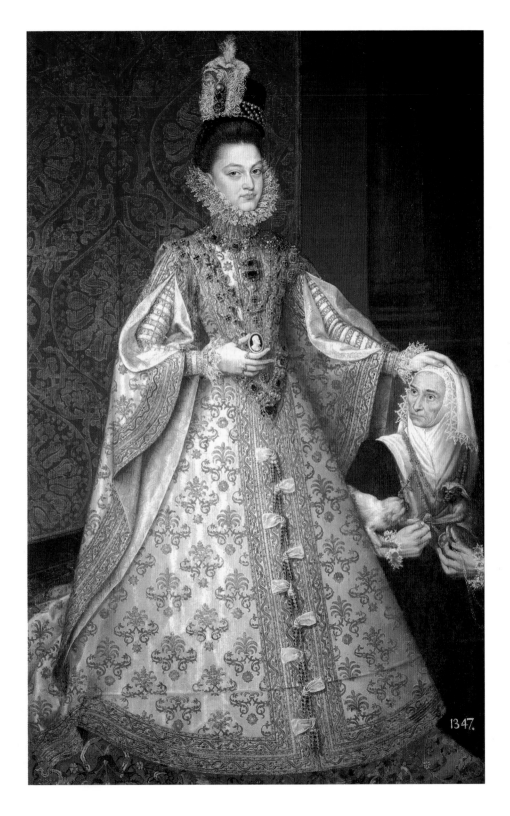

orations in the execution of court portraiture are fairly common since a single artist could never fulfill the demand, and so called upon assistants either to execute the costumes or to paint replicas of his own works. Trends in late sixteenth-century fashion, and particularly the Infanta's high ruff collar, as well as the sitter's apparent age, help to date the painting to the mid-1580s. Of course, those parts painted by Sánchez Coello must have been completed by the artist's death in 1588.

The presence of Magdalena, a dwarf who was a favorite of Philip's daughters and who had served Isabel Clara for almost twenty years by the time the portrait was painted, offers another insight into court life. Although the depiction of such people might today seem out of place in a court portrait (Magdalena, for example, suffered from alcoholism and epileptic seizures throughout her life), she and others like her were held in high esteem at the Habsburg court and appear in paintings throughout the seventeenth century. Magdalena had accompanied Philip to Portugal in the early 1580s, and had so much presence among his retinue that the king reported her actions – her displeasure with the king and threats to leave – in letters to his daughters. In spite of Magdalena's strong will, she is portrayed here as suitably subservient, as she looks beseechingly towards her mistress, who in turn comforts Magdalena with a pat on the head.

8. ALONSO SÁNCHEZ COELLO *The Infantas Isabel Clara Eugenia and Catalina Micaela*, c. 1568-69. Oil on canvas, 39 x 44½" (99 x 113 cm), Monasterio de las Delcalzas Reales, Madrid.

The two daughters of Philip II and his third wife, Elizabeth of Valois, are shown here, around the ages of three and four years. Through the window is glimpsed the Alcázar of Madrid, the main residence of Philip II.

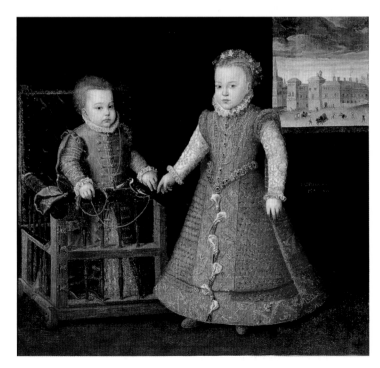

The esteem of the court for Magdalena is clear from her inclusion in this portrait: although she assumes a humble pose, it was nevertheless an honor to be immortalized by the most senior court painter. Magdalena also reinforces the Infanta's status by juxtaposition. Her aged face contrasts with the Infanta's youth and noble Habsburg features, and the simplicity of her dress sets off the Infanta's finery. Magdalena holds in her hand a round object which, though blurred, seems to be a miniature portrait, set off against the far more luxurious cameo of Philip II, held by the Infanta as testimony of her lineage. That these two figures in fact belong to different realms is emphasized even by the background – the princess stands before a richly brocaded cloth, Magdalena before dark shadows.

Almost twenty years earlier, the same Infanta had posed for another portrait by Sánchez Coello, this time with her older sister, Catalina Micaela (FIG. 8). Even though the sitters are both under the age of five, and Isabel is supported by a luxuriously padded walker, they possess the self-control and formal bearing seen in portraiture of adults at court. These are not children, but heirs to the Spanish throne, destined themselves to rule. The view through the window offers a glimpse of the Madrid Alcázar with the adjoining Torre Dorada, buildings identified with Philip II, perhaps included to underscore the standing of these two children.

The Escorial

Since the Alcázar, with its interior frescos (by Italian artists brought to Spain by Philip II), and the Torre Dorada were destroyed by fire in the eighteenth century, the Escorial naturally has become the building most readily associated with Philip's name. It is a unique complex that originally encompassed the *Casa del Rey* (household of the king), apartments for the royal family and courtiers, a seminary, a monastery, a basilica and a royal tomb. The project was begun by the court architect Juan Bautista de Toledo, who died in 1567, shortly after construction had begun. It was then taken over by his disciple, Juan de Herrera (1530?-97). Fortress-like in austerity and monumentality, the Escorial was perhaps inspired by the plan of the Alcázars that then stood in Madrid and Toledo. Some early sources, dating to the 1560s, refer to the complex as San Lorenzo de la Victoria, a dedication reflected by the grid plan of the complex, an emblematic reference to the grill upon which St. Lawrence was martyred. And although the association of St. Lawrence with victory was soon forgotten, it originally

recalled the Spanish victory over the French at the town of St. Quentin on 10 August 1557, the saint's name day, a victory which led to the peace of Cateau-Cambrésis in 1559, in which Spanish, French, and English claims over each other's territories were settled.

The political implications of the Escorial should not supersede its primary role, which was to provide a burial place for Philip's father and, after 1564, for the Habsburg dynasty. During the last two years of his life, the emperor Charles V had retired to a monastery of the Hieronymite order at Yuste in the Extremaduran province of Cáceres; this same religious order would occupy the monastery attached to the mausoleum and basilica of the Escorial and performed the requisite offices. As plans for the Escorial progressed, a royal residence was added to the convent; and in 1575, a decision was made to add a seminary. The separate apartments of the king and queen (together comprising the *Casa del Rey*), literally surround the sanctuary of the basilica, so that the monarchs could view the mass from windows in their respective bedrooms. The larger royal palace, for the *infantes* and courtiers, occupied the northeast quarter of the complex: this would be refurbished in the second half of the eighteenth century by the Bourbon monarch, Carlos III, who would build residences for courtiers surrounding the complex proper.

Some of the rich decoration of the complex still survives. Visitors can still see the elaborate grotteschi decoration of the capitular rooms in the monastery (occupying the southern half of the building) painted by teams of Italian artists in Philip's service including Fabrizio Castello (c. 1560-1617) and his half-brother Nicolas Granello (d. 1593). Pellegrino Tibaldi (1527-96), who arrived at the Escorial in 1588, would direct artists in painting the ceiling murals in the library, depicting the liberal arts, as well as a series of biblical scenes for the monastery's main cloister, before turning to work on the main altarpiece for the basilica. The cloister was seen by few outside the order, and decorative grotteschi or series celebrating the liberal arts found little patronage outside court circles. For most artists working in Spain outside of the court, the church was the foremost patron and devotional painting provided the mainstay for their careers. Thus, it is the altarpieces painted for the basilica itself that best serve the purpose of a more general study of painting, since they illustrate the accomplishments and shortcomings of native talent as well as the contributions of Italian artists active at the Escorial after the mid-1580s, whose style influenced painters working throughout the Iberian peninsula during the following decades.

The Basilica of the Escorial

The basilica is in the plan of a Greek cross, built like the rest of the complex of granite, with a central dome rising 302 feet (92 metres) and supported by massive piers. Still in use today, its scale cannot be captured in photographs. The architecture shows that the interior decoration, supplied by over forty altarpieces, was integral to the original conception, since niches for the altarpieces are carved into the granite of the walls and also into two faces of each of the central piers, providing an impressive framework for many of the paintings. In contrast to more traditional programs of church decoration, which focus on the main altarpiece, often depicting a scene from the life of the patron saint, the program of the Escorial fills the entire space of the basilica with devotional images. Five larger altarpieces, two reliquary altars flanking the main sanctuary, and the high altarpiece were the works of Italian artists; El Greco attempted to join their ranks, but his submis-

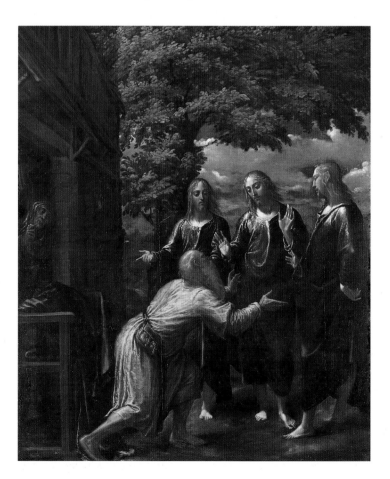

9. Juan Fernández de Navarrete *Abraham and the Three Angels*, 1575. Oil on canvas, 9′4″ x 7′9″ (2.8 x 2.4 m), National Gallery of Ireland, Dublin.

Painted after many years of study in Italy, this work attests to Navarrete's interest in narrative, as well as to the influence of Titian. In the scene, inspired by Genesis 18, Abraham is approached by the Lord in the guise of three men, whom he greets with the words, "My Lord, if now I have found favor in thy sight, pass not away, I pray thee, from thy servant." After receiving his hospitality, the strangers tell Abraham that his aging wife Sarah would bear a son: it is she who looks out from Abraham's humble dwelling. The relevance of the theme to the guest room of San Lorenzo, a hospice for the many pilgrims who visited the basilica, is readily apparent. By portraying hospitality to strangers, it also exemplifies the Counter-Reformation emphasis on good deeds, essential for the salvation of the soul.

sion, as we shall see, failed to gain Philip's patronage. Thirty-three smaller altarpieces, dispersed throughout the basilica and painted by Spanish-born artists, showed paired saints, with the exception of the *Martyrdom of SS. Justus and Pastor* by Sánchez Coello. Two lamps as well as candles originally illuminated each of these altarpieces, underscoring the presence of the saintly figures throughout the basilica.

Recent research suggests that the arrangement of the altarpieces in the basilica was inspired by a breviary (the liturgical book containing the psalms, hymns, lessons, and prayers of the mass) issued in 1568 by Pope Pius V in support of liturgical reforms decided by the Council of Trent. The multitude of saints portrayed confirms the Counter-Reformational assertion that images of saints were essential to religious devotion. Their placement within the basilica reflected their specific roles: apostles and evangelists were closest to the main altar, Doctors of the Church and theologians were situated near the seminary, and the founders of religious orders were placed nearest to the monastery. The high altar depicts the major feasts of the Roman Catholic church by surrounding the central images of St. Lawrence (to whom the complex is dedicated) and the assumption of the Virgin, with scenes representing the life and passion of Christ.

10. TITIAN
The Tribute Money, 1568. Oil on canvas, 43″ x 40″ (109.2 x 101.6 cm), National Gallery, London.

Sent by Titian to Philip II in 1568, this painting remained in the Escorial from 1574 to the early ninetheenth century.

The Spanish-born painter Juan Fernández de Navarrete (1526-79, also known as "El Mudo," the mute) was the first painter active in this commission. He completed seven of the smaller altarpieces before his death: that they portray apostles or evangelists and are situated nearest the high altar suggests that work proceeded outward from the sanctuary. He also received the commission for the high altarpiece months before his death: Padre Sigüenza (1544-1606), librarian, historian, and prior of the Escorial, wrote in his invaluable 1605 account of its history that, had Navarrete lived, Spain would have been spared the incursion of the many Italian painters who contributed to the decoration of the basilica after 1579.

According to the only surviving contract for the basilica paintings, made on 21 August 1576 between Navarrete and the Building Committee, whenever possible the representation of the saint was to follow a known and approved portrait, their figures were to be a uniform 6'3" (190.5 cm) in height, and if a figure of a saint was repeated, its physiognomy was not to change. Consistency

and accuracy were clearly valued above originality and invention. The decorative program of the basilica celebrated both the veneration of saints and the use of devotional images, tenets of the Catholic church that had been reconfirmed by the Council of Trent (1545-63). Counter-Reformation fervor also inspired Philip's collection of relics, housed and displayed at the Escorial.

By the time the painter Navarrete signed the contract for the thirty-two smaller altarpieces in 1576 his work was well known to the king. We know little of his early training: sources report that he studied in Florence, Rome, Venice, Milan, and Naples. If this is so, his travels in Italy had ended by 1568, when Philip appointed him court painter. At about this time, he presented to the king the *Baptism of Christ* (now in the Prado Museum), which ensured his success at court. Seven years later, he received a commission to paint *Abraham and the Three Angels* (FIG. 9) for the guest room of the Escorial monastery, where it hung, much admired, until taken as booty by the French during the Napoleonic Wars.

Abraham and the Three Angels bears witness to Navarrete's Italian background, which earned him the epithet of the "Spanish Titian." The figure of Abraham is indebted to Titian (FIG. 10), and Navarrete's depiction of the figures of the Trinity, distinguished only by position and gesture, shows the hand of an artist confident in his own powers of invention as he uses forms identical yet different to convey the unity of the Trinity. The figures of the saints who populate his altarpieces (FIG. 11), made more massive by their deeply shadowed drapery, also pay homage to the great Italian Renaissance painters. Navarrete turned for inspiration to earlier artists: his figures of *St. Peter and St. Paul* are clearly indebted to those of Plato and Aristotle in Raphael's (1483-1520) fresco of the *School of Athens* (1508-12) in the Stanza della Segnatura of the Vatican. Roman ruins in the background situate Navarrete's saints in the classical era – while also recalling the classical architectural precepts that simultaneously inspired Juan de Herrera, the main architect of the Escorial.

Philip II was clearly pleased with this achievement, for by January 1579 he offered Navarrete the most important commission within the basilica: the high altar. When Navarrete died two months later, he left the king without a court painter ready to fill the demands of the Escorial undertaking.

11. JUAN FERNÁNDEZ DE NAVARETTE
St. Peter and St. Paul, 1577. Oil on canvas, 7'6¹/₂" x 6' (2.3 x 1.8 m), the Escorial.

Navarrete's admiration for the works of Italian High Renaissance painters is seen in this painting, whose majestic figures recall those of Raphael. Their natural expressions stand in contrast vividly with the more theatrical faces of Sánchez Coello's saints (see FIG. 12).

12. ALONSO SÁNCHEZ COELLO
St. Stephen and St. Lawrence, 1580. Oil on canvas, 7'6½" x 6' (2.3 x 1.8 m), the Escorial.

Compared with Navarrete's images of paired saints, Sánchez Coello's altarpiece illustrates the alternative styles that converged at the Escorial. Here, the highly detailed handling betrays Netherlandish influence inherited from Antonis Mor, that stands in contrast to Navarrete's Italianate style.

Philip's first reaction was to identify painters within the court ranks who might take up where Navarrete had left off. Of the three painters chosen to execute smaller altarpieces – Alonso Sánchez Coello, Diego de Urbina, and Luis de Carvajal – Sánchez Coello alone introduced a clear departure from the Italianate idiom of Navarrete.

Alonso Sánchez Coello had already gained his reputation as a court portraitist by the time he turned to work at the Escorial. That he was summoned to fill in for Navarrete suggests that Philip II was more concerned with getting the project done than with any consistency of style among the artists involved, since Sánchez Coello's Netherlandish training represented an antithesis to Navarrete's Italian schooling. His altarpiece of *St. Stephen and St. Lawrence* (FIG. 12) illustrates both the strengths and weaknesses of his style. In place of Navarrete's classical figures with

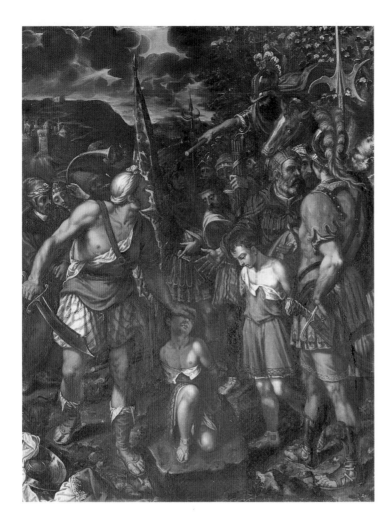

13. ALONSO SÁNCHEX COELLO
*The Martyrdom of St. Justus
and St. Pastor*, 1582-83.
Oil on canvas, 7'6¹/₂" x 6'
(2.3 x 1.8 m), the Escorial.

Peculiar by the standards
of Italian High Renaissance
classicism, Sánchez Coello's
elision of form and surface
offers an anticlassical
energy and intensity of
expression that a modernist
could well admire.
Apparently, his skills as
a history painter did not
please Philip II, who
turned to Italian artists for
the larger narrative scenes
painted for the basilica.

massive drapery, placed against a broadly defined landscape, these
two saints stand close to the picture plane, on a ledge above the
instruments of their respective martyrdoms, stones and firewood.
Ever the portraitist, Sánchez Coello creates an interior setting
for his saints. As if attributes were not sufficient to identify the
figures, we are offered the scenes of martyrdom embroidered
on their dalmatics, depicting the stoning of St. Stephen and the
grilling of St. Lawrence. The illusionistic depth of these scenes,
juxtaposed to the pattern of the saints' robes, creates a curious play
between surface and depth. When such busyness is compared with
the simplicity of Navarrete's saints, it suggests that Sánchez Coello
was working hard to prove himself worthy of the Escorial com-
mission.

Sánchez Coello's strengths as a portraitist – his precise ren-
dering of faces and translation of the rich detail of court costumes

– might be seen to work against him in compositions that rely upon the interaction of figures. He works from the individual to the whole, rather than allowing the whole – the *historia* or narrative – to dictate individual forms. One art historian has traced at least three distinct sources for figures in the *Martyrdom of St. Justus and St. Pastor* (FIG. 13), culled from artists as diverse (to the modern eye) as Dürer, Raphael, and Navarrete. Such mixing might be called eclecticism, although this term would demand a conscious borrowing of recognizably disparate sources – and we might do well to remember that clear distinctions between the Italian, Northern, and Spanish schools were rarely made during Sánchez Coello's own time.

The *Martyrdom* is painted as one of the smaller altarpieces, replacing the usual paired saints. Judged in terms of Italian High Renaissance painting, the result offered is not a happy one: consistent scale and proportion are lacking, and the illusionistic space is highly ambiguous. Perspective and individual forms are subsumed within the play of pattern. That this is the only narrative scene painted by Sánchez Coello suggests that his patrons were not fully satisfied. This is a curiously bloodless martyrdom, with frozen figures patiently awaiting their execution, and still lifes replacing the corpses that in other martyrdom scenes provide the foreground staffage.

El Greco at the Escorial

Sánchez Coello's main talent did not lie in creating large-scale narratives. Philip II perhaps realized this, and in seeking painters for the five larger altarpieces that would show multi-figured scenes, looked to Italian-trained artists. The best known of these had arrived in Spain around 1577: Domenikos Theotokopoulos, commonly known as El Greco (1541-1614). Given the number of Italian artists who had found work at Philip's court, it seems likely that El Greco came to Spain to seek such employment. But the reception of his altarpiece in fact curtailed his courtly career.

El Greco's route from his native Crete to Spain can be only partly reconstructed. His activity as a painter in the Cretan city of Candia is documented by 1566, when he was authorized to sell a painting by lottery. The description of the painting as a scene from the Passion on gold ground suggests that El Greco worked in a style similar to that seen in Byzantine icons, with stylized figures set against gold. The recent discovery of an early work showing the *Dormition of the Virgin* (in the Church of the Dormition, Syros, Greece) bears this out. Since Crete was a Venetian

territory, it is not surprising that Venice was El Greco's first stop when he went to Italy in about 1568. He did not remain there long, and by 1570 was in Rome, where he was introduced in a letter by the miniature painter Giulio Clovio to the circle of Count Alessandro Farnese (nephew to Philip II and later governor-general of the Netherlands). El Greco is identified in that letter as a disciple of Titian: yet since the great Venetian painter did not have students in the traditional sense, the exact relation between El Greco and Titian remains a matter of speculation. The rich palette of paintings executed after 1570, however, reveals El Greco's study of such Venetian artists as Titian, Tintoretto and Veronese.

Among the works that El Greco executed in Italy are at least three versions of *Christ Healing the Blind*. The final version (FIG. 14), apparently executed in Rome and taken by El Greco to Spain, reveals lessons learned during his Italian sojourn. A stage-set background of classically inspired architecture, arranged along a deep perspective marked by the pavement, replaces the archaic, Byzantine-style gold backgrounds seen in El Greco's early works, and recalls the work of Tintoretto. The figures of Christ and the

14. EL GRECO
Christ Healing the Blind, c. 1577. Oil on canvas, 47¼ x 57½" (120 x 146 cm), Metropolitan Museum of Art, New York.

Showing the influence of the artist's sojourn in Venice, this painting was attributed to Jacopo Tintoretto in the nineteenth century, an attribution that remained until its sale in 1958.

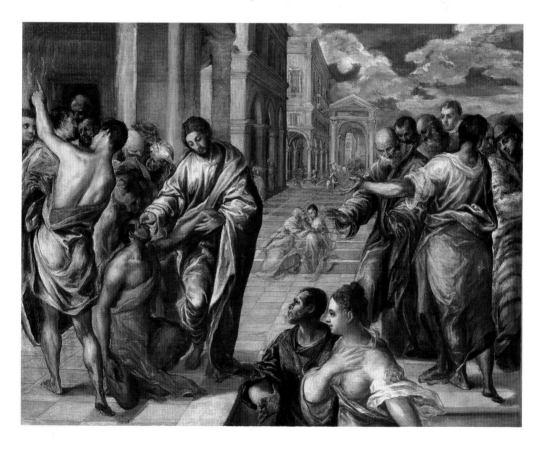

15. El Greco
The Martyrdom of St. Maurice and the Theban Legion, 1580-82. Oil on canvas, 14'8" x 9'11" (4.5 x 3 m), the Escorial.

Ordered in AD 302 to worship the idols of the Romans, the Christian Theban Legion under the command of St. Maurice made the decision to accept martyrdom rather than revolt against secular authority. In contrast to Sánchez Coello's *Martyrdom of St. Justus and St. Pastor*, El Greco gives pride of place to the consultation involving the foreground soldiers rather than to the martyrdom, relegated to the middle distance on the left. This iconographic twist is only one facet of El Greco's unique style, with elongated figures that are simultaneously sculptural and weightless, whose other-worldly grace is heightened by brilliant colors and fluid brushwork. The emphasis placed on the foreground consultation, and the consequent secondary role assigned to the martyrdom, is thought to have influenced the final decision not to display the painting in the basilica of the Escorial for which it was originally painted. (It was, however, housed elsewhere in the monastery.)

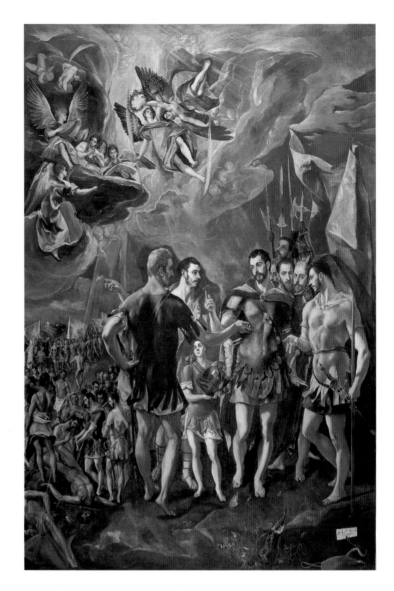

kneeling blind man are surrounded by secondary characters in classically composed groups, whose expressions and gestures develop the narrative. This marks a major step away from the repetition of iconic themes demanded by the Italo-Byzantine tradition. Eager to learn, the young artist was clearly looking at works around him: the arm of the blind man recalls that of Christ in Michelangelo's Vatican *Pietà*; while the vibrant colors, brushed loosely on the canvas, and the highlights defined by impastoed and unmixed strokes, look to Venice. The painting remains unfinished: the columns of the building on the far left, as well as some of the figures before it, have been summarily blocked in, and we see next to them strokes

of paint, as if El Greco wiped excess paint from his brush in this corner.

In 1576, the thirty-five-year-old artist was painting in Rome, apparently without any marked public success. Contacts made in Rome may have offered him an introduction to potential patrons in Toledo, where he arrived by 1577. He had settled there when in 1580 he was commissioned to paint an altarpiece for a chapel dedicated to St. Maurice in the basilica of the Escorial. He worked on *The Martyrdom of St. Maurice and the Theban Legion* (FIG. 15) for over two years, receiving periodic payments that totaled 300 ducats.

According to Padre Sigüenza, the historian of the Escorial, Philip II did not like this painting, even "though it is said to be very artistic and we are told that its painter is very proficient, and that many excellent things by him are seen." Although this comment might be seen as confirmation of Philip II's conservatism, the patron of Titian can hardly be considered naïve in artistic matters. What is more, El Greco's work, though not displayed in the basilica, was nevertheless kept in the chapter house of the monastery, where Sigüenza himself saw it. His lukewarm account of the work seems therefore to convey his own view, rather than that of Philip II.

Relegation of *St. Maurice* to the chapter house suggests that Philip deemed the work inappropriate for display within the basilica: perhaps because it was too "artistic," but also perhaps because its originality interfered with the lesson it was intended to illustrate. The theme of martyrdom, so often portrayed or alluded to in the altarpieces commissioned for the Escorial, exemplified the ultimate Christian devotion: the willingness to give one's life for one's faith. As paradigms of Christian sacrifice, martyred saints were central to Counter-Reformation belief. Yet in looking at El Greco's work, our eyes are drawn to the graceful figures of the soldiers, or perhaps to the angels above (who would have been more strongly emphasized before the arched crown of the painting was cut down). Only after examining these sections of the canvas do we notice the martyred legionnaires relegated to the middle distance.

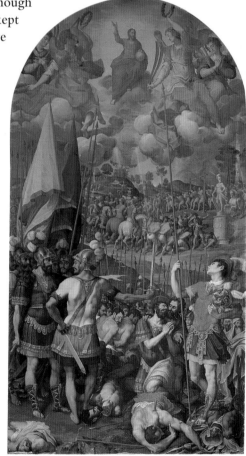

16. ROMULO CINCINATO *The Martyrdom of St. Maurice and the Theban Legion*, 1583-84. Oil on canvas, 16'11" x 9'3½" (5.1 x 2.8 m), the Escorial.

Cincinato was a Florentine artist who also painted frescoes for the choir of the basilica. His more orthodox representation of this martyrdom was deemed more suitable for the basilica than the earlier version by El Greco.

El Greco's perceived shortcomings become very clear in comparing this work to that commissioned to replace it. Philip II now turned to Romulo Cincinato (c. 1502-93), an Italian artist already in his service, who offered a version of the martyrdom with a cast of thousands (FIG. 16). The legion's inevitable (and chosen) fate is clearly illustrated by the fallen and beheaded corpses that threaten to spill forth from the painting. Moreover, the reason for their martyrdom – their refusal to worship idols – is spelled out in the middle distance; in El Greco's work, no such explanatory footnotes are offered. In contrast to El Greco, Cincinato also retained in his work the decorum essential to Counter-Reformation painting, dressing all his figures in what was considered to be historically accurate costume, avoiding gratuitous nudity and anachronism. El Greco, in contrast, follows none of the rudimentary demands of decorum, and even goes so far as to include portraits of contemporary military leaders in the group to the right of the saint, one of whom – the Duke of Savoy, leader of Philip II's troops at the Battle of St. Quentin – even wears sixteenth-century armor. As we shall see, this same melding of past and present would work to El Greco's credit when he returned to Toledo to work on the *Burial of the Count of Orgaz* in the mid-1580s.

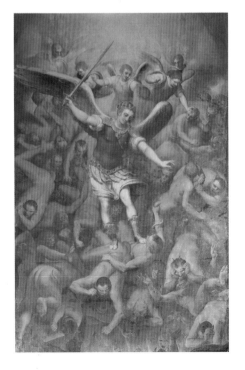

17. LUCA CAMBIASO
St. Michael, 1584. Oil on canvas, 8'5" x 5'5¾" (2.5 x 1.7 m), the Escorial.

The Italian Contribution: Luca Cambiaso and Pellegrino Tibaldi

Since the larger altarpieces for the basilica were painted by Italian artists, the commission given to El Greco suggests that he was considered among this group rather than as a "Spanish" painter. He was not the only painter at the Escorial whose lack of decorum was noted. The Italian Luca Cambiaso (1527-1585) painted an altarpiece showing St. Michael vanquishing the rebel angels, in which the figures of the fallen angels were said to distract too greatly from that of the Saint. This altarpiece was then replaced by a second version by Pellegrino Tibaldi, the most accomplished Italian painter participating in the basilica project.

Comparing the works by Cambiaso and Tibaldi (FIGS 17 and 18), we can understand the patron's decision. Cambiaso's *St. Michael* is a delicate angel who strikes a balletic pose amid the tangled figures he supposedly conquers. The combat portrayed

is at best ineffective, and fails as a statement of Good conquering Evil. Tibaldi's *St. Michael* is a different lesson entirely. Here the archangel, modeled on Michelangelo's figure of Christ in the Sistine Chapel *Last Judgment* (1508-12), surges forth from the void behind, directing his wrath toward the cowering angel beneath his feet. Sculptural in form, with wings spread, he dominates the canvas as his assistants on either side pummel the defiant rebels: there is a physicality to the confrontation lacking in Cambiaso's work. Comparison of Tibaldi's painting to a preliminary drawing shows that his turn toward more monumental forms was a conscious decision, perhaps an attempt to adjust the scale of his image to the monumental proportions of the basilica's interior. His efforts met with the approval of his patron.

The high altar, or *retablo*, of the Escorial is a monumental multimedia work (FIG. 5, page 21). Its framework, executed in red and green jasper, picks up the classical orders used by Herrera throughout the basilica and suggests that the architect contributed to its design. Paintings for the high altar had long been pending, and had once included canvases by Cambiaso, Veronese, and Tintoretto (the latter two painters never came to Spain). By 1585, Federico Zuccaro (1540/41-1609) was brought to Spain to work on the high altar, but was soon distracted by a commission for the two lateral reliquary altars. He did finally paint the eight scenes of the main altar, which included the central images of the Martyrdom of St. Lawrence and the Assumption of the Virgin, and six flanking scenes of Christ's life: the Adoration of the Shepherds, the Adoration of the Magi, the Flagellation, the Bearing of the Cross, the Ascension, and Pentecost. Still the exigent Philip II was not satisfied, and in the end Tibaldi would paint new versions of the *Martyrdom of St. Lawrence*, the *Adoration of the Shepherds* and the *Adoration of the Magi*, seen today. Sculptures representing the Fathers of the Latin church, the Evangelists, and selected saints frame the whole and complement its painted imagery.

Directly above the tabernacle, at the center of this magnificent ensemble, is Tibaldi's scene of the martyrdom of St. Lawrence (FIG.

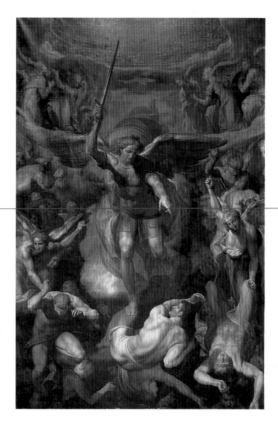

18. PELLEGRINO TIBALDI *St. Michael*, 1592. Oil on canvas, 13'4" x 9'4½" (4 x 2.8 m), the Escorial.

The robust and sculptural figures and linear contours of Tibaldi's style descend from Michelangelo.

19). Painted in 1591, it marks the end of Philip's quest for the best painting to fill the most visible and sacred space within the basilica. The first version had been painted by Titian in the mid-1560s: yet when Titian painted his work, the altarpiece itself had not been designed. Once it was completed, the framework did not fit the proportions of Titian's painting, which was instead hung above the main altar of a smaller, adjoining church. Philip then turned to Navarrete, perhaps seeing him as capable of working in a Titianesque style. His early death reopened the search as now the king turned toward Cambiaso, whose scene of martyrdom reiterates the confusion of his earlier *St. Michael*. The Italian Federico Zuccaro was then approached, and submitted a work judged so poor that it was hung in a chapel in the village for the Escorial workers (and has since disappeared).

After so many frustrations and apparently mediocre renditions of the subject, Tibaldi's must have provided a welcome relief. The saint dominates the scene, his stoney contours derived from Michelangelo's figures on the ceiling of the Sistine Chapel, just as the Tyrant Decius and the saint's tormentors recall the Sistine's stony *ignudi*. Tibaldi's monumental style and clarity of contours and modeling prove the effectiveness of his Michelangelesque idiom for this commission.

The fact that the paintings for the high altar of the basilica at the Escorial, the most important artistic endeavor during the reign of Philip II, were executed by Italian painters, indicates the problems that arise when we take for granted the homogeneous character of painting in Spain. In portraiture too, Philip II was not averse to bringing to court foreign talent: the Fleming Antonis Mor (whose style would be perpetuated by Sánchez Coello) and the Italian Sophonisba Anguissola (who worked at the Spanish court from 1559 to about 1571) are two cases in point. The traditions of portraiture established by Mor and Sánchez Coello, like the Italian traditions imported to the Escorial, remain crucial influences in the development of painting in Spain during the later sixteenth and seventeenth centuries.

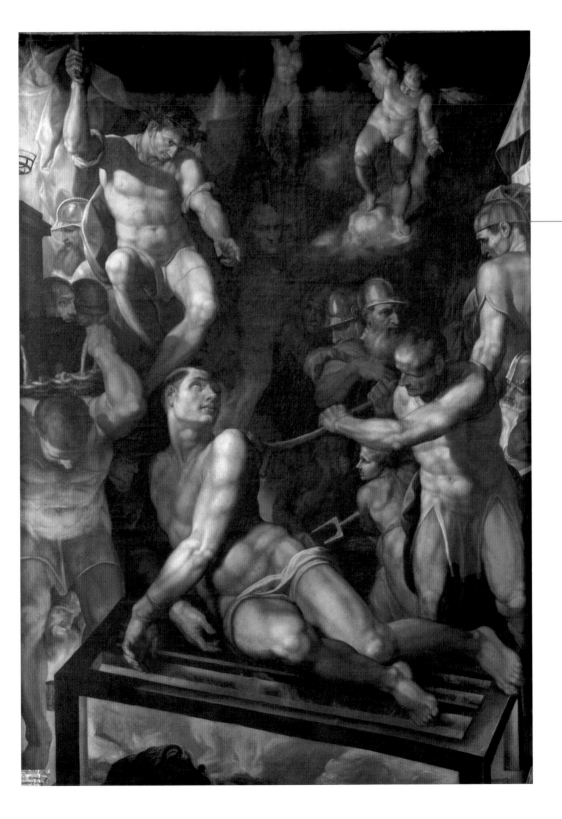

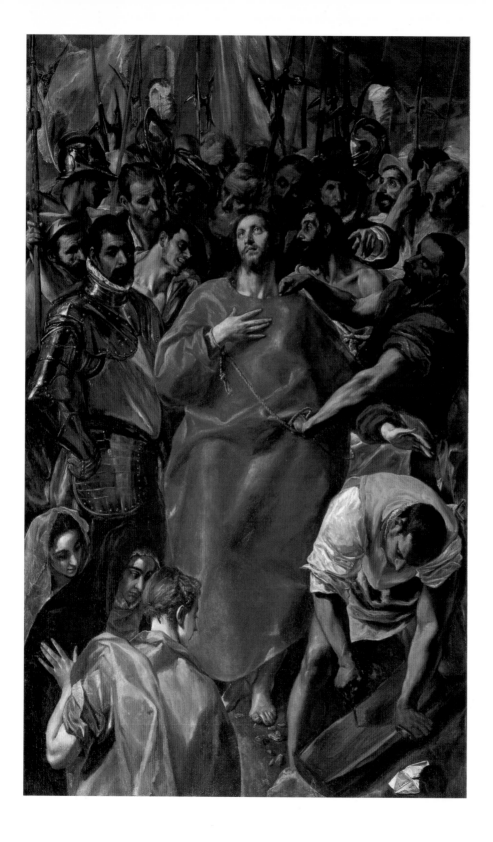

The Toledo of El Greco

20. EL GRECO
The Disrobing of Christ,
1577-79. Oil on canvas,
9′4¼″ x 5′8¼″ (2.8 x 1.7 m),
Cathedral Sacristy, Toledo.

In spite of disagreements
with his patrons over price
and iconography, this
painting was hung in the
Sacristy of Toledo Cathedral.
Over two centuries later it
inspired Francisco Goya to
paint the *Taking of Christ*
for the same room, where
both paintings can be seen
today.

A visit to Toledo is not soon forgotten (FIG. 21). The riches
of its Gothic cathedral, the austerity of its Alcázar, the del-
icate tracery of the Gothic cloister of San Juan de los Reyes
remain etched in memory. These monuments were largely com-
pleted by 1500, three quarters of a century before Toledo's most
famous denizen, El Greco, arrived in 1577.

It was probably during his stay in Rome that El Greco met
within the Farnese circle a young Spaniard, Luis de Castilla, the
illegitimate son of Diego de Castilla, the dean of the cathedral
in Toledo. Luis had returned to Toledo in 1575 and perhaps informed
his father of the Greek painter he had met in Rome, for even
though El Greco may have come to Spain to seek the patron-
age of the king, it was the elder Castilla who was his earliest patron.
He probably influenced the choice of El Greco to paint the *Dis-
robing of Christ* (FIG. 20) for the cathedral of Toledo, on which
El Greco was working by July 1577. A month later, Castilla
himself signed with El Greco a contract for six paintings for the
main and lateral altars of the convent church of Santo Domingo
el Antiguo in Toledo.

The *Disrobing of Christ* develops aspects of El Greco's style
seen in *Christ Healing the Blind* (see FIG. 14). Intended for the cathe-
dral sacristy (where it can still be seen today), its vertical dimen-
sions were undoubtedly specified in the commission. Consequently,
El Greco was forced to compress his narrative composition, in

which we again find the protagonists surrounded by the supporting cast, with three half-figures relegated to the foreground. The palette is reduced, as yellows and blues offset the vibrant red of Christ's robe. Perhaps to please his patrons, El Greco applied his paint in a manner more apparently controlled than in *Christ Healing the Blind*. But if El Greco hoped to win approval by tempering his style, he overlooked a major concern of his cathedral patrons: the iconography of the scene.

Debate about the iconography of the *Disrobing of Christ* arose during the procedure for pricing the painting. In accordance with the custom of the country, El Greco had painted on contract without a set price. Once the work was finished in 1579, representatives of the artist and of the cathedral met to hammer out an agreement. Since this initiative failed (El Greco's party valued the work at 900 ducats; the cathedral at 228), a third party was brought in to arbitrate. Cathedral representatives argued that specific improprieties justified their low estimation of the work: the heads of the supporting cast were placed above that of Christ, and the Three Marys included in the lower corner were nowhere mentioned in the Gospel. After two years of debate, El Greco settled for a total payment of 350 ducats, and – not surprisingly – never received another commission from the cathedral authorities.

The patron's disapproval of the *Disrobing of Christ*, like Padre Sigüenza's tempered condemnation of the Escorial work *St. Maurice and the Theban Legion*, suggests that El Greco's sense of artistic license often clashed with the Counter-Reformation orthodoxy of his patrons (although it is possible that monetary matters more than dogmatic concerns motivated the qualms of the Toledo cathedral chapter). The art historian Rudolf Wittkower summarizes the dictates of the Council of Trent that pertained to the visual arts under three headings: clarity, simplicity, and intelligibility; realistic interpretation; and emotional stimulus to piety. Clearly some thought El Greco failed to meet these criteria.

The determination to uphold Tridentine dictates was personalized in Toledo by the figure of the Gaspar de Quiroga (1499-1593), who had been Inquisitor-General in 1572 and was named Archbishop in 1577, the year of El Greco's arrival. His reforms were immediate: in 1578, he established a commission to ensure that cathedral ceremonies conformed with Tridentine decrees; four years later other reforms were initiated. Not surprisingly, Quiroga opposed any kind of church decoration that might offend these standards. Images that fostered erroneous beliefs, or that conveyed "false dogmas," were to be replaced.

Given this context, it is easy to see how El Greco failed his

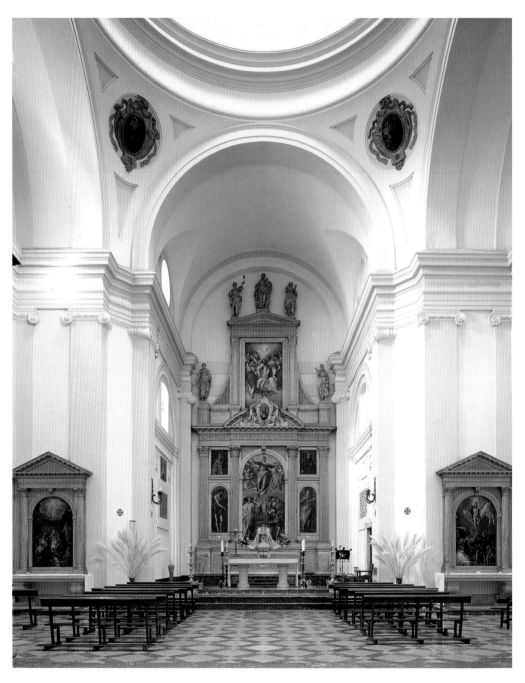

22. The interior of Santo Domingo el Antiguo, Toledo, with the main and side altarpieces for which El Greco executed paintings from 1577 to 1579.

The survival of some, though by no means all, of the frames for altarpieces executed by El Greco allows us to reconstruct the placement of paintings removed or lost. Two of the paintings for the main altar remain *in situ*, but the others are now in private collections or museums, and are here replaced by modern replicas.

cathedral patrons. Only two years after Quiroga's appointment, the cathedral chapter would have been particularly cautious in accepting unorthodox and potentially embarrassing images: it was hardly the moment to embrace the stylistic innovations of a young artist infused with concepts of artistic freedom and invention from Renaissance Italy. Somewhat more open-minded were the private patrons upon whom El Greco came to rely during the following years.

Private Patrons and Religious Commissions

The first private commission was that signed with Diego de Castilla for the Toledan convent church of Santo Domingo el Antiguo. Castilla was serving as the executor for the estate of a wealthy noblewoman, María de Silva, who had left funds for a church to be built adjoining an existing convent. Construction had begun in 1575; two years later, attention turned to its decoration. As in the Escorial (though on a much smaller scale), the decoration centered on an altarpiece framing multiple images (FIG. 22).

The central painting on the lower level, the *Assumption of the Virgin* (FIG. 23; now in Chicago), shows Mary ascending to heaven before the startled apostles. Following prescriptions for the representation of the Virgin of the Assumption codified in 1568 by the Jesuit Johannes Molanus, she is depicted on a crescent moon, according to the vision of St. John. The choice of the theme alludes both to the name of the donor (María) and by analogy to the donor's own salvation, implicitly guaranteed by her good works and charity.

Several elements of the work are familiar: the gesturing figures of the Apostles recall the supporting cast of *Christ Healing the Blind* (see FIG. 14); the foreground figure with back turned to us seems a direct quotation. Now, however, those gestures no longer seem gratuitous: they express wonder as well as reverence, and also lead

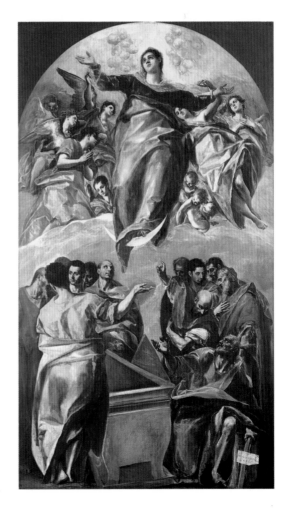

23. EL GRECO
The Assumption of the Virgin, 1577. Oil on canvas, 13'4" x 6'10¼" (4 x 2.1 m), Art Institute of Chicago.

This painting was the central painting for the main altar of Santo Domingo el Antiguo (FIG. 22). The interest in gesture, expression, and narrative in this majestic *Assumption* attest to lessons learned in Venice and Rome.

24. EL GRECO
The Trinity, 1577. Oil on
canvas, 9'10¹/₄" x 5'10¹/₄"
(3 x 1.8 m), Museo del
Prado, Madrid.

God the Father and God
the Son are surrounded
by supporting angels, above
whom the dove of God
the Holy Spirit hovers. The
painting was placed directly
above the *Assumption of
the Virgin* in the original
altarpiece for Santo
Domingo el Antiguo in
Toledo.

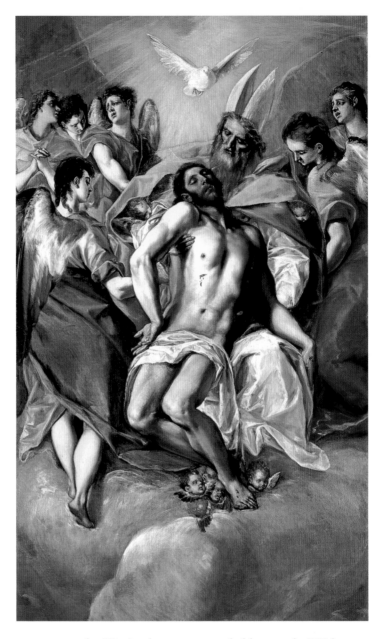

our eyes to the Virgin above, surrounded by angels. With arms
extended, pivoting slightly in space, the Virgin herself accepts the
miracle, looking into the light of the heavens above. Brilliant colors reverberate against the grayish white clouds to heighten the
energy of this scene, which may find a precedent in Titian's *Assumption of the Virgin* (1516-18) for the Church of the Frari in Venice.

The ascending movement of the Virgin finds its antithesis in
the scene placed above it at the central pinnacle of the altar-

piece. The source of light toward which the Virgin looks, the *Trinity* (FIG. 24, now in the Prado), shows God the Father holding the body of the dead Christ. El Greco's composition is based on an engraving by Dürer, while the anatomy of Christ recalls that of Michelangelo's Florentine *Pietà* (c. 1547-55, Cathedral, Florence). These sources are transformed by El Greco's use of color to set off Christ's pale flesh, thus emphasizing both his suffering and his humanity. At the center of the canvas, the wound in Christ's chest is accentuated by the sculptural modeling of his body, which pulls his lifeless arm and chest into high relief as his left shoulder and head fall back into shadow. The acceptance of Christ's sacrifice by God the Father justified the re-enactment of that sacrifice in the celebration of the Eucharist: El Greco's image thus corroborates the Counter-Reformation emphasis on the Eucharist as a re-enactment of that sacrifice, a belief rejected by Protestants.

Upon completing the *Disrobing of Christ* and the altarpieces for Santo Domingo el Antiguo, El Greco turned toward royal patronage: the *Martyrdom of St. Maurice and the Theban Legion*, completed for the Escorial in 1582, as we have seen, received only a lukewarm reception. Soon after that El Greco was offered a commission that was in the works by 1584. In that year, Andrés Nuñez de Madrid, priest of the parish of Santo Tomé, was granted permission by the archdiocesan council to commission what has become El Greco's most famous work, the *Burial of the Count of Orgaz* (FIG. 25). The contract for the work was signed two years later.

The subject is the funeral in 1323 of González Ruiz, the Count of Orgaz and patron of the building of Santo Tomé. His good works, among which was the building of a new Augustinian monastery in Toledo, won him the reward of St. Stephen and St. Augustine appearing miraculously at his funeral to lower him into the grave. The iconography again addressed Counter-Reformation principles by proving the rewards awaiting those who perform good deeds. Moreover, a contemporary controversy over the Count's will made the subject of the altarpiece newly relevant in the 1580s and explains the commission of a commemorative work over two centuries after the protagonist's death. The Count had also stipulated that after his death the residents of Orgaz were to make an annual donation to the church of Santo Tomé, in which he was buried. In 1564, they refused to do so, and Andrés Nuñez de Madrid brought a lawsuit that eventually forced the town to resume the donation. The parish priest then decided to refurbish the burial chapel of this most pious Count, and it was for this chapel that Nuñez commissioned the painting.

Description of the subject and of the commission are not enough to explain El Greco's achievement. In this large painting, he creates a dual-level stage. Closest to the viewer stands a young boy, thought to be a portrait of El Greco's son, Jorge Manuel, who points to the two saints burying the count, inviting us to witness the miracle. To the viewer of the painting in a dimly lit burial chapel, the golden brocades worn by these saintly figures would seem to float against the black costumes of the figures behind: the viewer becomes witness in perpetuity to the miraculous appearance of the saints. The role of witness is mirrored by the figures portrayed in attendance at the funeral, portraits of distinguished citizens of Toledo. According to an account of 1612, their inclusion was one of the main attractions of the work: "The people of our city [Toledo] never grow tired of the painting not only because there are always new things to contemplate in it but also because there are realistic portraits of many notable men of our times."

A very different manner of painting defines the upper half of the scene, where the soul of the Count is taken up to heaven for judgment as Mary, seated on our left, assumes her traditional intercessorial role. In contrast to the earthly realm, dominated by verticals and horizontals, this heavenly place is – at the risk of a tautology – other-worldly. Weightless and elongated figures balance on ethereal and translucent clouds. In this world of the soul there is neither mass nor scale to mark the distance the soul must travel: the only recognizable portrait among these ranks is that of Philip II, seated amid hosts of saints. Just as viewers are invited to relive the historical level of what took place on earth, so too they are offered a glimpse of what lies beyond – a world of shadows, saints, and angels. And that vision of the Count's impending judgment would also remind the viewers of their own ultimate fate.

We tend today to see the *Burial of the Count of Orgaz* as a religious painting exemplifying the values of the Counter-Reformation and the mystical spirituality with which El Greco's name has too often been associated. But such interpretation betrays a modern tendency to sever church from state, and is probably at odds with the original tone of the work. The inclusion of the portraits of distinguished citizens invites a reading of the painting as a manifestation of civic pride. In spite of the court's move to Madrid, Toledo remained a prosperous town throughout the sixteenth century and continued to thrive even after Madrid had been chosen as the capital by Philip II in 1561. Toledans were proud of their city's position as the center of the Catholic

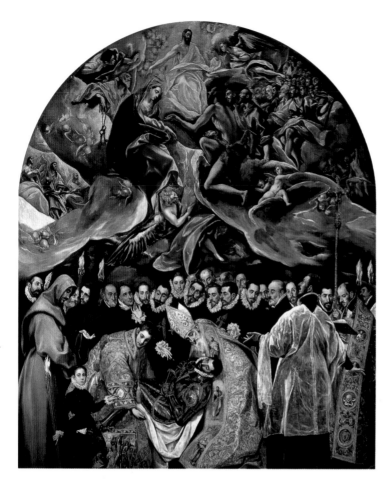

25. EL GRECO
*Burial of the Count of
Orgaz*, 1586-88. Oil on
canvas, 15'9" x 11'10" (4.8
x 3.6 m), Church of Santo
Tomé, Toledo.

This altarpiece for the
burial chapel of the Count
shows a unique recreation
of an event both historical
and miraculous. To heighten
the immediacy of the
miracle, the 1323 funeral
is updated, not only by the
inclusion of portraits of
citizens of El Greco's
Toledo, but also by the
costumes of the witnesses,
the church vestments of
the saints, and of the
Count himself, who wears
sixteenth-century armor.

church in Spain, and of its commercial success as a manufacturing
center for luxury cloth and swords. Renovations to its urban
site were admittedly necessary, and were undertaken during the
late sixteenth century. Several contemporary treatises on the
city – many of which mention its famous citizen, Orgaz – testi-
fy to the glory of both Toledo and her famous citizen, so good
a man that saints attended his burial.

El Greco brought the civic and the holy together again in a
painting for the Chapel of San José in Toledo (FIG. 26). The chapel
had been founded by Martín Ramírez, a wealthy merchant, thought
to have made his fortune in trade with the New World. Before
his death in 1569 Ramírez had hoped to found a convent of
"Discalced (or 'unshod') Carmelites," an order with a primitive
rule that was strictly observed, founded by Teresa of Avila in 1562.
His heirs took over the project, dedicating the chapel to St. Joseph
(San José), to whom Teresa was particularly devoted and whose
cult was fairly new. Joseph is no longer a figure subsidiary to Mary

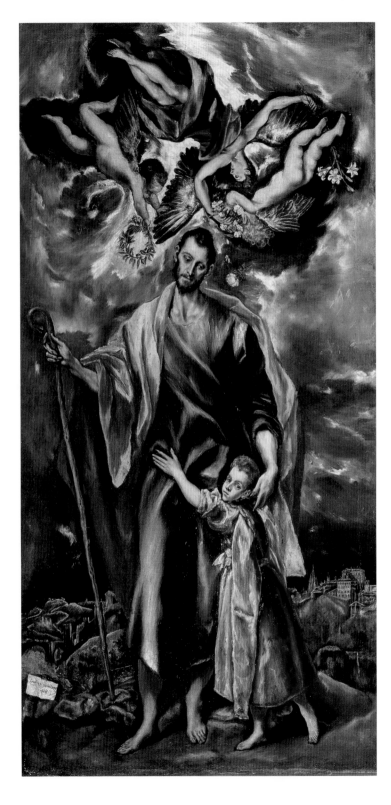

26. El Greco
St. Joseph and the Christ Child, c. 1597-99. Oil on canvas, 42³/₄ x 22" (109 x 56 cm), chapel of San José, Toledo.

The chapel for which this work was painted was the first chapel or church in Spain dedicated to Joseph, and illustrates the growing importance of his cult, which received a special impetus from the devotion of St. Teresa of Avila to Joseph.

and the Christ child (as seen in Italian Renaissance painting), but now holds pride of place in the central altarpiece. A carpenter according to the Gospels, he has exchanged his tools for a shepherd's crook, as he shelters his son, the "lamb of God." Included behind the saint is a landscape of Toledo, as an inscription adjacent to the altarpiece refers to the Christ child as the ruler of Toledo, making St. Joseph indirectly its protector.

The lateral altarpieces for the chapel of St. Joseph were removed in 1908, and are today in the National Gallery of Art in Washington, D.C. Recalling the patron saint of the donor Martín Ramírez, the north altarpiece provides a lesson in Christian charity by showing St. Martin sharing his cloak with the beggar (FIG. 27). As in the *Burial of the Count of Orgaz*, the lesson acquires a new immediacy as St. Martin dons the costume of a sixteenth-century nobleman, an identification of saintliness with contemporary nobility that implicitly parallels the social hierarchy of late sixteenth-century Spain. No matter how "romantic" a figure El Greco might be thought to be, and even if he did occasionally part ways with his patrons, his paintings reinforce what commissions and documents show: he was comfortably installed in Toledo, and had few qualms about the patrons he served.

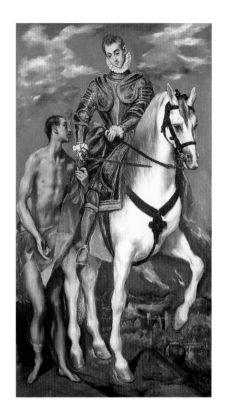

27. El Greco
St. Martin and the Beggar, c. 1597-99. Oil on canvas, 76¼ x 40½" (193.5 x 103 cm), National Gallery of Art, Washington, D.C.

A lateral altarpiece for the chapel of St. Joseph, this painting found immediate popularity, proven by five approximately contemporary copies that still survive.

El Greco, Humanist

For decades, El Greco's works have been seen as testimony of his religious fervor, associated by some writers with currents of late sixteenth-century Spanish mysticism. The discovery of two texts annotated by the artist challenge that romanticized notion of the artist and support an assessment of El Greco as a philosophic painter who had written about painting, sculpture, and architecture. Although none of El Greco's writings have come to light, his erudition is borne out by the annotations he made to an edition of Daniele Barbaro's 1556 edition of Vitruvius's *Ten Books of Architecture*, and to a 1568 edition of Vasari's *Lives of the Artists*, apparently given to El Greco in 1586 by the Italian painter Federico Zuccaro, who was then working at the Escorial. The annotations of both texts, written over a period of years from 1586 to the early 1600s, reveal a consideration of artists and issues that clearly undermines the notion of El Greco as an impetuous

28. EL GRECO
Antonio Covarrubias,
c. 1600. Oil on canvas,
25³/₅ x 22²/³″ (68 x
57.5 cm), Louvre, Paris.

Despite its limited palette,
the handling of the paint is
rich, and suggests that El
Greco lavished attention
on the painting, allowing
colors to dry before adding
more highlights, building
up a controlled but rich
surface. Closely scrutinizing
his sitter, he captures subtle
physical traits: the narrow
lips, the curve of a long
nose, the slight unevenness
of his averted eyes.

artist or intuitive mystic.

Professing nature as the artist's most important measure, El Greco takes issue with the Vitruvian reliance on mathematic proportion and excessive idealization in art. His concern for nature as paradigm is also consistent with his annotations to Vasari, in which Correggio earns high praise; Michelangelo is criticized for his inability to paint portraits; and Raphael is deemed far too dependent on antiquity. (El Greco is recorded as considering Michelangelo a "good man" who didn't know how to paint.) If El Greco's own desire to emulate nature is not readily seen in religious paintings, where decorum demanded a certain idealization, it is visibly demonstrated when the artist turned to portraiture.

El Greco's portraits also attest to his association with many learned men of his day. The white-bearded Antonio Covarrubias, who first appeared among the attendants in the *Burial of the Count of Orgaz* (see FIG. 25), was portrayed later in life in a bust-length portrait (FIG. 28). Having graduated from the University of Salamanca, served as royal magistrate, and attended the final meeting of the Council of Trent in 1563, Covarrubias served until 1581 on the Council of Castile (a combined supreme court of Castile and royal advisory council). From this date to his death in 1602, he served as *maestraescuela* (in fact, the director) of the university in Toledo. In a lengthy note added to his tome of Vitruvius, El Greco credits Covarrubias with inspiring his comments on the text and praises his mentor for his Ciceronian eloquence, perfect knowledge of Greek, and infinite goodness and prudence. These comments show that the relation between artist and sitter was not merely one of artistic patronage. Their mutual esteem is also suggested by a Greek edition of the fourth-century BC author Xenophon, left to El Greco by Covarrubias and documented in the painter's library at his own death in 1614. The intimacy implied by these documents is confirmed by El Greco's portrait of Covarrubias, which may be dated on the basis of style and on the age of the sitter to around 1600. An averted gaze implies the sitter's absorption in thought and possibly also his isolation; by the time the work was painted, the aging Hellenist was deaf.

Far more formal in tone is El Greco's 1609 portrait of the Dominican prodigy, poet, and orator Fray Hortensio Félix Paravicino

(1580-1633; FIG. 29). Although the cleric holds the place open in his book as if momentarily disturbed from his reading, there is nothing else casual about this work. Frontally enthroned, the sitter casts a level eye at the viewer. The richness of El Greco's limited palette is far more eloquently developed here than in the portrait of Covarrubias, as the harshness of white and black is tempered by the earth-toned underpainting. Matching the scale of the portrait, the handling is broad and sure, as seen in the strokes of white highlights defining the friar's garment. If Paravicino was immortalized by El Greco's brush, he thought to return the compliment in a sonnet included in his Posthumous Works (Madrid, 1641):

> Divine Greek, what amazes in your work is not that art should surpass Nature in the images, but that Heaven, to temper you withdraws from it the life that your brush has given it.
> The sun does not cast its rays in its own orbit as it does in your canvases; it is enough for you to attempt to take God's role for Nature to take sides, seeing itself undone ...

The predominance of religious painting in El Greco's Toledo career is undoubtedly to be credited to the available patronage. In the aftermath of the Council of Trent, new and approved images were needed to decorate the many churches of Toledo and its surrounding province. And despite El Greco's own early disagreements with cathedral patrons over the iconography and pricing of the *Disrobing of Christ*, his son Jorge Manuel was appointed in 1603 to oversee new proposals for altarpieces, a position we may only suppose brought new work to El Greco's shop. Financial problems nevertheless led the artist to pursue a variety of new commissions during the final decade of his life, many of which remained unfinished at his death in 1614.

His concern with such commissions did not occupy him exclusively. Found in his studio at his death were three versions of a painting depicting the story of the Laocoön, popularized after the discovery in Rome a century earlier of the Hellenistic sculptural group of the same theme. One version is documented in the royal collection by the mid-seventeenth century. But this is probably not the same

29. EL GRECO
Fray Hortensio Félix Paravicino, c. 1609. Oil on canvas, 44¹/2 x 34″ (113 x 86 cm), Museum of Fine Arts, Boston.

Professor of rhetoric at the University of Salamanca as well as a poet, Paravicino was appointed preacher to Philip III in 1616.

30. EL GRECO
Laocoön, 1614. Oil on canvas, 4'6¼" x 5'8" (1.38 x 1.73 m), National Gallery of Art, Washington, D.C.

El Greco's portrayal of the mythological martyrdom attests to freedom not permitted in Counter-Reformational religious imagery, as his nude figures engage in a dance-like struggle with the serpents.

as the version that survives today, the only known mythological work by El Greco (FIG. 30). As the priest of Apollo, Laocoön had warned the Trojans against accepting the horse left outside the city's walls: that horse is seen in the mid-distance of El Greco's work, although Troy is depicted as the walled city of Toledo. While the Trojans debated accepting the gift, the priest and his two sons were attacked by two serpents (sent by Apollo), an incident interpreted by the Trojans as a sign to accept the horse.

Unfinished, the canvas reveals El Greco's indecision about the inclusion of a third onlooker on the right. These figures, the body of the Laocoön, and the distant landscape also show El Greco's working method, as forms are determined by color and worked out directly on the canvas. Particularly in the unfinished landscape and view of Toledo, thin passages of color barely cover the reddish-brown underpainting. Asked which was more difficult, color or drawing (*disegno*), El Greco stated unequivocally that color was more difficult. The *Laocoön* proves that difficulty, revealing the effort underlying El Greco's deceptively "impetuous" handling.

Naturalism in Early Seventeenth-Century Toledo

A group of paintings executed by other artists working in Toledo during the two years immediately preceding El Greco's death suggests how tastes were moving away from his idealism to a far more naturalistic idiom. In 1612, Juan Bautista Maino (1578-1641) was painting the altarpiece for the convent church of St. Peter Martyr

in Toledo. Its four main scenes depict the *Adoration of the Shepherds*, the *Adoration of the Magi* (FIG. 31), the *Pentecost*, and the *Resurrection*. Although Maino had been described as a student of El Greco, the seventeenth-century painter Jusepe Martínez, who, in his *Discursos practicables del nobilísimo arte de la pintura* (Practical discourses on the noble art of painting) stated that Maino was a "disciple and friend of Annibale Carracci and a great companion of our great Guido Reni," Italian artists active in the early seventeenth century. We can only speculate as to how Maino's career might have developed from this point forward had painting remained his chief vocation, since in 1613 he joined the Dominican order and thereafter painted only infrequently. Named by Philip III as drawing master for the future Philip IV, he led an influential career at court where, according to Martínez, he was known for his portraiture, and in 1634 contributed a scene to Philip IV's decoration of the Hall of the Realms in the Buen Retiro Palace in Madrid.

Maino may also have influenced Luis Tristán (1585-1624), the only disciple of El Greco to have achieved his own unique style. Documented as an apprentice to El Greco in 1603, Tristán traveled to Italy sometime between 1606 and 1613, where he would undoubtedly have come into contact with a naturalist style antithetic to that of his first master. The confluence of both styles are seen in many of his figural works, where bodies are often elongated, and might appear weightless were it not for the bold *chiaroscuro* that models their forms. Upon returning to Toledo by 1613, Tristán seems to have picked up much of the clientele for whom El Greco once painted, producing several altarpieces before his premature death in 1624 (FIG. 32).

A more eloquent manifestation of the growing naturalism in painting chronologically parallels the mature career of El Greco. Inventories of private collections in Toledo as early as 1599 list paintings of fruits and vegetables by Juan Sánchez Cotán. In these works, individual fruits, vegetables, and pieces of game are meticulously rendered against a black background (FIG. 33). The inventories identify these paintings according to their contents, naming the specific objects portrayed: a melon, a quince, a carrot. This manner of describing underscores the painter's own insistence on individual objects, each of which is given equal

31. JUAN BAUTISTA MAINO *The Adoration of the Magi*, 1612-13. Oil on canvas, 10'4½" x 5'8½" (3.1 x 1.7 m), Museo del Prado, Madrid.

Although the idealization of the Virgin might recall Guido Reni, the direct influence of Roman models is not readily seen in Maino's highly decorative sense of color and surface pattern.

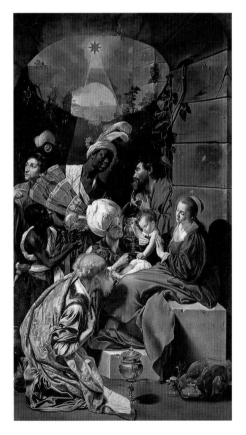

prominence on the pictorial surface. The composition remains an aggregate of individual objects that refuse to give way to a greater whole.

The seeming austerity of these works, and the manner in which they force the viewer to confront the intricacies of each form, has led at least one scholar to see them as a "transfiguration of the commonplace," which reflects a spiritual oneness with the object reminiscent of the contemplation recommended in the *Spiritual Exercises* of St. Ignatius Loyola. This has been justified by reference to Sánchez Cotán's own decision to join the Carthusian order. But we should be wary of such easy comparisons, which betray a lingering romantic view of Spain as a land pervaded by mysticism. With regard to Sánchez Cotán, the comparison overplays the painter's monastic vocation, since he was a lay brother, and as such did not wear the robe of a Carthusian monk and was also at liberty to leave the monastery; what is more, many of his still-life paintings were painted before his entry into the Carthusian order in 1603. The *Spiritual Exercises of St. Ignatius* instruct the practicant to contemplate the scenes of Hell or scenes of Christ's passion; never did he instruct the novice to contemplate a melon.

An alternative is to interpret these still life paintings in light of more general European trends of the time. Throughout sixteenth-century Europe, there was a growing interest in natural history, as well as in subjects taken from the everyday, depicted by artists as disparate as Pieter Aertsen in Flanders and Vicenzo Campi in northern Italy. Recognizing the intellectual life of Toledo as the context, we might also see Sánchez Cotán's closely studied objects as a Renaissance response to such painters of antiquity as Zeuxis, who according to Pliny's *Natural History* painted grapes so real that birds attempted to peck at them. Sánchez Cotán shows a similar interest in illusionistic games, as objects are placed on ledges that bring to mind the concept propounded by the Italian fifteenth-century humanist Alberti of the painting as a window; the objects protrude into the viewer's realm, tempting us to reach out for them.

Like El Greco, Sánchez Cotán worked in Toledo for patrons who were both men of learning and men of religion. Too often, modern accounts stress the latter, seeing these works simply as evidence of a kind of immediate and untutored mysticism that finds a literary parallel in the works of St. Teresa of Avila. The intellectual content of these works must be realized, even if it can-

not be fully recovered; and it should be remembered that in sixteenth-century Spain intellect did not necessarily stand in conflict with heartfelt religious fervor.

Although El Greco's *Burial of the Count of Orgaz* (see FIG. 25) has been convincingly interpreted in the light of sixteenth-century liturgy, not all the mysteries of El Greco's iconography have been resolved: what, for example, is the meaning of the Toledan landscape that serves as background to so many of his scenes? And the paintings of Sánchez Cotán continue to be read in a variety of ways, as warnings against gluttony, as studies in mathematically arranged forms, as responses to the painters of antiquity. Given the myriad influences working upon the artists, various interpretations may complement one another rather than cancel one another out, proving the richness of the culture to be identified with the Toledo of El Greco.

33. JUAN SÁNCHEZ COTÁN
Still Life with Game Fowl, Fruit, and Vegetables, 1602. Oil on canvas, 26¾ x 35″ (68 x 89 cm), Museo del Prado, Madrid.

The success of works such as this during Sánchez Cotán's life is suggested by an inventory entry of 1603, which refers to copies made after this work.

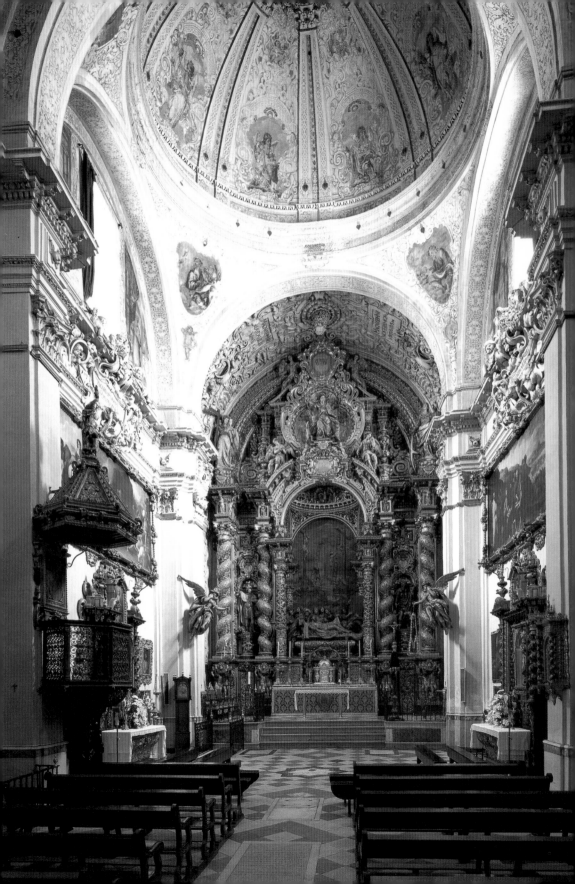

Ribalta in Valencia and Painting in Seville

34. Interior view, looking toward the altar of the Church of the Hospital of the Brotherhood of Charity, Seville.

In spite of its rather plain exterior, the rich interior of this church owes its decoration to the patronage of Miguel de Mañara, once thought to be the model for the character of Don Juan Tenorio. The sculptor Pedro Roldán, and the painters Murillo and Valdés Leal participated in the work during the early 1670's.

T he Counter-Reformation ideals that inspired the paired saints painted for the basilica at the Escorial as well as the iconography of many of El Greco's commissions were carried throughout Spain by patrons eager to promote the renewed orthodoxy. In Valencia, for example, they were fostered by Juan de Ribera, the Patriarch and Archbishop who dominated this Catalan city and province from his appointment in 1569 until his death in 1611. Ribera assumed the position of Captain-General and President of the Audencia, positions that gave him ultimate authority in the military and civil realms respectively, as well as the ecclesiastic. Devoted to strict Catholic doctrine, he was also a strong voice of the increasing distrust of the *morisco* population – the Moors who had remained in Spain and converted from Islam to Christianity. Such distrust was on the rise throughout late sixteenth-century Spain and culminated in a royal decree expelling the *moriscos* from Spain in 1609.

The Patriarch was interested in art as well as doctrine and owned paintings by or after El Greco, Sánchez Cotán, and the court portraitist Pantoja de la Cruz. His collection also included a copy after Caravaggio's (1571-1610) *Crucifixion of St. Peter*, testimony of the early availability of the Italian painter's style within Spain. In 1599, Francisco Ribalta (1564-1628) arrived in Valencia, perhaps with the hopes of working for the Patriarch.

Although the artist was born in the Catalan town of Sol-

35. FRANCISCO RIBALTA
The Preparation for the Crucifixion, 1582. Oil on canvas, 4'9" x 3'5" (1.45 x 1.04 m), Hermitage, St. Petersburg.

Opposite

36. FRANCISCO RIBALTA
St. James at the Battle of Clavijo, 1603. Oil on panel, 6'6¾" x 4'3¾" (2 x 1.3 m). Church of St. James the Apostle, Algemesí.

The original main altar, which once incorporated twenty-seven paintings as well as eight polychrome figures, was destroyed during 1936-39 in the Spanish Civil War.

sona, the earliest evidence of Ribalta's artistic activity is the *Preparation for the Crucifixion* (FIG. 35), signed "The Catalan Francisco Ribalta painted it in Madrid in 1582." Its complex composition, in which a variety of figures are posed around Christ in foreshortened positions, perhaps indicates that Ribalta had been studying the works of Italian painters then working at the Escorial. The forced intricacy of the work has suggested to at least one scholar that it served as a diploma piece for Ribalta's advancement from guild apprentice to master.

One of Ribalta's first important commissions upon his arrival in Valencia was for the church of St. James the Apostle at Algemesí, executed from 1603 to late 1604 or 1605. The dedication of the church to the patron saint of the Reconquest (the campaign waged by the Christians in Spain against the Moors from the tenth to the fifteenth centuries), paralleled growing anti-*morisco* sentiments. This distrust was particularly strong in Valencia, where *moriscos* made up about one third of the population. Moreover, the growth rate of the *morisco* population exceeded that of the Christian, and suggested to many that a potential conspiracy of Protestants, Moors, and Turks might threaten the city.

This growing paranoia probably influenced the imagery and reception of the central painting of Ribalta's altarpiece (FIG. 36). Its subject is the miraculous appearance at the Battle of Clavijo (844) of St. James, who turned the outcome in favor of the Christian forces commanded by Ramiro I. Christ-like in appearance, his face enframed by a radiant halo, the clearly Caucasian saint commands a white steed to trample the forces of evil, here embodied by the darker-skinned Moors. Viewed by patrons and public who increasingly saw the *moriscos* as a threat, Ribalta's image could only serve to confirm the racial prejudices already in place. It has been suggested that the program for the Algemesí altarpiece can be attributed to the patriarch Ribera and his associate, the Dominican friar and Algemesí native Padre Jaime Juan Bleda: both men were known for their strong anti-Moorish sentiments. As so often happened in Habsburg Spain, concerns

37. FRANCISCO RIBALTA
The Vision of St. Bernard,
c. 1625-27. Oil on canvas,
5′2¹/₄″ x 3′8¹/₂″ (1.58 x
1.13 m), Museo del Prado,
Madrid.

St. Bernard's mystical
experience is here translated
into a physical reality, as
the saint's pleasure is
translated into a sensuality
unprecedented in Spanish
painting.

with purity of the blood and religion over-rode pragmatism. Although the 1609 expulsion was effective throughout Spain, it took its most significant toll on the economy of Valencia, where the large *morisco* population had supplied an important source of labor to many noble estates.

After the death of the patriarch Ribera in 1611, Ribalta's career is largely undocumented. We are unable to say with any certainty what caused the change in his style from the early 1600s, when he painted the *St. James*, to the mid-1620s, a date assigned to a painting long attributed to Ribalta that hung in the Charterhouse of Porta Coeli in Valencia. *The Vision of St. Bernard* (FIG. 37) shows the crucified Christ lowering himself from the cross to embrace this founder of the Carthusian order, a miracle witnessed by two angels, today barely seen on the darkened canvas. The theme of a holy image coming alive before the devout has a long heritage. But what surprises here is Ribalta's naturalistic idiom and economic composition – a far cry from the colorful melee of the *St. James* piece. It is painted in a neutral palette, dominated by the cream-color tones of the monk's robe and Christ's flesh. Christ's face falls into shadow as light emphasizes his extended arms and the saint's ecstatic expression. Although specific sources for this stylistic shift cannot be cited, Ribalta had clearly been influenced by tendencies toward a greater naturalism paralleling those witnessed in early seventeenth-century Toledo, which emerged almost simultaneously in Seville and Madrid.

Seventeenth-Century Seville

Seville was the boom town of late sixteenth- and early seventeenth-century Spain, more populous than any other Spanish city and surpassed in size only by Paris and Naples. An inscription on a 1617 view of the city in the British Museum sums up the city's splendor: "Qui non ha visto Sevillia, non ha vista maraviglia" (he who has not seen Seville, has not seen a marvel). Although today it appears a picturesque spot removed from the coast, it was then the major port for Spain's monopoly on New World trade, con-

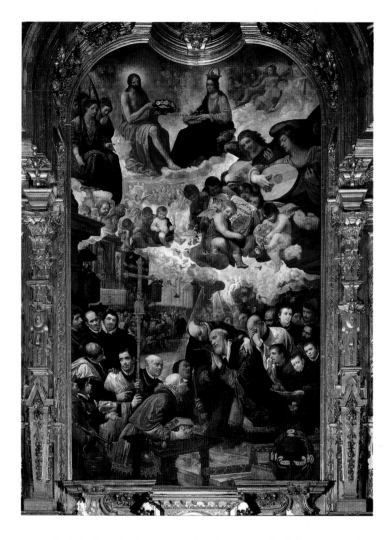

38. Juan de Roelas
The Death of St. Isidore,
1613. Oil on canvas,
17'3" x 10'7" (5.2 x 3.2 m),
Church of St. Isidore,
Seville.

The naturalism sensed
in the lower half of the
composition anticipates
developments in Sevillian
art during the seventeenth
century.

nected with the Mediterranean by the Guadalquivir River. That river gradually silted up, forcing the functions of the port to be transferred southward to Cádiz later in the seventeenth century. Before this, Seville had been a magnet for growth as many came in search of new wealth to settle in the city and its outlying areas. A growing economy led to artistic opportunity, as chapels were built, churches redecorated, and religious establishments founded. At the same time, a number of portraits and genre paintings suggest that artists found a market among the city's international clientele that included Italians, Flemings, and Portuguese. Such patrons might also introduce art from their home countries to Sevillian artists, whether in the form of paintings or engravings.

The most successful painter in Seville during the first two decades of the seventeenth century is Juan de Roelas (c. 1588-1625),

39. JUSEPE DE RIBERA
St. Jerome, 1616-20. Oil
on canvas, 5'11" x 4'7"
1.8 x 1.4 m (179 x139 cm),
Parish Museum, Collegiate
Church, Osuna.

Ribera's work presents
another variant on the
naturalist style after
Caravaggio that may have
influenced the young
Zurbarán and Velázquez
in Seville.

whose fame has been eclipsed by more famous artists of the next generation, Velázquez, Zurbarán, and Murillo. Active in Valladolid around 1600, Roelas was university-educated and by 1603 served as the priest in the town of Olivares, near Seville, a position he held until 1606. Proximity to Seville gave Roelas the opportunity to develop a circle of patrons in that city. In 1613, Roelas executed for the church of St. Isidore an altarpiece showing the death of the laborer saint (FIG. 38). In its two-level composition, the altarpiece might recall the *Burial of the Count of Orgaz* (see FIG. 24), although there is no evidence that Roelas knew El Greco's work. The lower half of the painting shows the dying saint among a cortege of clerics whose gestures and reactions heighten the drama of the story; behind, a vast perspective opens on the crowd of the faithful before a large altarpiece. In envisioning the heavens, Roelas abandons naturalism to paint in an idiom reminiscent again of the Italian painters of the Escorial.

José (or Jusepe) de Ribera (c. 1590-1652) also contributed to the dissemination in Spain of the theatrical lighting and bold *chiaroscuro* that had been perfected in Italy in the work of Michelangelo Merisi da Caravaggio (1573-1610). Working first in Rome and then in Naples, where Caravaggio spent the last four years of his short life, Ribera undoubtedly knew the Italian artist's works. Born in Spain, Ribera is usually considered a "Spanish" painter, a national identity solidified in the early nineteenth century, when his scenes of martyrdom were considered a manifestation of Spanish religious devotion. Yet the entirety of his documented career was spent in Rome and Naples (the latter under Spanish control throughout the seventeenth century). There he enjoyed the patronage of a succession of Spanish viceroys, who on returning to Spain often took with them works by Ribera. His stature as a painter eventually made him attractive to Spain's foremost seventeenth-century collector, Philip IV.

By 1627, the Collegiate Church in Osuna, 53 miles (about 85 kilometers) from Seville, housed five paintings by Ribera, among them the *St. Jerome* (FIG. 39). These exemplify his early style, and had been commissioned by the Duke of Osuna while he was viceroy of Naples. Detailed rendering of St. Jerome's aging

skin and close study of unidealized anatomy revealed by strong *chiaroscuro* enhance the verisimilitude of the figure, as still-life elements strewn in the foreground invite us into the scene. Yet detail is deceptive: analyzing the figure, we realize the ambiguity of its volumes (camouflaged by red drapery), and the shallowness of the composition, cut off by a dark background. Although the flatness of the composition might be seen as a shortcoming to those viewers accustomed to Roman painting at this time, such compression in fact heightens the visual impact of the image as it confronts the viewer with evidence of the physical hardship endured by the hermit saint.

Genre Painting in Seville

It was in Seville in 1617 that the young Diego Velázquez (1599-1660) passed his guild examination to become a master of painting, having studied under Francisco Pacheco (1564-1644), today better known as an art theorist than as a painter. It is in Pacheco's *Art of Painting* (1649) that we find the earliest reference to Velázquez's early works. In writing of *bodegones*, or still-life paintings, Pacheco condemns them as a lowly art, unless executed with the mastery seen in the work of his son-in-law, Velázquez. As used by Pacheco, the term *bodegón* in fact refers to paintings that incorporate both still-life objects and figures – for example, Velázquez's *Old Woman Frying Eggs* (in the National Gallery of Scotland, Edinburgh) and *Christ in the House of Martha and Mary* (FIG. 40). Two figures and a still life share the foreground of the painting, although for the modern viewer, the freely painted still life, showing the young artist's mastery of his medium, threatens to upstage his figures. The two women seem to be based on specific models – indeed, the older is the same who fries eggs in the Edinburgh painting. But what is the relation between them? The older woman directs our attention to her pouting companion, as if we are to learn something from her.

The woman's gesture recalls that of the boy who stands in the left foreground of the *Burial of the Count of Orgaz* (see FIG. 24) in its appeal to the viewer to look – and to learn. The background clarifies the issue. It represents a scene from the Gospel of Luke, describing Christ's visit to the house of Martha and Mary. As Martha busied herself with serving, Mary sat listening to Christ's words. When Martha complained about Mary's unwillingness to help, Christ replied that it was Mary who had chosen the better path. Relating this story to the foreground scene, we might wonder if the older woman points to a modern-day Martha, who ignores the

righteous path as she busies herself with the mundane. The "scene within a scene" is a compositional type to be repeated in Velázquez's work. Perhaps inspired by prints after similar compositions by the Flemish painter Pieter Aertsen, the composition becomes a way of enriching the meaning of a painting, or, perhaps, of turning the painting into a kind of riddle to be deciphered by its audience.

Although painting in seventeenth-century Spain is predominantly religious, we should not overlook those works that defy easy categorization. For example, is *Christ in the House of Martha and Mary* a religious painting, a narrative, or a still life? Equally perplexing is a painting done after mid-century by another great Sevillian painter, Bartolomé Esteban Murillo (1618-82), to whom we shall return later in the chapter. *Four Figures on a Step* (FIG. 41) shows just that: a young man in tawdry finery, a woman behind who grabs his shoulder as she lifts a veil to look out at the spectator, another woman with spectacles, and a young boy, turned from us and apparently sleeping. Who are these figures? Some historians have suggested that the background woman is a prostitute, soliciting the viewer; another interpretation suggests that she is in fact offering the young man's services. But what are we to make of the woman on the right and the sleeping child? And what is the meaning of his exposed flesh, so carefully centered in the work? Such details suggest an unwholesomeness not usually associated with Murillo, who became widely known as a painter of innocent children and scenes from the life of the Virgin.

40. DIEGO VELÁZQUEZ
Christ in the House of Martha and Mary, 1618. Oil on canvas, 23³/4 x 41″ (60 x 104 cm), National Gallery, London.

The painting was probably intended to hang in a private house, possibly over a door – a position that would explain the work's proportions and skewed perspective, that compensates for a view from below by compressing the foreground elements to the pictorial plane.

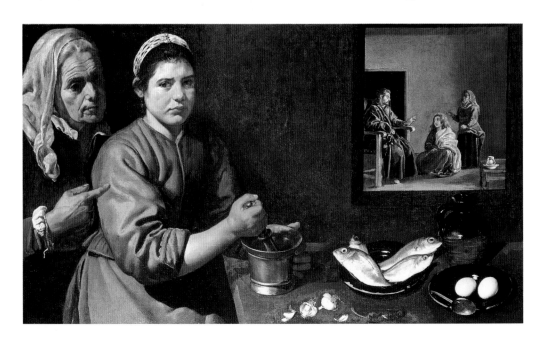

Today, *Four Figures on a Step* seems anomalous within the history of seventeenth-century Spanish painting. But such works may once have been more numerous: painted for private patrons, they in fact had a far lesser chance of survival through the centuries than did an altarpiece, safely sequestered in a convent or chapel. The survival of even a small number of such works – among which we might count Murillo's *Two Women at a Window* (in the National Gallery of Art, Washington) – leads us to suspect the existence of others, now lost. Of course, in examining painting of this period in Seville, we turn to the evidence which does survive: paintings that are, primarily, religious. But despite differences in subject matter, many of these religious paintings share with the *Four Figures on a Step* an insistent naturalism, sharp modeling, and a direct presentation of subject matter that approaches the confrontational: traits which could only heighten their appeal to the viewer and serve the Catholic faith by convincing the viewer of the reality of the events portrayed.

Religious Painting in Seville

Francisco Pacheco stated that the goal of the religious images was to "perfect our understanding, move our will, refresh our memory of divine things"; goals achieved by *Christ on the Cross*, painted in 1627 by Francisco de Zurbarán (1598-1664) for the Sevillian monastery of San Pablo el Real (FIG. 42). The image is not an historical rendering of the crucifixion as all narrative details are

eliminated (although early accounts of the painting mention a background landscape of which there remains no trace). The inert body commands our attention (as it must have that of the monks who would originally have seen the painting in the oratory of the sacristy), to inspire meditation on Christ's humanity and sacrifice. Our focus is sharpened by Zurbarán's precise handling and almost violent *chiaroscuro* that gives volume to the emaciated form and emphasizes the drapery that seems to cling to the surface of the canvas. Verisimilitude is heightened by the *trompe l'oeil* scrap of paper pinned to the bottom of the cross, upon which the artist signed his name. Anatomical correctness is secondary to the overall impact: Christ's arms are too long for his form, and his body, despite its surface modeling, appears without volume in space.

Christ on the Cross was much admired at the time of its creation and was cited in 1629 by Sevillian city officials as justification for inviting Zurbarán to settle in Seville. A century later, an observer singled it out for praise, stating that everyone who saw it believed it to be sculpture. This leads us to a possible inspiration for the work *Christ of Clemency* (FIG. 43), a polychrome wood crucifix sculpted for the private chapel of the archdeacon of Carmona, Mateo Vázquez de Leca, in the early years of the century by Juan Martínez Montañés (1568-1649). When Vázquez left Seville in 1614, he gave the crucifix to the Carthusian monastery of Santa María de la Cuevas. Such wooden sculpture was pervasive and highly regarded in sixteenth- and seventeenth-century Spain, displayed in churches and paraded in religious processions. It was often the result of team work, involving one who carved the image, another who prepared the wood for painting, and those that painted the flesh tones, draperies, or rich brocades. The result was a sculpture that aroused the viewer's emotional response through its lifelike qualities. Ribalta had portrayed how the crucified Christ came alive to embrace St. Bernard; polychrome sculptures seemed to hold the promise of coming alive, and thereby set a standard for devotional imagery.

Zurbarán's *St. Francis in Meditation* (FIG. 44) likewise presents a contrived fiction of the "real." The saint is depicted in his later years, when he had left his apostolic activity to meditate on the passion of Christ. His removal from worldly things is implicit in his isolation, and light directs us to the elements essential to his state. Although his face is cast in shadow, light reveals a mouth open in oration or awe, as well as the patched, coarse woolen

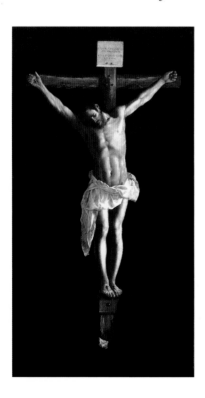

42. FRANCISCO DE ZURBARÁN
Christ on the Cross, 1627.
Oil on canvas, 9′6¾″ x
5′5″ (2.9 x 1.6 m), Art
Institute of Chicago.

One of Zurbarán's earliest paintings for the monastic patrons who proved essential to his career, this work contributed to his early fame, and led to an invitation to settle in Seville.

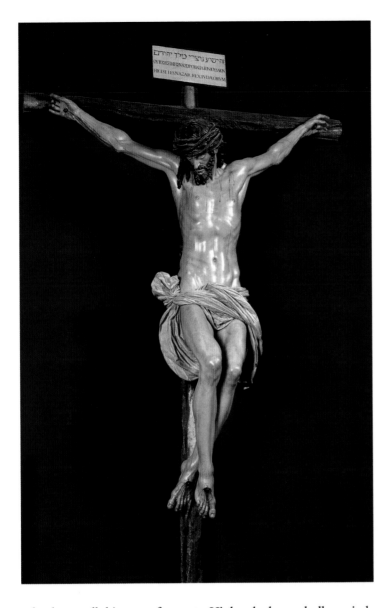

43. Juan Martínez
Montañés
Christ of Clemency,
1603-06. Polychrome
wood, Seville Cathedral.

robe that recalls his vow of poverty. His hands clasp a skull, remind-
ing the viewer of the vanity of all worldly things. Again, the body
remains undefined, but is taken for granted by the viewer, con-
vinced of the image's reality through the accumulation of details.

During the 1620s and 1630s, Zurbarán found numerous monas-
tic patrons in Seville and its environs. One of his most impor-
tant commissions was for an altarpiece for the Carthusian monastery
of Santa María de la Defensión at Jerez de la Frontera. Already on
the site known as El Sotillo (the Little Grove), stood a her-
mitage housing a painting (today lost) that showed the miracu-

44. FRANCISCO DE ZURBARÁN
St. Francis in Meditation,
1635-40. Oil on canvas,
60 x 39" (152 x 99 cm),
National Gallery, London.

The history of this work
is not known, prior to its
exhibition in Paris in 1838.
There it became the
paradigm of Zurbarán's
austere style, thought to
embody the spartan
devotion that the French
associated with Spain, her
people and her painting.

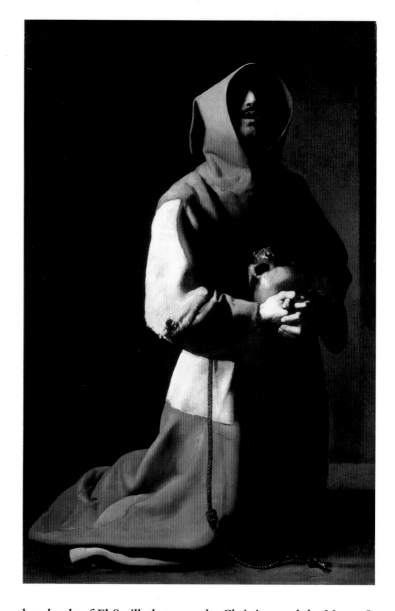

lous battle of El Sotillo between the Christians and the Moors. It
followed historical accounts in depicting the Virgin enthroned
against a resplendent heaven, revealing to the Christian forces the
Moors who lay in wait, ready to ambush (FIG. 45). As a result
of the Virgin's intervention, the Moors were routed, and the Chris-
tians were victorious. That which the modern mind might seg-
regate as secular and religious histories become one: as in Ribalta's
image of *St. James at the Battle of Clavijo* (see FIG. 36), Christian-
ity again triumphs because of divine intervention at the Battle
of El Sotillo, proving that the Christians are a chosen people.

The conflation of secular and religious, past and present, seen in these histories is mirrored in Zurbarán's central image for the high altar of the monastery. In the foreground, a pikeman in contemporary garb serves as intercessor as he directs our attention to the routing of the Moors portrayed in the middle distance. From foreground to middleground, we cross over at least three, and possibly four, centuries (uncertainty remains as to whether the battle took place in the thirteenth or fourteenth century). The spheres of present and past are distinguished only by costume and by lighting: the foreground pikeman is illuminated by a source to the outside left of the painting, while the protagonists of the battle – including those immediately behind the pikeman and in the lower right foreground – are illuminated by the resplendent Virgin appearing in the heavens above.

By the time Zurbarán painted the commission for Jerez de la Frontera, he was also involved in selling paintings in the New World, which involved a very different kind of patronage. Although at times painters might respond to a direct commission, they often depended on the chance of the New World open market. This procedure was not of great advantage to the painter, who would consign a group of paintings to a trade ship's captain with the request that they be sold, like any other merchandise, to the highest bidder. The painter would then have to await the ship's return for payment: for this reason, in 1638, Zurbarán asked to postpone payment of part of his daughter's dowry until the arrival of the ships. One work probably exported around this time is the *Supper at Emmaus* (FIG. 46), signed and dated 1639, which once hung in the church of the Monastery of St. Augustine in Mexico City. It is a solemn and understated representation of the theme, as Zurbarán underplays the reaction of Christ's followers at the meal after his resurrection, casting the face of the man on the left in dark shadow, and suggesting his surprise only by the partially seen wrinkled brow.

That Zurbarán turned to New World patronage, and even to its open market, suggests that he sensed a decline in Sevillian patronage, which indeed became pronounced after 1640. Documents suggest that during this decade, shipments to the New World of paintings by Zurbarán and by his shop increased. Seville's declining econ-

45. FRANCISCO DE ZURBARÁN *The Battle of the Christians and Moors at El Sotillo,* 1638-40. Oil on canvas, 11′1″ x 6′3¼″ (3.3 x 1.9 m). Metropolitan Museum of Art, New York.

Images such as this show that the heritage of the Reconquest remained alive in seventeenth-century Spain, where continued aversion to Moors (as well as Jews and Protestants) empowered the Inquisition, and fostered an obsession with "purity of the blood," or tracing one's lineage to Spain's old Christians.

omy probably influenced Zurbarán to turn to this potentially lucrative market. But another catalyst was competition from a younger artist who soon developed a style dramatically different from that of Zurbarán: Bartolomé Esteban Murillo.

Although Murillo's earliest documented works can be dated to the late 1630s, he received his first major commission only in 1645. This was for a series of paintings for the small cloister of the Monastery of San Francisco el Grande in Seville, depicting episodes from the lives of founding members of the Franciscan order. *St. Diego of Alcalá Distributing Bread to the Poor* (FIG. 47) illustrates the degree to which the young Murillo emulated the preceding Sevillian painters. His characterization of the impoverished people who surround the saint seems to be an attempt to study from nature, perhaps inspired by (though not as accomplished as) that seen in Velázquez's early *bodegones*. Earth tones dominate, and although the description of the various faces is extremely controlled, the drapery of the two beggars on the right betrays a broader application of paint to become more pronounced in Murillo's later works.

A variety of paintings by Murillo are attributed, on stylistic grounds, to the following decade. Yet, with the exception of a commission for a series of paintings for the convent of San Leandro in Seville and the execution of an *Immaculate Conception* for the Franciscan Convent in the same city, Murillo was not awarded any commissions of sufficient value to sustain him for a long period of time. In the spring of 1648, the bubonic plague began to spread through southern Spain, and reached Seville by the end of the year. It is estimated that the plague took between 50,000 and 60,000 inhabitants of the city in 1649, cutting its population approximately in half. Famine struck the city in 1651, and a food shortage the next year inspired a popular uprising. Clearly, times were not auspicious for the patronage of art.

As Seville recuperated from these crises, Murillo became the painter of the moment, displacing the austerity of Zurbarán with an idealizing style that perhaps offered his audience what they most desired: the promise of a better world beyond. In 1656, Murillo completed for the cathedral chapter the *Vision of St. Anthony of Padua* (FIG. 48), the largest painting of his career. Its stylistic distance from

46. FRANCISCO DE ZURBARÁN *Supper at Emmaus*, 1639. Oil on canvas, 7'5¾" x 5'5⅝" (2.28 x 1.54 m), Museo National de San Carlos, Mexico City.

The darkening of the background over time has heightened the relief of the beautifully rendered objects on the table, reminding us also of Zurbarán's achievement as a painter of still life.

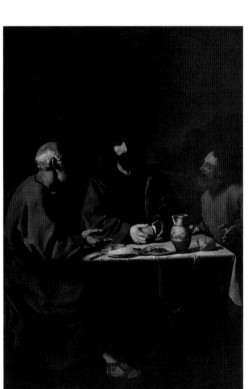

Dade Comer al Pobre De sproucha. El Pobre Come y Diego Satisfecho. Mira en el Pobre la Dios y de sperecha. Iuan tiempo Exercitando de vida açti

Reciue Diego deque el Pobre Coma, El dar las Gracias por Juquenta toma. Caridad todos a Dios se ofrece Aroma. El Santo Gozo en la Corona dichosa

47. Bartolomé Esteban Murillo *St. Diego of Alcalá Distributing Bread to the Poor,* 1645-46. Oil on canvas, 5'6³/4" x 6'1¹/4" (1.7 x 1.86 m), Museum of the Royal Academy of San Fernando, Madrid.

Murillo's composition suggests a compilation of individual figures rather than a unified conception of the whole: figures in the crowd look and turn in a variety of directions, and the composition lacks any strong dramatic focus. Despite these inauspicious beginnings, Murillo would develop a unique talent for religious narrative.

Saint Diego of Alcalá is striking: the vast canvas opens onto a perspective of a Renaissance courtyard, allowing natural light to enter the saint's darkened cell. But daylight is overpowered by the divine light emanating from the Christ child, surrounded by angels and cherubim who float on luminous and evanescent clouds. Comparison of the *Vision of St. Anthony* with Zurbarán's *Battle of the Christians and Moors at El Sotillo* (see FIG. 45) illustrates the degree to which Murillo's light, reflecting off the angels and cherubim who serve as transitional figures, joins the earthly and the celestial. Whereas light distinguishes levels of reality in Zurbarán's painting, in Murillo's it serves to unify: The visionary enters the world of the viewer as it enters that of St. Anthony.

Beyond offering a glimpse of otherworldly light, Murillo also created figures that identified spiritual purity with idealized beauty. The most famous examples of this are his figures of the Madonna, particularly those of the Immaculate Conception, on which Murillo's popular reputation has largely rested. The iconography of the *Inmaculada* derives from the Revelation of St. John, and became increasingly familiar in seventeenth-century Spain, paralleling the dissemination of the belief that the Mother of God had been born without sin. Earlier Sevillian painters, including Roelas, Zurbarán, and Velázquez, had portrayed the theme of the Vir-

48. BARTOLOMÉ ESTEBAN
MURILLO
*The Vision of St. Anthony
of Padua*, 1656. Oil on
canvas, 18'6" x 11'1" (5.6
x 3.3m), Seville Cathedral.

Color and light become
increasingly important
to Murillo's style as he
abandons the harsh
chiaroscuro of early
paintings, a change
illustrated by comparing
the figure of St. Anthony
with that of St. Diego of
Alcalá (FIG. 47). Light now
serves to unify rather than
to define individual figures.

gin standing solemnly upon a crescent moon, surrounded by clouds, and often by symbols of her purity, such as a mirror and a closed garden. In Murillo's work, the symbols disappear and the idealized Virgin is shown clothed by the sun.

As part of a commission for the church of Santa María la Blanca executed in the early 1660s, Murillo depicts the Virgin of the Immaculate Conception appearing before a group of contemporary Sevillians that includes secular and clerical, rich and poor (FIG. 49). The *Virgin of the Immaculate Conception with Six Figures* confirms the popularity of her cult, also suggested by an altarpiece (which no longer survives), temporarily erected in the plaza

in front of the church on the occasion of its dedication in 1665. Its central image was an Immaculate Conception by Murillo, and accompanying texts – written in Spanish rather than Latin – made the image even more accessible to the literate public.

Murillo's fame as a painter of beautiful Virgins and children has, as mentioned above, eclipsed other aspects of his career that make him a far more intriguing figure than is usually thought. The *Four Figures on a Step* (see FIG. 41) offers a glimpse of his activity as a painter of contemporary types who seem in their apparent unwholesomeness a clear antithesis to chaste Virgins. But Murillo remains above all else a master of religious narrative. *St. Diego of Alcalá* (see FIG. 47) illustrates Murillo's point of departure in the mid-1640s, against which we might measure a second scene of almsgiving, painted for the Capuchin Church in Seville in 1678, *St. Thomas of Villanueva Giving Alms* (FIG. 50).

The theme would have been especially relevant to Seville of the later seventeenth century, with its population decimated, and its former source of wealth – New World trade – moved southward to Cádiz: the actions of St. Thomas serve as a paradigm for support of the poor, which became an increasingly important aspect of Sevillian life. The saint's downturned face directs our gaze to the focus of the painting: the coin being given to the destitute beggar. With his back toward us, he remains an anonymous representation of poverty, as does the boy to the right, with

49. BARTOLOMÉ ESTEBAN MURILLO
The Virgin of the Immaculate Conception with Six Figures, 1665. Oil on canvas, 5'7¾" x 9'9⅓" (1.72 x 2.98 m), Musée du Louvre, Paris.

As in *The Vision of St. Anthony of Padua*, the Virgin of the Immaculate Conception serves as the painting's source of light, unifying the worldly and the celestial.

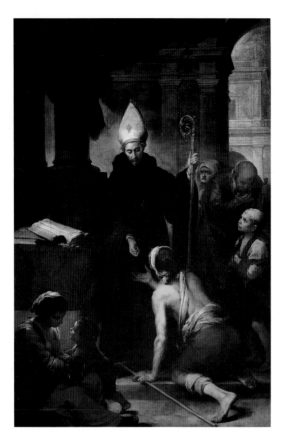

50. BARTOLOMÉ ESTEBAN
MURILLO
*St. Thomas of Villanueva
Giving Alms*, c. 1678. Oil
on canvas, 9′4¹/₄″ x 5′6¹/₄″
(2.8 x 1.6 m), Museo de
Bellas Artes, Seville.

In contrast to his earlier
painting of St. Diego
(see FIG. 45), Murillo
compromises the number
of supporting figures and
the specificity of the
individual to offer a
paradigmatic image of the
charitable saint surrounded
by the indigent.

tattered clothes and head shaven to elim-
inate lice. The six figures surrounding the
saint show that Murillo retained an inter-
est in characterization, clearly seen in the
older, distrusting man, who scrutinizes the
coin given to him, or the young boy with
shaved head, who looks at the saint with
combined anticipation and distrust.

The crisis of late seventeenth-century
Seville, implicit in the painting of *St.
Thomas of Villanueva*, is perhaps best rep-
resented through an institution founded
and decorated during the 1660s and 1670s
for the church of the Hospital of the Broth-
erhood of Charity, or *la Caridad* (FIG. 34,
page 61). Founded in the sixteenth cen-
tury for the purpose of giving a decent
burial to hanged convicts, the Brother-
hood had gained a renewed importance as
a charitable foundation after the plague of
1649. Its membership comprised mainly
well-to-do men, and even some nobles,
who offered aid to the sick and the indi-
gent of the city. The rebuilding and redec-
oration of the Brotherhood's church in the
1660s was due mainly to the initiative of Miguel de Mañara, a man
who, after a dissolute youth and the death of his family and of his
wife in 1660, turned to religion. So offensive was Mañara's rep-
utation that the Brotherhood debated his admission, granted only
in 1663. From that date until his death in 1679, Mañara oversaw
the opening of a hospital as well as the rebuilding of the church.

The decoration involved two painters who by this time were
recognized as Seville's foremost artists, Murillo and Juan de Valdés
Leal (1622-90); the sculptor Pedro Roldán (1624-99) executed
the *Entombment of Christ* for the main altar. Murillo painted three
pairs of paintings illustrating acts of charity from the Bible, as well
as the charity of St. John of God and St. Elizabeth of Hungary.
Removed by the French Marshall Soult during the Napoleonic
campaign in Spain (1808-13), several of these works have since
made their way to museums in Europe, Russia, and the United
States. *The Return of the Prodigal Son* (FIG. 51) focuses on the
forgiving embrace offered by the richly dressed father, whose
clothes contrast with the rags worn by his son. Rather than empha-
size the dissolution, Murillo implies the joy of forgiveness and rec-

onciliation: rich clothes are brought in by a servant on the right, as, on the left, a calf is led to slaughter for the feast in the son's honor.

A far less comforting lesson is learned from two paintings commissioned from Juan de Valdés Leal, a contemporary of Murillo's, and apparently his main rival for the position of Seville's pre-eminent painter after 1650. Valdés Leal is best remembered for his still-life paintings symbolizing the vanity of human achievements. Those in the church of *la Caridad* are known as the "hieroglyphs of death and salvation" (FIGS 52 and 53). Their imagery has been related to Mañara's own treatise, *Discourse on Truth* (1671), that has as its main themes the inevitability of death, and the vanity of all worldly achievement. The message is brought home by *In Ictu Oculi* (*In the Blink of an Eye*; FIG. 52). The figure of Death the Reaper stands upon a globe and before a tomb, surrounded by objects representing worldly wealth and power. They include armor and swords, the hats worn by ecclesiastic officials ranging from cardinal to pope, and even the Order of the Golden Fleece, brought to Spain in 1519 by its first Habsburg king, the Holy Roman Emperor Charles V. The books in the foreground have been identified as Pliny's *Natural History*, a history of Charles V, and the *Pompa introitus honori serenissimi principis Ferdinandi Austriaci hispaniarum infantis*, a tome commissioned in 1642 by the City of

51. Bartolomé Esteban Murillo
The Return of the Prodigal Son, 1671-74. Oil on canvas, 7'9" x 9'6³/4" (2.3 x 2.6 m), National Gallery of Art, Washington, D.C.

This is one of a series of six images of acts of charity, taken from the Bible. As an illustration of repentance and forgiveness, it was intended to exemplify Christian behavior to members of the Brotherhood of Charity.

52. Juan de Valdés Leal
In Ictu Oculi, 1670-72.
Oil on canvas, 7'2¾" x
7'1" (2.2 x 2.1 m), Church
of the Hospital of the
Brotherhood of Charity,
Seville. See caption
opposite.

Antwerp to commemorate the 1635 entry of Prince Cardinal Ferdinand (brother of Philip IV), here opened to an engraving after Rubens of a triumphal arch. Books and regalia attest that, no matter how powerful on earth, no one escapes the power of Death, who snuffs out the candle at will.

This "hieroglyph of death" prepares us for that of salvation which faces it, to offer a glimpse of our inescapable fate. Inscribed *Finis Gloriae Mundi* (*The End of Worldly Glory*; FIG. 53), it shows a bishop, a knight of the royal order of Calatrava (identified by the red cross on his mantle), and a third figure in the background shadows, lying in their open coffins, their flesh being consumed by insects. A hand above bears a scale, now balanced by objects representing the Seven Deadly Sins on the left, and by objects representing penitence on the right. Held in balance, it seems that a decisive factor in the scale's final shift is the individual being weighed. One way to shift the balance in favor of salvation was to emulate those acts of charity portrayed in the paintings on either side of the church's nave.

A gloomy note upon which to end a discussion of painting

in seventeenth-century Seville, these paintings of death and salvation might be seen as a reflection of an era. Their patron, Miguel de Mañara, was only one of many Sevillians who faced devastating losses after 1649, incurred by the plague or the economic downturn, and possibly both. The demise of worldly splendor then must have seemed assured, to suggest that one's time was well spent in pursuit of salvation. Glimpses of glory were offered by Murillo, as were lessons on how to attain salvation. A far more bitter lesson was to be learned from the paintings of Valdés Leal, perhaps most appropriately described by the painter and author Antonio Palomino (1655-1726) as "some Heiroglyphs of Time and Death and a decayed corpse, half eaten by worms, which causes horror and fear to look at, for it is so real that many, upon seeing it, instinctively withdraw in fright or cover their noses, afraid of being contaminated by the foul odor of its corruption."

53. JUAN DE VALDÉS LEAL *Finis Gloriae Mundi,* 1670-72. Oil on canvas, 7'2³/4" x 7'1" (2.2 x 2.1 m), Church of the Hospital of the Brotherhood of Charity, Seville.

In these pendants, still in their original location, to the left and right of the main entrance to the church, we see illustrated both the vanity of worldly pursuits and the fate of any who pursue them. Only good deeds can tip the scale of judgment in our favor.

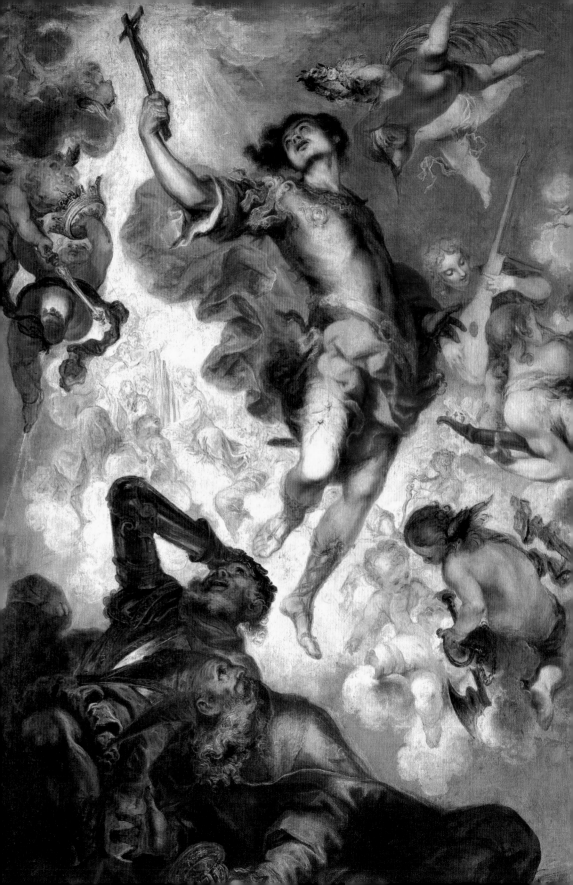

The Habsburg Court: 1598-1655

T he reputation of Diego Rodriguez de Silva Velázquez (1599-1660) has long eclipsed all others who painted for the Spanish Habsburg court. Although his mastery is beyond dispute, consideration of other court painters provides an essential context for his accomplishment. Times were auspicious for his development. Painting for Philip IV (r. 1621-65) from 1623 until his death in 1660, Velázquez served a patron with avid artistic interests who looked beyond the immediately available painters at court to commission and collect works from several renowned artists including Rubens, van Dyck, Poussin, and Claude Lorrain. Philip IV's enthusiasm marks a clear departure from the passiveness of his father, Philip III (r. 1598-1621), who left little mark on the visual arts.

54. FRANCISCO DE HERRERA THE YOUNGER
The Triumph of St. Hermengild, 1654. Oil on canvas, 11'1" x 7'6¹/4" (3.3 x 2.3 cm), Museo del Prado, Madrid.

Exuding a dynamism usually associated with the Italian Baroque, and a palette indebted to Rubens, this painting is often cited as a turning point in Spanish Baroque painting.

The Legacy of the Sixteenth Century

The continuing influence of Italian painters introduced to Spain through the Escorial is readily apparent throughout the first three decades of the seventeenth century, particularly in the realm of history painting. Eugenio Cajés (1574-1634) was the son of the Tuscan painter, Patrizio Cascezi, who had arrived in Spain in 1567 to work at the Escorial; Bartolomé Carducho (1560-c. 1608) had himself come to Spain in the workshop of Federico Zuccaro. Carducho had been accompanied to Spain by his younger brother

55. EUGENIO CAJÉS
*The Meeting at the
Golden Gate*, c. 1604.
Oil on canvas, 8'11¹/₄"
x 4'8¹/₄" (2.7 x 1.4 m),
Museo de la Real
Academia de Bellas
Artes, Madrid.

According to apocryphal
accounts, Joachim and
Anna, the parents of the
Virgin Mary, had been
married for twenty
years, and had not yet
had a child. Since
sterility was seen as
divine punishment,
Joachim's temple
offering was refused,
and he went out to the
wilderness. During his
absence, an angel
appeared to both
Joachim and Anna
telling them that Anna
would conceive a child
who would be the
mother of Jesus. Their
embrace at the city
gates upon Joachim's
return was a popular
subject in cycles of the
Virgin's life.

Vicente (1576-1638), who would inherit Bartolomé's position as court painter upon the older brother's death.

An early work by Eugenio Cajés, *The Meeting at the Golden Gate* (FIG. 55), was originally part of an altarpiece commissioned for the church of San Felipe el Real in Madrid in 1604. A reference to Cajés in 1599 as "el que talla en marfil!" (he who sculpts in marble) suggests that he was also a sculptor. This might explain the monumental figures of Joachim and Anna, with boldly modeled draperies that seem to be at odds with the much softer handling of their faces: the contrast of Joachim's rose and lavender costume with the gold and turquoise worn by Anna recalls the palettes of the Italian painters of the Escorial. Made court painter in 1612, Cajés collaborated on various religious commissions with Vicente Carducho. Both artists also contributed paintings to the Hall of the Realms in the Buen Retiro Palace in Madrid.

56. VICENTE CARDUCHO *St. John the Baptist Preaching*, 1610. Oil on canvas, 8'9" x 6'11" (2.7 x 1.8 m), Museo de la Real Academia de Bellas Artes, Madrid.

The Carducho brothers have been identified with a "reformed Mannerist" style, described as combining the drawing and compositional sense of Florentine painting with the blended contours (or *sfumato*) of the Lombard school and the colorism of Venetian painters. As we have seen, this trend toward a greater naturalism was not unique to Madrid. This style might recall traits seen in painting in Toledo of these same years, and it has also been suggested that the transformation of Ribalta's style can be attributed to his familiarity with the works of Carducho. *St. John the Baptist Preaching* (FIG. 56), painted by Vicente Carducho in 1610, is an ambitious composition by the newly appointed court painter, inspired by a Cambiaso altarpiece in the Escorial. The listeners surrounding St. John assume varied seemingly natural poses: two chatting women at center seem oblivious to the saint's words. The earth tones of the foreground that give way to the cooler tones of the distant landscape and overcast sky also reveal a turn to a more

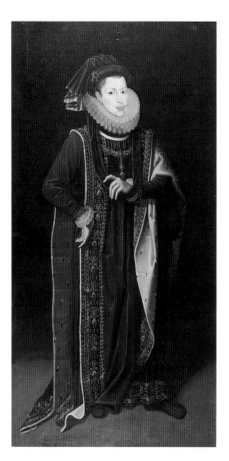

57. Juan Pantoja de la Cruz *Philip III*, 1608. Oil on canvas, 6′8¼″ x 3′4¼″ (2.4 x 1.2 m), Musée Goya (on loan from the Musée du Louvre), Castres.

The portrait illustrates the essentially conservative trend in court portraiture, as the artist emulates the precise delineation of costume and exact rendering of expressionless facial features seen in the portraits of his teacher, Sánchez Coello.

naturalistic palette than that employed by the earlier generation of Italian artists at the Escorial.

Portrait painting at court tended to reiterate formulas inherited from Sánchez Coello – not surprising, since one of his disciples, Juan Pantoja de la Cruz (c. 1553-1608), succeeded him as painter to Philip II and, subsequently, to Philip III. His portrait of Philip III in the mantle and habit of the Order of the Golden Fleece (FIG. 57) provides unintentionally a visual counterpart to the historical consensus about this king. Even before Philip III inherited the throne at the age of 20, his father had expressed concern about his ability to reign; that concern proved to be well founded, as Philip III essentially handed over the reins of government to his favorite, the Duke of Lerma (1553-1625). In the words of the historian J. H. Elliott, "Where Philip II moulded the form of the court to suit the character of his kingship, Philip III, lacking all character to his kingship, allowed himself to be enveloped by the forms. During the first two decades of the seventeenth century, the court may be said to have imposed itself on the king." Analogously, in the portrait by Pantoja de la Cruz, the blank-faced king seems younger than his thirty years, engulfed by the robes of the Golden Fleece that alone declare his royal character. Isolated against a black background without tables, chairs, or draperies, the king seems more a mannequin than the ruler of an empire.

Velázquez's Early Works at the Court of Philip IV

The problems with the Spanish empire became increasingly evident during the 1610s. The impact of the 1609 expulsion of the *moriscos* is difficult to calculate, but the absence of these people, who took on a variety of menial tasks in Seville, undoubtedly contributed to the growing problems of that port city. Profits from trade with the New World were declining, as the Netherlands and England encroached on Spain's monopoly, and as the colonists became more self-sufficient. Although a twelve-year truce with the rebellious Dutch provinces was reached in 1609, the Dutch used peacetime to their benefit, increasing their gains in the Far East at the expense of the Portuguese Empire. Within the Spanish court, dissension culminated with the overthrow of the Duke of Lerma in

1618; three years later his king, Philip III, died prematurely at the age of 43, leaving the throne to his sixteen-year-old son, Philip IV.

The king did not come alone to power: at his side was an Andalusian aristocrat, Gaspar de Guzmán, better known as the Count-Duke of Olivares (1587-1645). This reformer inherited the role of royal favorite, established by the Duke of Lerma, and served until his downfall in 1643. Ever faithful to his *patria chica*, or home province, Olivares brought to court many acquaintances from his native Seville, among whom was Juan de Fonseca. In 1623, and reputedly at Olivares's bidding, Fonseca introduced another Sevillian at court, the twenty-four-year-old Velázquez.

Velázquez soon established himself as a portraitist. He painted Fonseca in a portrait now lost, and then was given permission to paint the young king in a portrait which earned him the title of court painter, and is tentatively identified with a bust-length study now in the Meadows Museum, Dallas. He portrayed the most powerful members of the court, including the Count-Duke Olivares (now at the Hispanic Society of America, New York City), the Infante Don Carlos (now in the Prado), and of the king himself (FIG. 58). Recently published documents show that he painted numerous portraits of the king, and also of the royal family and royal favorite, for courtiers who were expected to own such images.

Technical analyses have shown that his portrait of the young king represents an evolution: first painted around 1625, it was apparently reworked about three years later. The portrait perhaps depicts the monarch as he would have been seen by those distinguished visitors who earned an audience. Having greeted the visitor by lifting his hat (here placed on the table behind), the king would stand next to a console table, listening silently and without expression until he ended the audience with a noncommittal remark. It was an encounter dictated by the strict etiquette of the Spanish Habsburg court, an etiquette that turned the king himself into a puppet. To heighten the wooden quality of this portrait, the king wears the flat, stiff collar, or *golilla*, that reformers (who promoted less expenditure on luxurious excesses through sumptuary laws) had introduced to replace the sumptuous ruffs seen in El Greco's portraits. Such ruffs were proscribed after 1 March 1623.

In reworking the portrait, Velázquez apparently turned his attention to the king's costume, painting a variety of details in black on black – many of which are today lost – to reveal the luxuriant stuff of Philip's costume, which sets off the Order of the Golden Fleece. In spite of the attention paid to costume, it is

58. DIEGO VELÁZQUEZ
Philip IV, c. 1625-28. Oil
on canvas, 6′5¹/₄″ x 3′4¹/₄″
(1.96 x 1 m), Museo del
Prado, Madrid.

An example of Velázquez's
early style, this portrait
marks a decisive turn from
the linearity and attention
to surface detail seen in
the works of earlier court
portraitists such as Sánchez
Coello and Pantoja de la
Cruz. The style is at one
with the austere elegance
of his subject. An emphatic
chiaroscuro gives a certain
hyperreality to the presence
of this rarely seen monarch.
The palette is limited, as
the severity of the king's
black costume and pallid
skin is relieved only by the
red tones in his face and
lips, and the tablecloth
behind. These stark contrasts
have been heightened by
the passage of time: just
as the once invisible
overpainted cape has now
emerged into view, so have
the dark undertones of the
painting become more
visible, turning once white
cuffs grey, and darkening
the tonal variations within
the king's costume.

the young king's face that draws our attention, in contrast with portraits of the Sánchez Coello school, where intricately detailed costumes distract often from the sitters' faces.

Rubens, Rivalries, and Italy

By 1626 there hung in the Salón Nuevo of the Alcázar an equestrian portrait by Velázquez of Philip IV, today lost. This large room was used for court ceremonies and the reception of dignitaries; it had an appropriately dignified decor comprised of paintings that glorified the Habsburg dynasty. Velázquez's own portrait hung as a pendant to the paradigmatic image of equestrian portraiture, Titian's *Charles V at Mühlberg* (1548). Older painters at court were clearly jealous of the favor that the young artist from Seville had achieved, and according to the early biographer Jusepe Martínez, malicious gossip soon began to circulate. One criticism supposedly leveled at Velázquez is that he did not know how to paint anything but heads.

To silence such gossip, in 1627 the king ordered a competition among court painters to depict an assigned subject: the 1609 expulsion of the *moriscos*. Velázquez's painting (today lost) was judged the winner by two artists who themselves did not hold positions as court painters: Juan Bautista Maino, who had settled at court after his early career in Italy and Toledo, and the Italian Giovanni Battista Crescenzi, who had arrived in Spain in 1617. Both of these artists were aware of recent trends in Italian painting, including the art of Caravaggio, and would perhaps have appreciated the innovative nature of Velázquez's painting in contrast to the more old-fashioned style of Carducho, Cajés, and the Italian Angelo Nardi, who also submitted paintings. Of all the entries, only a sketch by Carducho survives (now in the Museo del Prado).

By 1636, an inventory shows that Velázquez's *Expulsion of the Moriscos* hung in the Salón Nuevo. Of equal interest is that by 1636, Velázquez's equestrian portrait of Philip IV was no longer in the room, having been replaced by Rubens's equestrian portrait of the king. Peter Paul Rubens (1577-1640) had first visited Spain in 1603, leaving as visual testimony an equestrian portrait of the Duke of Lerma (now in the Prado). In 1628, he returned to Madrid in a diplomatic role, to broker a treaty between Spain and England (which was signed two years later). According to Pacheco, the equestrian portrait (today known only through a copy in the Uffizi in Florence) was one of five portraits of the king that Rubens painted. He also painted several half-length portraits of

the royal family to be sent back to Flanders (governed by Philip's aunt, Isabel, portrayed by Sánchez Coello; see FIG. 7, page 24). By 1636, the equestrian portrait was one of eleven works by Rubens that hung in the Salón Nuevo, a harbinger of what would become Philip IV's lifelong obsession for the Flemish artist's work.

It was probably during Rubens's seven-month stay in Madrid that Velázquez embarked on the *Feast of Bacchus* (more popularly known as *Los Borrachos* or "The Topers"; FIG. 59). His experimentation with mythological subject matter, in a composition that includes partially nude figures, may well have been inspired by the Flemish painter. Although once explained as a "false Bacchus" amid a group of peasants, the painting has more recently been interpreted as a scene of a benevolent visit to mortals by the god who presents them with the gift of wine. Yet the ambiguity of the image is hard to ignore. The pudgy Bacchus seems too human, differentiated from the peasants only by the pallor of his flesh; his face is that of a studio model. The surrounding peasants likewise recall the realistic types seen in the earlier *bodegones*, also recalled by the earth-toned palette and crowding of figures. In a signature again reminiscent of the early Sevillian paintings, Velázquez marks the foreground space by the inclusion of a humble still life. The painter is not yet entirely at ease with the human form, as freely painted draperies of white and carmine obscure the foreshortening of Bacchus's thigh. *The Feast of Bacchus* suggests that Velázquez aspired to move beyond the court portraiture to which he could attribute his main success to date. It also shows that his style was not up to his aspirations. Where to turn? The question led the young artist to Italy.

59. DIEGO VELÁZQUEZ *The Feast of Bacchus* (or *Los Borrachos*, "The Topers"), 1628. Oil on canvas, 5'5" x 7'4¹/₂" (1.6 x 2.2 m), Museo del Prado, Madrid.

Although this painting is the artist's first known attempt at a mythological subject, it nevertheless retains the earth-toned palette and insistent naturalism seen in his early Seville-period *bodegones*.

60. DIEGO VELÁZQUEZ
The Forge of Vulcan, 1630.
Oil on canvas, 7'3¹/₂"
x 9'6¹/₄" (2.2 x 2.9 m),
Museo del Prado, Madrid.

Testimony of lessons
learned during the artist's
first trip to Italy, this
painting shows a new
competence in painting the
human figure, in creating
illusionistic space, and in
evoking a moment of
intense drama.

In late summer 1629, Velázquez departed from Madrid, beginning an eighteenth-month journey that would take him to Venice, Ferrara, Cento, Rome, and Naples. The painter came armed with letters of recommendation from Italian representatives at the Spanish court – although some of these secretly warned the Italian hosts that the painter came as a spy. Amid the receptions and social climbing with which Velázquez has often been credited, he still found time to study Italian painting. The fruits of his efforts are revealed in two large paintings, purchased by Philip IV upon the artist's return, *Joseph's Bloodied Coat Presented to Jacob* (now in the Museos Nuevos at the Escorial) and the *Forge of Vulcan* (FIG. 60).

The *Forge of Vulcan* differs significantly from the figural scenes painted before Velázquez's Italian sojourn. In the *Feast of Bacchus* and in the early *bodegones*, we sense a quality of timelessness as figures pose for the viewer. By contrast, the *Forge of Vulcan* shows a new interest in achieving a sense of a psychological moment as Apollo here informs the older Vulcan of the infidelity of his wife, Venus. Vulcan's stunned silence reverberates in the postures and expressions of his workshop assistants, who freeze in position and look slack-jawed toward the messenger. On a formal level, a comparison with the *Feast* – painted only two years earlier – betrays the impact of Italy. In the *Forge*, Velázquez paints large-scale, semi-nude figures that have forsaken the heavy draperies that in earlier paintings camouflaged the human forms. In contrast to the earlier inebriated and somewhat lumpy peasants,

61. DIEGO VELÁZQUEZ
The Surrender at Breda,
1634-35. Oil on canvas,
10'1" x 12' (3.1 x 3.6 m),
Museo del Prado, Madrid.

An assured combination
of portrait, landscape, and
history painting, this work
shows the surrender in
1625 of the Dutch general
Justin of Nassau to Ambrogio
Spinola, the general of the
Spanish forces. Luminosity
is achieved by liberal use of
lead white underpainting,
covered by many very thin
layers of color, which
evoke the distant landscape.

Vulcan and his assistants assume graceful positions within a clearly defined illusionistic space. Warmer tones and a more painterly handling of the flesh replace the harsher contrasts of near white and dark shadows seen a few years earlier in the *Feast of Bacchus*. Comparison of Apollo with Bacchus shows a nascent luminescence that was subsequently developed in works painted upon his return to Madrid in 1631.

The Buen Retiro Palace

Back in Madrid, Velázquez soon became aware of the remodeling of the royal apartments adjoining the Church of San Jerónimo. During the next four years, that undertaking grew into a far more ambitious project, the building and decoration of the Palace of the Buen Retiro. Planned as a pleasure palace to provide adequate space for the spectacles and ceremonies of Philip's court, the Buen Retiro eventually housed eighteen paintings by Velázquez, includ-

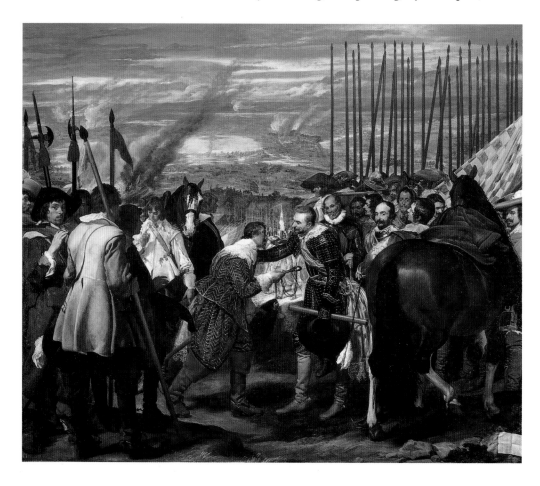

62. ANTONIO DE PEREDA
The Relief of Genoa, 1634.
Oil on canvas, 9'6¹/4" x
12'2" (2.9 x 3.7 m), Museo
del Prado, Madrid.

The stalwart Spanish leader
here accepts the gratitude
of the bent and aged Dux
of Genoa for having
relieved his city from siege
in 1625. In the background,
an imaginary landscape
ostensibly represents the
city of Genoa. Pereda is
best known for his still
lifes, whose precise style
is reflected here in his
detailed handling of lace
cuffs, plumes and surface
textures. Colored reflections
on the armor of the
Marqués de Santa Cruz
show that Pereda looked at
Titian and possibly Rubens,
although his application
remains very controlled.

ing the *Forge of Vulcan* and *Joseph's Bloodied Coat*.

The painting most readily identified with the Buen Retiro pro-
ject is the *Surrender at Breda* (FIG. 61), undertaken in 1634 and com-
pleted by early spring of the following year. It was one of a
series of twelve painted by the court's leading artists that cele-
brated recent victories of the Spanish army. Of the twelve vic-
tories portrayed, two were won in the early 1620s, five in 1625,
including that at Breda in the Netherlands, one in the late 1620s,
and four as recently as 1633. Rather than history paintings, these
might seem more like the seventeenth-century equivalent of large
documentary photographs, doctored to flatter the Spanish forces:
one of the problems with portraying events so recent was that
many of the victories commemorated in the paintings were
overturned by 1640. The series was to decorate a room intended
for courtly ceremonies and royal audiences, known as the Hall
of the Realms because of the inclusion in its ceiling decoration
of the escutcheons of the twenty-four kingdoms of the Spanish
monarchy.

A brief look at two other paintings that, like the *Surrender
at Breda*, commemorate victories of 1625, helps illustrate the nature
of the commission. That by the youngest artist involved, Anto-
nio de Pereda (1611-78), shows the Marquis of Santa Cruz reliev-
ing Genoa (a Spanish ally) from the siege laid by the Savoyards
and the French (FIG. 62). Pereda adopts a compositional formula
used by many of the artists involved in the commission, as the mil-
itary leader in the foreground ceremoniously performs his benev-

olent duties against a backdrop that specifies the location of the scene. As in other paintings of the series, conquest is transformed into genteel demeanor, proving the benevolence of the Spanish victors. The inclusion of halbadiers on the left provides relief from the frieze-like arrangement of foreground figures seen in other paintings for the Hall, and suggests that Pereda was perhaps taking a cue from Velázquez.

It is the secondary figures that have given Velázquez's work its popular title, *Las Lanzas* ("The Lances"). In contrast to Pereda and other painters who contributed to this commission, Velázquez unifies foreground action and background panorama as the majestic horse on the right leads us to the soldiers at the rear of the foreground group, facilitating our visual progression to the troops in the middle distance. At center, Ambrogio Spinola, the famous Italian general from Genoa who entered Spanish service, accepts the surrender of the city of Breda by Justin of Nassau. Like the playwright Pedro Calderón de la Barca (1600-81), who wrote a work commemorating the victory, Velázquez exercises his artistic license, since keys were in fact never handed over. Spinola maintains the dignity appropriate to an officer and a gentleman, as he dismounts to meet his adversary on equal footing, placing his hand upon his adversary's shoulders as if to console. We might even imagine him speaking the words from Calderón's play: "Justin, I accept them [the keys] in full awareness of your valor, for the valor of the defeated confers fame upon the victor." Velázquez jux-

63. Juan Bautista Maino *The Recapture of Bahia*, 1634-35. Oil on canvas, 10'1¹/₄" x 12'6" (3.1 x 3.8 m), Museo del Prado, Madrid.

Maino creates a story far more complicated than other artists, breaking from formulae of figures against topographical backdrops to portray both the pain of defeat and the pride of triumph.

taposes the wearied Dutch to the elegant Spanish forces on the right, who stand with lances held high. In fact, eyewitnesses reported that the opposite was true and recorded the scruffiness of the Spaniards compared with the Dutch. In the end, artistic license could not defeat reality, as the Dutch recaptured Breda two years after Valázquez completed his painting.

We recall that in the mid-1610s, Juan Bautista Maino had turned from painting to join the Dominican order, before coming to Madrid, where he served as drawing instructor to the future Philip IV. With Crescenzi, he had judged the 1627 competition in favor of Velázquez. The commission for the Hall of the Realms brought Maino back to the easel to portray the 1625 victory of the combined Spanish and Portuguese fleet over the Dutch at Bahia in Brazil. The *Recapture of Bahia* (FIG. 63) shows a mature artist at work, both in composition and style. On the left, a woman – possibly one of the Portuguese inhabitants of Bahia – tends to the wounds of a fallen soldier. This vignette of human charity, dominated by the figures of women and children, is juxtaposed with the allegory of military triumph and defeat on the right. The Commander, Don Fadrique de Toledo, indicates to the kneeling Dutch troops the ultimate power behind his triumph: he points to a tapestry of the king crowned by Minerva, and accompanied by the Count-Duke Olivares. Although the subject is a secular one, religious undertones are present throughout. Others have pointed out the similarities of figures in the left-hand group to allegories of Charity, and images of St. Irene curing St. Sebastian. But on the right, Don Fadrique assumes the role of a benevolent Inquisitor, showing the penitent heathens the path of the righteous.

The Buen Retiro palace was largely destroyed in the early nineteenth century, although its name is retained by the modern Parque del Retiro – the gardens that once extended westward from the palace. Many small shrines were built in the garden, including the hermitage Chapel of San Pablo that probably housed Velázquez's *Landscape with St. Anthony Abbot and St. Paul the Hermit* (FIG. 64). The two saints are shown before an expansive landscape, a choice of format perhaps inspired by works of such northern painters as Joachim Patinir (c. 1485-1524), available to Velázquez in the royal collection. Employing a device that seems

64. Diego Velázquez *Landscape with St. Anthony Abbot and St. Paul the Hermit*, c. 1633. Oil on canvas, 8'6¹/₂" x 6'3³/₄" (2.6 x 1.9 m), Museo del Prado, Madrid.

During the mid-1630s, the Spanish ambassador to the Holy See commissioned for the Buen Retiro a series of landscapes from Claude Lorrain and other painters working in Rome. Philip IV's interest in landscape may have inspired Velázquez to create in this altarpiece a landscape that explained the story of the saints in the foreground.

anachronistic, Velázquez ignores temporal unity and uses the landscape as a setting for events surrounding the foreground scene. In the left distance, St. Anthony asks directions of a centaur, and stops a second time to get help from a satyr. The cave's opening shows St. Anthony knocking at the gate of the hermit's cave. The main subject is the conference between the saints, who are miraculously fed by a raven bringing a daily ration of bread. But it is the landscape that remains the painting's unique achievement: Velázquez painted layer upon layer of glazes with highly diluted pigments to achieve a marvelous fluidity and lightness – similar to that seen in the *Surrender at Breda*.

The 1701 inventory of the Buen Retiro lists a painting of "a buffoon called Don Juan of Austria with various pieces of armour," a painting thought to have been one in a series of portraits of court jesters originally painted for the Buen Retiro (FIG. 65). The background battle scene links the mustachioed jester with his namesake, the illegitimate son of Charles V, who led the Holy League of Spain, Venice, and the Papacy to victory against the Ottomans at the Battle of Lepanto in 1571. The jester's pose and placement parodies the grand tradition, as Don Juan is shown in a full-length, three quarters format reminiscent of royal portraits. The potentially sublime turns ridiculous, as military dress and armor are replaced by a showy outfit and plumed hat seemingly antithetic to the somber costumes worn by more noble sitters. Also in contrast to the royal portraits, Velázquez experiments freely: the loose and painterly style seen in his landscapes and backgrounds is here brought forward in the figure to give the painting an unfinished appearance, as the

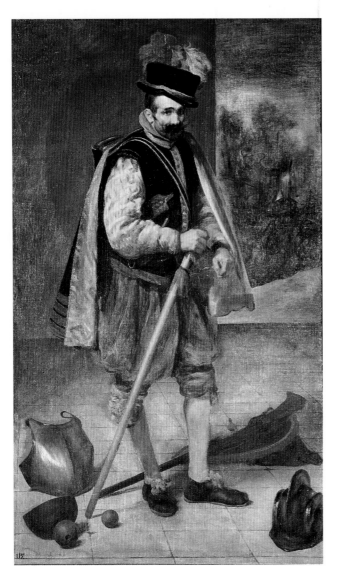

65. DIEGO VELÁZQUEZ
Don Juan of Austria,
c. 1635-36. Oil on canvas,
6'10" x 4'4½" (2.1 x 1.3 m),
Museo del Prado, Madrid.

Analogous to the role of the buffoon, this portrait seems a witty play on courtly grandeur, as the attributes of military might are assumed by the court fool.

application of wet paint on wet softens the contours of the face that seems veiled in atmosphere.

The portrait of another court jester, *Calabacillas* (or "little gourd" – a name referred to by the gourd lying at his side), declares this artistic freedom more forcefully (FIG. 66). Calabacillas's documented date of death in 1639 has led many to date this work to the late 1630s, yet we should not overlook the possibility that it could have been painted posthumously. Certainly, its technique marks a unique departure that might suggest it was painted in the sitter's absence, or hurriedly after his death in an attempt to remember his features. Velázquez paints over a ground thinner than that seen in other works, and technical analyses indicate that the figure was quickly sketched in – suggested most clearly in the handling of the collar. The insubstantiality of the figure adds to the pervasively pathetic quality of the whole, as the almost evanescent Calabacillas looks up to the viewer as if hoping to please, from the corner of a room that seems to press in around him.

The aesthetic of the borrón

Velázquez's technique, in which clearly perceptible strokes of color, or *borrones* (*borrón* is the singular), define form, was compared even in the seventeenth century to the paintings of Titian. By the 1630s, there seems to have existed at court a preference for this manner of painting, attested by the marked number of works by Titian and Rubens. This taste is reflected in the collecting patterns of Philip IV, who took refuge in the beauties of art as the political situation of Spain worsened (an escape noticed and admonished by some of his contemporaries). By 1640, the victories celebrated in the paintings of the Buen Retiro had been reversed: the Dutch reconquered Breda in 1637, and Breisach fell in 1638, cutting off an important route for the reinforcement of troops in the Netherlands. An alternative route was by sea, but the Spanish fleet was defeated in the English Channel by the Dutch Admiral Tromp in 1639. In the New World, the combined Portuguese and Spanish fleet failed to secure their foothold in Brazil, which would only become a Portuguese possession in 1654. Within Spain, 1640 saw the rebellion of the Catalans and the Portuguese against the king. In September 1640, Olivares himself described the

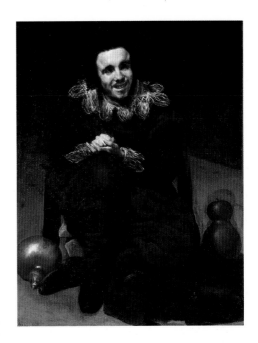

66. DIEGO VELÁZQUEZ *Calabacillas*, c. 1640. Oil on canvas, 42 x 32¹/₂" (106.5 x 82.5 cm), Museo del Prado, Madrid.

Unique in its insightful characterization, the portrait of the court jester displays a freedom of handling exceptional within Velázquez's œuvre.

current year as "the most unfortunate this monarchy has ever experienced." His own fortunes were to suffer further, as he fell from power in 1643, and died, in exile in Toro, two years later. By 1648, Spain signed the Peace of Westphalia, recognizing the independence of the United Provinces; eleven years later the Treaty of the Pyrenees settled a peace with France – as well as the marriage of Philip IV's daughter, María Teresa to Louis XIV.

It remains ironic that these most disastrous years coincided with Philip IV's greatest accomplishments as a patron and collector and with Velázquez's greatest works, *Las Meninas* and *The Fable of Arachne*, to be discussed in the next chapter. Rubens died in 1640, and two years later Philip was an active buyer at the sale of his collection. His taste for paintings by Rubens was shared by many prominent members of Madrid's aristocracy. In the early 1650s, the king acquired through an agent more works by Titian and Rubens in the sale of the collection of the late Charles I of England and Scotland.

Color had triumphed over line in Madrid painting by the 1640s. This is apparent even when painters did not show Velázquez's virtuosity of handling, as seen in *St. Isidore and the Miracle of the Well* (FIG. 67) by Alonso Cano (1601-67). Cano had been appointed in 1638 as painter to the Count-Duke Olivares, who fell from

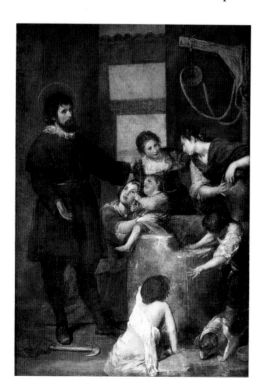

67. Alonso Cano
St. Isidore and the Miracle of the Well, c. 1645-49. Oil on canvas, 7'1" x 4'10¾" (2.2 x 1.5 m), Museo del Prado, Madrid.

Subtle colorism and painterly handling here replace the hard-edged *chiaroscuro* that had dominated painting in Madrid and Seville two decades earlier.

power four years later. Cano did not fare much better, since he was accused of hiring an assassin to kill his wife and, in a story much loved by nineteenth-century Romantics, was cleared of charges only after being tortured. It was probably in the mid- to late 1640s that Cano painted the *Miracle of the Well* for the church of Santa Maria de la Almudena in Madrid, showing the rescue of a child who had fallen into a well by the laborer St. Isidore, patron saint of Madrid. The painting (which has been cropped) betrays in its handling the influence of Velázquez and, according to Palomino, it was a work admired by the aging Maino before his death in 1649. In the 1650s, Cano returned to his native Granada, and eventually became a prebendary in the cathedral, where he worked as a painter, sculptor, and architect.

During the early 1640s Velázquez's production of paintings fell dramatically, a fact traditionally ascribed to his increased activi-

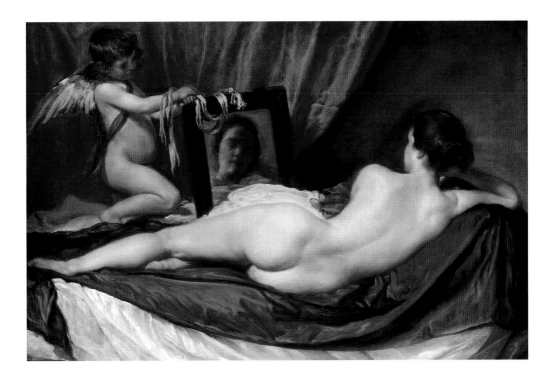

ty within the royal household. In fact, Velázquez became an important consultant and was charged with overseeing the redecorations of several rooms within the Alcázar. A second project that occupied him was the Escorial, which Philip IV began to frequent at that time. Work was resumed in 1645 to finish the crypt beneath the main altar, richly refurbished under Velázquez's direction in 1652-53. Although its decoration was principally architectural and sculptural, paintings were brought into play as Velázquez rehung the monastery's sacristy and one of its capitular rooms. In the sacristy, the eclectic mixture of paintings from the northern and Italian schools was replaced with an arrangement focusing on sixteenth- and seventeenth-century Italian paintings. In the capitular room, these artists' works were joined by those of Rubens and van Dyck. Velázquez's selection of paintings once again betrays a high estimation of Titian, ten of whose paintings were chosen for the sacristy.

Velázquez's *Venus and Cupid* (commonly known as the *Rokeby Venus*; FIG. 68) was first documented in 1651 in the collection of the *bon vivant* Gaspar de Haro, nephew of the Count-Duke Olivares. The exceptional subject matter suggests that *Venus and Cupid* was a private commission. It also seems to be Velázquez's personal tribute to Titian, whose paintings of reclining Venuses and whose *Venus with a Mirror* (now in the National Gallery of Art, Wash-

68. DIEGO VELÁZQUEZ *Venus and Cupid* (the *Rokeby Venus*), c. 1648. Oil on canvas, 4' x 5'10" (1.23 x 1.77 m), National Gallery, London.

Depicting a subject rare in Spanish art, this painting looks back to the reclining Venuses of Titian, collected by Philip II and in the royal collection in Velázquez's time.

ington, D.C.) are often cited as his possible inspiration. Velázquez vies with Titian in subtly modeling the nude's satin-textured flesh, set off by the drapery behind. He endows her with an obvious coyness, as she admires in her reflection the beauty withheld from the frustrated viewer. Adding to this titillation is the placement of the mirror, positioned to reflect the nude's most intimate attributes. But even this is not granted to the viewer, whose gaze is instead greeted with a hazy reflection of the woman's face.

Venus and Cupid was painted either in 1648 before Velázquez's departure for Rome, or else sent to Spain from the Holy City. This second conjecture seems highly unlikely, since Velázquez was engaged on a royal mission, attempting to persuade patrons to give works to the king of Spain and to allow molds to be made of precious antiquities so that copies could be sent back to Madrid. In an attempt to bring to Spain a painter of magnificent illusionistic ceiling frescoes, Velázquez also sought to persuade the Italian painter Pietro da Cortona (1596-1669) to come to Madrid. Although Cortona declined, two other fresco painters did arrive in Madrid in 1658: Angelo Colonna (1600-86) and Agostino Mitelli (1609-60). Their works in the Alcázar are lost, but their influence was seen in the work of their Spanish assistants, Francisco Rizi (1614-85) and Juan Carreño de Miranda (1614-85). While in Rome, Velázquez also sought to meet the rich and influential, perhaps with the aim of garnering support for his own bid for entry into a noble order. His success in reaching the influential echelons is reflected in his portrait of Innocent X in the Galleria Doria Pamphili, Rome, which again marks Velázquez's appeal to the tradition of Titian and also to Raphael.

The growing prestige of Venetian and Flemish painters, the formation of collections that represented painting from all schools, the arrival of Italian painters in Madrid: all of these factors attest to what, in modern terms, would be an "internationalization" of the art scene in mid-seventeenth-century Madrid. The influence of these cross-currents is seen in the *Penitent Magdalene* by Juan Carreño, a work in which the secular and divine might at first seem dangerously close (FIG. 69). An explanation may lie with the fact that the painting was commissioned for a convent and thus safely removed from male viewers. Seen by a female audience, the Magdalene loses effectiveness as a sexual symbol and instead provides a model of a beautiful woman who has foresaken worldly things. The blues, rose and cream tones linking the distant sky with the figure reveal once again a study of Titian.

By the mid-1650s, Madrid was the undisputed center for painting and patronage in Spain, surpassing the once prosperous Seville,

69. Juan Carreño de Miranda
The Penitent Magdalene, 1654. Oil on canvas, 7'3"x 5'11"(2.2 x 1.8 m), Museo de la Real Academia de Bellas Artes de San Fernando, Madrid.

Carreño's second version of a theme first painted five years earlier shows a heightened colorism influenced by Titian.

ravaged after 1649 by plague. These circumstances led the Sevillian Francisco de Herrera the Younger (1627-85) to the court in 1654. He was there contracted to paint an altarpiece for the Carmelite Church of St. Hermengild, a martyr who refused to accept the Aryan faith of his father, King Leogivild (FIG. 54, page 83). The father and Aryan bishop cower in the lower left corner in this scene of explosive apotheosis, a powerful emblem of the church triumphant. The size of the painting gives Herrera a field to show off his highly keyed color, which now becomes equated with light. The artist was aware of his innovative accomplishment, and according to Palomino boasted – justifiably, perhaps – that this work should be exhibited with "trumpets and kettle drums." Herrera the Younger returned to Seville, where his light-filled allegory of the *Triumph of the Eucharist* (1655, in the cathedral) inspired the young Murillo, who in the following year painted the *Vision of St. Anthony of Padua* (see FIG. 48, page 76).

Painting at Court 1655-1700

70. DIEGO VELÁZQUEZ
Las Meninas, c. 1656. Oil
on canvas, 10'5¹/₄" x 9'1/₂"
(3.2 x 2.7 m), Museo del
Prado, Madrid.

Extraordinary works force us to admit the incommensu-
rability of the artist's accomplishment and whatever ver-
bal explanation might be offered. Yet writers try con-
tinually to compensate for the gap, as great works inspire more
verbiage than all others. Such is the case with two paintings by
Velázquez – the *Fable of Arachne* and, to an even greater extent,
Las Meninas, the latter appropriately described by the Neapolitan
painter Luca Giordano (who served at the court of Carlos II) as
the "Theology of Painting."

A painting probably to be identified with the *Fable of Arachne*
(FIG. 71) was listed in a private collection by 1664, giving us lit-
tle precise evidence for the date of the work, generally thought
to have been painted during the mid-1650s. Its familiar name, *Las
Hilanderas* ("The Spinners"), recalls eighteenth- and nineteenth-
century interpretations of its subject as a scene in a tapestry fac-
tory. But certain anomalies were soon detected. The tapestry hang-
ing in the background was after a painting by Titian in the royal
collection, the *Rape of Europa* (1559-62, Boston, Isabella Stew-
art Gardner Museum). Before the tapestry stands a figure in
helmet and armor gesticulating before a younger woman, as three
elegantly dressed women – one with a viol de gamba – look on.
The scene was soon identified with the classical myth of Arachne,
a young woman from Lydia in Asia Minor famed for her skill
as a weaver. She wove a tapestry showing the loves of the gods
that infuriated Pallas Athena (the Roman Minerva), one of whose

many roles was as patroness of spinners and weavers. When the goddess tore the tapestry in anger, the overwhelmed Arachne hanged herself. To save her from death, Athena turned her into a spider dangling on its thread.

Once the background subject is recognized as the confrontation between Athena and Arachne, it suggests that Velázquez returned to the format first seen in his early *bodegones*, incorporating a scene within a scene as a means of transforming a painting into an iconographic conundrum. In earlier *bodegones*, the secondary scene was either a painting or a view into another room: here, the secondary scene seems to continue the foreground space. The relation of the two is nevertheless ambiguous. The foreground women seem unaware of the drama taking place behind them; and the role of the elegantly dressed musical trio has yet to be fully explained. One possible explanation is that Velázquez intended to create an image that juxtaposes weaving as craft (taking place in the foreground) from weaving as high art – an activity proven by the production of tapestries, a commodity more highly valued than paintings during Velázquez's day. *The Fable of Arachne* confirms the prestige of tapestry weaving by its allusion to Titian (and indirectly to Rubens, who had copied Titian's *Rape of Europa*). The distinction between craft and noble art would certainly have been near to Velázquez's heart during the 1650s, when, to gain entry into a noble order, he had to prove that he had never worked as a manual laborer.

Proof of the nobility of painting has also been seen as a theme central to *Las Meninas* ("The Maids of Honor"; FIG. 70, page 103), a thesis that we shall examine after considering earlier interpretations. In the early eighteenth century, Palomino, who ostensibly relied upon the account of Juan Alfaro, a student of Velázquez, identified the cast of characters. Although the specific identities need not concern us, the central figure is the Infanta Margarita, the future Empress of Austria, who is served by two ladies-in-waiting. A dwarf and midget to the viewer's right help to entertain the princess, while other members of the royal household look on. Velázquez stands at his easel, bearing on his chest the red cross of the order of Santiago, which, according to Palomino, was "painted after the painter's death by order of His Majesty; for when Velázquez painted this picture the king had not yet bestowed on him that honor." Reflected in the mirror hanging on the rear wall are the king, Philip IV, and his second wife, Mariana of Austria (1634-96). Palomino tells us that the king often visited Velázquez in his studio as he worked on *Las Meninas*, which on completion was hung in the king's lower apartments. Royal admi-

71. DIEGO VELÁZQUEZ
The Fable of Arachne (*Las Hilanderas*, "The Spinners"), c. 1655. Oil on canvas, 7'2½" x 9'5¾" (2.2 x 2.9 m), Museo del Prado, Madrid.

This is one of Velázquez's most innovative canvases. The arrangement of the foreground women parallels that of the five figures behind; and Velázquez uses several devices to draw us to the background scene. He daringly "erases" the central, foreground woman carding wool, whose shadowed face is literally illegible; thus she does not distract our view. He also weaves the foreground and background together, as one continuous stroke of paint defines both the yarn being wound in the left foreground as well as the highlights on the blue gown of the woman in the distance.

ration and treatment of the painter argues for the noble status of painting. But the nobility of painting – and its distinction from manual labor – is also proven by its intellectual component, exhibited through a witty perspectival game that becomes integral to the painting's theme.

The orthogonals – perspectival lines – of the work meet in a vanishing point just beneath the bent arm of the man in the rear doorway. The rules of perspective dictate that the ideal viewer be placed directly before this point. Thus, if the background mirror actually reflects the king and queen, the viewer stands to their right as they face the work. But what is reflected in that mirror? Is it, in fact, the king and queen, or is it the double portrait of the monarchs that Velázquez is perhaps painting? Either answer suggests that Velázquez is now looking not at the viewer but at the royal couple. The viewer, like the man in the background doorway, becomes a bystander of the painter in the presence of his royal patrons.

What is the subject of the painting? On the one hand, it is the painter painting, although his subjects (the king and queen) stand outside of the frame. But clearly, this is not the only sub-

ject: there is the princess, who seems, like Velázquez, to look at the king and queen outside of the work. A few of those in attendance acknowledge the royal couple to suggest they have just entered the room. But if they have just entered the room, they are clearly not posing: so what is Velázquez painting? *Las Meninas* becomes a theatrical riddle. Like the plays performed at court, the entire action is directed outward to the king, in whose apartments it once hung. But in this scenario, the king became the actual viewer – standing next to the illusionary king (reflected in the mirror within the painting) who has just entered the room. It is no wonder that, according to Palomino, the king and queen, *infantas*, and ladies-in-waiting often visited Velázquez as he worked on *Las Meninas*, which they considered "a delightful treat and entertainment."

Juan Bautista Martínez del Mazo

Velázquez died in 1660, leaving as one of two executors his son-in-law, the painter Juan Bautista Martínez del Mazo (1610/15-70), who also inherited his father-in-law's position as court painter. Mazo was well known for his views of cities and royal residences; he was also (according to Palomino) a copyist of works by his father-in-law, Titian, Veronese, and Tintoretto. It is in this capacity that he is implicated in *Las Meninas*, where his copies after Rubens hang on the rear wall of the depicted room. Five years after

72. JUAN BAUTISTA MARTÍNEZ DEL MAZO
The Artist's Family, 1664-65. Oil on canvas, 4'10¼" x 5'8½" (1.48 x 1.74 m), Kunsthistorisches Museum, Vienna.

In this family portrait, Velázquez's son-in-law pays tribute to the great artist, with a composition and setting reminiscent of *Las Meninas*.

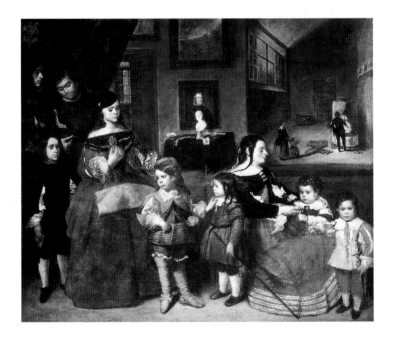

Velázquez's death, Mazo reciprocated the tribute in a portrait of his own family (FIG. 72).

Francisca Velázquez had predeceased her father in 1554, and Mazo then married Francisca de la Vega, seen here. Mazo pays homage to *Las Meninas* through his apparently nonchalant arrangement of figures, and the inclusion of a portrait of the king in the center of the rear wall. Yet these compositional borrowings are devoid of the rich ambiguity seen in Velázquez's work: Philip IV appears unambiguously as an image rather than a reflection; no spectator is implied, and the figures within the painting are oblivious to the world outside the canvas. An artist stands in the far right, working on a full-length painting of an *infanta*, observed by a woman and child. Is this Mazo, who so often copied the works of his father-in-law? Or is it the master himself, to whom Mazo pays homage by the inclusion of a scene within a scene – a format that itself pays tribute to the *Fable of Arachne*?

Painting in the final Years of the Habsburg Monarchy

Philip IV died in 1665, leaving a four-year-old son who assumed the throne as Carlos II upon reaching fourteen years of age. In the meantime, the state was left in the hands of the Queen Regent Mariana and a committee (*junta*) consisting of five ministers chosen by Philip IV. The ineffectiveness of Spain's monarchy and of its advisers from this point to the end of the century, as well as the declining economy of Castile, have generally been seen as part of the swan song of the glory that was Habsburg Spain. Further historical research might show that the fortunes of the country are not to be so closely identified with the sad reign of the sickly Carlos II, who died without heir in 1700. Yet the common understanding of the period as one of abject decline continues to color conceptions of its painting.

Generally speaking, painting in Madrid after the death of Velázquez is a subject rarely treated and even less often understood. Artists active after 1660 have, until recently, been little studied; their works are often inaccessible, especially outside of Spain. The predominance of religious works among those that survive also might make them less appealing to modern audiences. Finally, many of the artists' efforts were directed to the creation either of fresco paintings or ephemeral decorations constructed for royal or religious celebrations, of which little remains.

The death of Philip IV marked the death of a great connoisseur and patron: his royal successors tended to content themselves with portraits, decorative frescoes, and, only occasionally, the

73. Francisco Rizi and
Juan Carreño de Miranda
The Vision of St. Anthony,
1665-68. Cupola, San
Antonio de los Portugueses,
Madrid.

This ceiling shows the influence of the Italian painters Colonna and Mitelli, who brought to Madrid a style of ceiling painting defined as High Baroque. Illusionism is used to open up an infinite space, as the fictive architecture on the lower part of the dome gives way to clouds and heavenly figures who, with St. Anthony, witness a vision of Glory. Figures become secondary to the overall effect. At the end of the century, Luca Giordano would continue the project, painting scenes of the saint's life to cover the walls of the small church.

exceptionally original work, exemplified by Claudio Coello's *Sagrada Forma* (see FIGS. 77 and 78). Many of the major works of these years resulted from church commissions, in Madrid as well as in other parts of Spain. One example of the grandeur of church patronage at this time is seen in the frescoed cupola of San Antonio de los Portugueses in Madrid (FIG. 73), the only extant work that shows the influence of the brief sojourn in Madrid of the Italian fresco painters Colonna and Mitelli. (After Mitelli's death in 1660, Colonna stayed in Madrid only until 1662.) The illusionistic architectural framework was devised by Francisco Rizi (1614-85), a student of Vicente Carducho, who also served as director of stage design for the Coliseo Theater of the Buen Retiro. His experience in set design surely prepared him for the lessons in illusionistic ceiling painting taught by the newly arrived Italians, to which were added the figures – thought to be the work of Carreño. Nothing could seem further from the intricate illusionistic play of *Las Meninas* than the High Baroque bombast of this ceiling, which opens up to the celestial hierarchy that greets St. Anthony.

Another result of the collaboration of Rizi and Carreño is the large altarpiece commissioned in 1664 by the Trinitarian monks for their monastery church in Pamplona (FIG. 74). The subject is a scene from the life of the founder of the order, John of Matha, showing the miracle that occurred during his first celebration of the Mass. Holding up the Host, he had a vision of a boy dressed

74. Juan Carreño de Miranda
The Mass of St. John Matha, 1666. Oil on canvas, 16'5¹/₂" x 10'4¹/₄" (5 x 3.1 m), Musée du Louvre, Paris.

Although signed only by Carreño, this painting is thought to have been based on a drawing by Francisco Rizi, today in the Uffizi, Florence.

in white, with his hands upon two prisoners, one Christian, one Moor. This vision determined the mission of the order, to redeem Christian prisoners. The perspectival setting of this large work betrays Rizi's hand, although the dazzling effects of color and shimmering highlights suggest an evolution of the colorism detected a decade earlier in Carreño's *Penitent Magdalene* (see FIG. 69). A testament to the triumph of the High Baroque in Madrid, the altarpiece nonetheless displeased its provincial patrons, who had to be persuaded by a local painter to accept the work.

Named painter to the king in 1669, Carreño became court painter two years later, and soon devised a royal iconography for the young prince Carlos (FIG. 75). As others have noted, the

future king poses in the Hall of Mirrors, redecorated in the 1650s under the direction of Velázquez and used for the reception of highly regarded dignitaries. Thus, this is not merely a likeness, but a portrait that shows Carlos in the act of receiving a visitor. The portrait places the viewer in the role of a visiting dignitary, a device that might be compared to that seen in Velázquez's earlier full-length portrait of Philip IV (see FIG. 58, page 88). A comparison of Carreño's portrait with Velázquez's earlier works betrays the older painter's influence as Carlos's pose recalls that seen in full-length portraits of his father. But Carreño – perhaps taking a hint from the complexity of *Las Meninas* – also uses

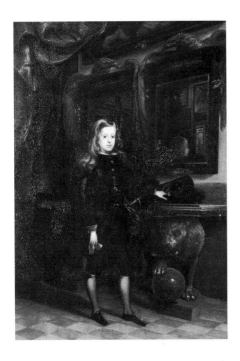

the play of mirrors to enrich the iconography of his image. The mirrors reflect Rubens's last equestrian portrait of Philip IV to illustrate the lineage of this present sitter, as well as a painting by Titian, as Carreño pays tribute to his own artistic lineage of Titian, Rubens, and Velázquez.

A second disciple of Rizi, Claudio Coello (1642-93), played an important artistic role at the court of Carlos II. Having been named painter to the king in 1683, in 1686 he inherited the position of court painter left vacant by Carreño's death the previous year. Like Carreño, Coello is not an easy artist to know, since his works are either lost, dispersed among museums in Europe and America, or remain in the churches for which they were originally commissioned. An early work of 1664, the *Apotheosis of St. Augustine* (FIG. 76), shows that the young Coello was fully aware of the innovations introduced a decade earlier by Herrera the Younger in the *Triumph of St. Hermengild* (see FIG. 54, page 83), although Coello is less flamboyant than his Sevillian predecessor.

75. JUAN CARREÑO DE MIRANDA
Carlos II, 1673. Oil on canvas, 6'8³⁄4 " x 4'8" (2 x 1.42 m), Gemäldegalerie, Staatliche Museen zu Berlin.

Carreño here looks back to Velázquez in the pose and use of mirrors to enhance the meaning of this portrait.

Coello's best known work is a painting that epitomizes the unity of Throne and altar under the Habsburg monarchy, and is, fittingly, in the sacristy of the Escorial (FIGS 77 and 78). Its subject is Carlos II of Spain adoring the Host, more commonly known by its Spanish title, the *Sagrada Forma*. The commission had first been given to Rizi, who died in 1685. According to Palomino, Coello reworked Rizi's initial conception, finding its vanishing point too high. Rizi's possible role in the work would explain its compositional similarity to Carreño's *Mass of St. John Matha*, a painting of similar scale that likewise probably originated with a sketch by Rizi.

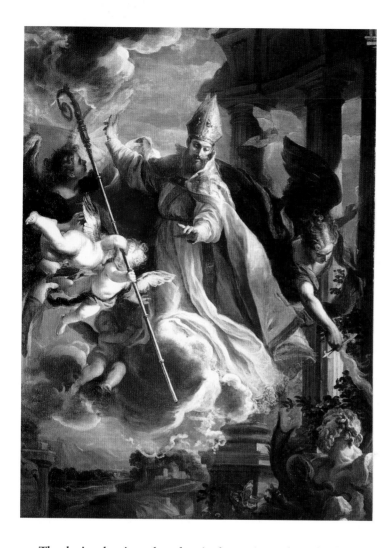

76. CLAUDIO COELLO
*The Apotheosis of St.
Augustine*, 1664. Oil on
canvas, 8'10¾" x 6'8"
(2.7 x 2 m), Museo del
Prado, Madrid.

The saint calmly
acknowledges the demons
below, as he is lifted
heavenwards, the white of
his billowing drapery set off
by the counterpoint of his
golden miter, and salmon
lining of his cape.

The depicted action takes place in the sacristy, where the finished painting itself was to be placed. It is both a scene of worship and a group portrait, including the king, the prior of the monastery, who holds the relic, accompanied by a deacon and subdeacon. Behind are members of the court; behind them, choirboys and monks are directed by the Escorial chapel master. Three figures in the lower left corner were unidentified until the late nineteenth century, when two were identified as the artist himself (in profile) and the mayor of the town. Today the work is seen in its original site at the center of an elaborate marble retable, flanked by doors leading to a small chamber behind (FIG. 78). The doors are executed in bronze and tortoiseshell, surmounted by white marble medallions depicting the history of the Sacred Host that is the focus of the picture. That history, which takes us back to the

reign of Philip II, is essential to an understanding of the painting's significance.

The Sacred Host originated with the Spanish wars against the Dutch Protestants. In 1572, the Dutch village of Gorkum was attacked by insurgents whose specific target was the town church. Once in the church, one of the rebels began to trample the consecrated host with his hobnail boots, and the host spurted blood. The heretic was converted to Catholicism on the spot, and remained in the church to care for the miraculous host, which was later taken to Antwerp for safe keeping. This relic passed through various hands before coming to Philip II in 1594, in honor of his role in liberating the Netherlands from the heretics. It was placed on an altar in the basilica of the Escorial for the next ninety years.

The relic acquired renewed relevance during the reign of Philip II's great-grandson, Carlos II. Upon assuming the throne in 1675, it was hoped by the members of the governing *junta* that Carlos would banish the favorite, Fernando Valenzuela, who had held great sway during the regency of his mother Mariana. In fact, Carlos followed his mother's will, giving Valenzuela more power over the other members of the *junta*. Sensing their discontent, and that Valenzuela was in mortal danger, the king ordered the prior of the Escorial to hide the favorite. This did not keep 500 men from ransacking the monastery and basilica in search of their enemy. The prior punished them with excommunication, but the king, recognizing the awkwardness of having many of his advisers excommunicated, interceded. Papal pardon was granted, on the condition that the rebels build a chapel or altar within the Escorial. That altar was to contain the Sacred Host, which was now moved from the main basilica to the sacristy. Although the weak will of Carlos II had led to a situation that might have been avoided through negotiation, he is portrayed in the *Sagrada Forma* as the respected king who worships amid an orderly retinue that includes some of those formerly excommunicated. Just as the miraculous host had a century earlier converted a heretic to the righteous path, so now does it prove its efficacy as a symbol of the divine, before which the rightful hierarchy of church, monarch, and courtiers is restored.

More than an image of the relic, Coello's painting serves as a surrogate for the relic. On two days each year (29 September – the feast of St. Michael – and 28 October – the feast of St. Simon) the painting is lowered into the floor by a system of pulleys, allowing those attending services in the sacristy to see the sacred relic on the altar behind the painting. Thus, the painting itself func-

77. CLAUDIO COELLO
Sagrada Forma, 1685-90.
Oil on canvas, approximately 9'10" x 16'5½ " (3 x 5 m), Sacristy, The Escorial.

The last Habsburg king of Spain is seen worshipping a relic housed in the Escorial since the reign of his great-grandfather, Philip II.

78. CLAUDIO COELLO
*A View of the Sagrada
Forma, in situ,* in the
Escorial Sacristy.

The painting serves as a
screen, behind which the
Sacred Host is kept at an
altar resembling that
depicted by Coello.

tions as an elaborate stage curtain, an illusion reiterated by the fictive curtains included within the painting. These are seemingly lifted to reveal the scene of Carlos II and his courtiers, worshiping the relic in perpetuity; when the painting is lowered, the spectator assumes the role of Carlos II.

The sacristy of the Escorial had been rehung with Italian and Flemish paintings under the supervision of Velázquez more than thirty years earlier. It is probable that these paintings still decorated the sacristy in 1690, presenting some serious competition for Coello. His theme of the worship of the host finds a long tradition in Renaissance and Baroque art, and his illusionistic portrayal of the sacristy itself is perhaps intended to compete with his predecessors. Certainly, the specter of Velázquez's *Las Meninas* seems to haunt the work, as does the tradition of narrative group portraits, particularly those commissioned for the Hall of the Realms in the Buen Retiro. With the Spanish royal collection at his disposal, Coello attempted to absorb and perhaps also surpass traditions there represented.

The final years of the Habsburg dynasty in Spain were not happy ones. The first wife of Carlos II, María Luisa of Orleans, had died in 1689, childless. In the hope of providing an heir, a second marriage to Mariana de Neuberg was soon arranged, but prayers were not answered. The Escorial remained the focus of major artistic undertakings until the death of Carlos II in 1700. In 1692, the king invited – although some say coerced – the Neapolitan painter Luca Giordano (1632-1705) to come to the Spanish court. During his decade-long stay he would paint ceiling frescoes in the monastery and basilica of the Escorial, another in the casón of the Buen Retiro (today the museum of nineteenth-century painting), and augment the fresco decorations of San Antonio de los Portugueses (see FIG. 73), rededicated in 1689 as San Antonio de los Alemanes. In these last days of the Spanish Habsburg monarchy, Carlos II seems to have taken some comfort in the illusions of glory presented by the frescoes of Giordano.

His first undertaking in the Escorial was a fresco for the main staircase, the *Adoration of the Trinity*, which takes as its main theme the devotion of the Spanish Habsburgs (FIG. 79). The heavens open to reveal the Trinity, surrounded by a heavenly host. To the right, on the clouds beneath, are Charles V and Philip II, founder of the dynasty and founder of the Escorial, respectively. Charles V offers the crowns of the Holy Roman Empire and of Spain, as Philip II offers the globe of the world. Interceding on behalf of the kings is St. Jerome, founder of the Hieronymite order housed in the Escorial. Three figures stand on a fictive balustrade: Car-

los II, his second queen, Mariana of Neuberg, and his mother, Mariana of Austria, the last survivors and witnesses to the glory of a moribund dynasty.

As Carlos's diminishing health became ever more apparent, arrangements were made for his succession. The first candidate was Joseph Ferdinand of Bavaria, the grandson of Margarita (daughter of Philip IV featured in *Las Meninas*). His untimely death in 1699 led to a frantic search, with Carlos II finally recommending the Bourbon Philip, Duke of Anjou, grandson of Louis XIV and Philip IV's daughter María Teresa. His succession to the throne as Philip V in 1700 was challenged by England, Austria, and the United Provinces in the Netherlands, which stood against Spain and France in the ensuing War

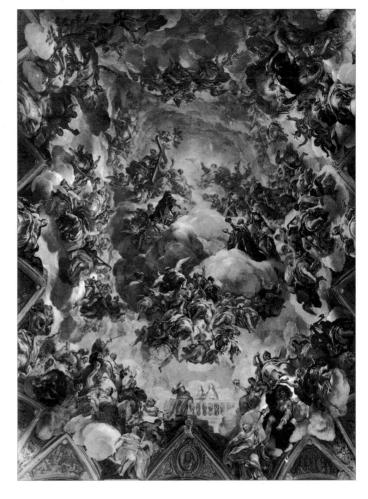

of the Spanish Succession. Circumstances changed in 1711, when the Austrian candidate for the Spanish throne assumed the Austrian throne. His triumph in Spain would mean a threatening unification of Austria and Spain – a realization that led to the end of the war in 1713 with the Treaty of Utrecht. With the coming of peace, the new Bourbon king of Spain, Philip V, could turn his attention to artistic matters.

79. LUCA GIORDANO
Adoration of the Trinity, c. 1695. Ceiling fresco, Imperial Staircase, the Escorial.

Giordano brought to Spain an influential fresco style that simplified the more complicated illusionism seen in San Antonio de los Portugueses.

Painting under the Bourbon Monarchy 1700-70

U pon arriving in Madrid in 1701, Philip V (r. 1700-46) was greeted by an artistic environment that can at best be described as lackluster. The aging Giordano departed in 1702; while Teodoro Ardemans, named court painter in 1704, was sidetracked from painting by his duties as architect of the Alcázar and of the city of Madrid; Antonio Palomino – the author of a treatise on painting to which was added the *Lives of the Artists,* published in 1724 – was executing frescos in Salamanca before turning to those for the Charterhouse of Granada. Lesser-known artists remained at court, such as Juan van Kessel (who, in response to a portrait painted of the new king, lost his post as court painter); Francisco Ignacio Ruiz de la Iglesia (1648-1704); Juan García de Miranda (1677-1749); and Miguel Jacinto Meléndez (1679-1734), uncle of the more famous painter of still lifes, Luis Meléndez (1716-80). The older Meléndez was one of the more successful Spanish artists at court. He brought to his portraiture (FIG. 81) a hybrid style, combining the naturalism of Carreño's physiognomies with a highly detailed if somewhat flat rendering of the embroidery and lace of the elegant Bourbon costume.

In looking at painting in isolation from the many architectural projects undertaken by the Bourbon monarchs, we run the risk of underestimating their artistic accomplishment. The austerity of the Madrid Alcázar and the Escorial did not well suit the tastes of the patron whose grandfather had transformed the hunting lodge

81. MIGUEL JACINTO MELÉNDEZ
Philip V, 1712. Oil on canvas, 39 x 32" (100 x 82 cm), Museo Cerralbo, Madrid.

The colorism of this portrait, as well as the costume worn by the new king of Spain, illustrates the Bourbon will to replace the austere imagery of the Spanish Habsburgs. In the end, the efforts of the painters at court did not suffice, as the Bourbons turned to French-trained artists.

of Versailles into the spectacular palace known today. The most enduring evidence of the dynastic change is the French- and Italian-inspired palace built under Philip V at La Granja (FIG. 82), near the former Habsburg palace of Valsaín. Built between 1721 and 1723 under the direction of Teodoro Ardemans, it was expanded and decorated by the Italian history painter Procaccini (1671-1734), assisted by the architect Filippo Juvarra (1676-1734). Its extensive gardens were decorated with fountains and sculptures executed by a team of French sculptors in the early 1720s. A second major undertaking was the rebuilding by Giovanni Battista Sacchetti (1690-1764) of the Alcázar as the royal palace of Madrid (FIG. 83). Sacchetti took over the project after Juvarra's death, and continued work until 1760, when the king Carlos III replaced him with another Italian architect, Francisco Sabatini (1721-97); the project was completed in 1764. The employment of Italian architects on both of these projects was influenced by Philip's

second wife, Elizabeth Farnese. Under her son, Carlos III (r. 1759-88), and his son, Carlos IV (r. 1789-1808), attention turned to the interior decoration of the royal palace, the refurbishing of the Escorial, and the construction of pleasure houses or *casitas* in the grounds of the Escorial, the Pardo palace, and at Aranjuez.

The new monarchs' taste in painting followed the tendencies current throughout Europe during the eighteenth century. Portraits of the new royal family were required, and finding artists to paint them was a priority. At the same time, other venues for painters were opened. With the Treaty of Utrecht (1713), Spain lost her possessions in the Netherlands, which up to this point had supplied its royal houses with tapestries. A royal tapestry factory was founded in Madrid, and throughout the century artists created large-scale designs, or cartoons, to be woven by its workers. Aside from tapestries, the Bourbon monarchs of Spain adhered to a general eighteenth-century taste for small-scale works that included the genre scenes and landscape paintings of Michel-Ange Houasse, the still-life paintings of Luis Meléndez, and the genre scenes and landscapes of Luis Paret y Alcázar. Such tastes were diametrically opposed to the initiatives of the Royal Academy of San Fernando, founded in 1752 on the model of the French academy. Although the architectural section of the Royal Academy wielded significant power, its counterpart in painting never

82. The Palace of La Granja.

Situated outside Segovia, La Granja was begun by the court architect Teodoro Ardemans in 1721-23, but was expanded and decorated by Italians, with gardens designed by the French architect René Carlier, after Ardemans's death in 1726. Its rococo forms, and extensive gardens mark an intentional turn from the less ornamented exteriors of palaces built under the Habsburgs.

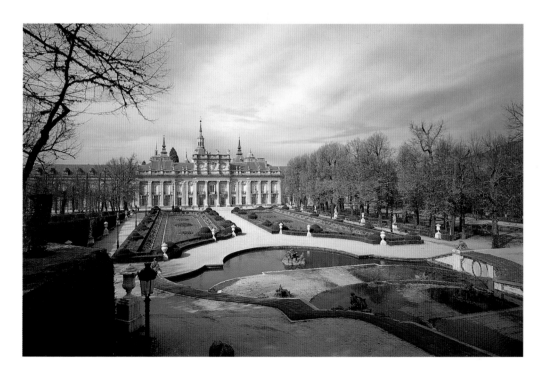

83. The Royal Palace (Palacio de Oriente), Madrid.

The Alcázar of Madrid, the palace used by the Habsburg monarchs, was destroyed by fire in 1734. Italian architects were soon enlisted to build a new palace, which would be largely completed by 1764. At this time, attention turned toward the decoration of the interior.

realized its goals: academic painters might be trained in painting historical compositions, but their professional goal was still to earn court patronage or, even better, a position as court painter – which meant they painted to please the king.

Portraiture at the Bourbon Court

Despite Meléndez's efforts as a portrait painter to the court of Philip V and his appointment as Painter to the King in May 1712, none of the painters who served the new court in the years immediately following his arrival met the expectations of their new Bourbon patrons. In a letter to the French court of 12 September 1712, Queen Marie Louise of Savoy lamented that no portraits had been sent since all those produced to date had been "so bad" (*si mauvais*), a situation that could only be remedied by finding a French painter willing to work at the Spanish court. That quest was fulfilled a decade later, when the French portraitist Jean Ranc (1674-1735) arrived in Madrid.

Ranc had achieved recognition in Paris as an academician and also as a portraitist of the aristocracy. He continued his role as a portraitist in Madrid, and spent a year from 1729 to 1730 in Lisbon, painting portraits of the Portuguese monarchy for his Spanish patrons. A comparison of Ranc's portrait of the future Carlos III (FIG. 84) with Carreño's portrait of Carlos II (see FIG. 75, page 110) attests the introduction of a new iconography for the Bourbon monarchy. The weighty mirrors and table of Carreño's

portrait are replaced in Ranc's work by the more overtly luxurious trappings of the new age: a vase of flowers sits on a gilt table that is draped with lavender velvet. Rather than merely pose in imitation of his ancestors, as does Carlos II, Ranc's young prince is momentarily interrupted from his efforts to categorize the blossoms scattered on the table before him – an intimation of the interests that led to his patronage of the Madrid Botanical Garden once he became king. Even though the scene is set in an interior, the activities of the future Carlos III imply a verdant world beyond the palace walls, in contrast to the sequestered sterility that characterized the image of Carlos II. The image is not totally lighthearted, however, as the Latin inscription of the open book reads: "May I be given fragrant flowers, garlands made with the buds of spikenard and the finest blossoms. Yet it is also right to gather the heroic deeds and glorious achievements of our forefathers."

With Ranc's death in 1735, word was immediately sent to Paris to find another portraitist to serve at the Spanish court, resulting in the arrival in 1737 of Louis-Michel van Loo (1707-71), who served Philip V and his successor, Ferdinand VI (r. 1746-59), until 1752. Having studied in Italy before arriving in Paris and Madrid, van Loo brought to his portrait *The Family of Philip V* (see FIG. 2, page 12) a grandiose stage set that has been compared with Veronese. In fact, the portrait is a curious hybrid of operatic stage-set and English conversation piece. The members of the royal family are deployed before a setting of marble and gilt columns that form an arcade opening onto formal gardens. Musicians on a balcony intimate music pervading the scene, dominated by Elizabeth Farnese at center, who looks out toward the viewer and remains seemingly unaware of the benevolent gaze of her aging husband, Philip V, seated to the left. To his left is the future Ferdinand VI, balanced by the future Carlos III on the far right. The lack of interaction among the sitters betrays the fiction of the work, a portrait comprised of individual studies brought together on a single canvas.

Ferdinand VI reigned until his premature death in 1759. Although he maintained van Loo and the Italian painter Jacopo Amigoni (1680-1752) at court and

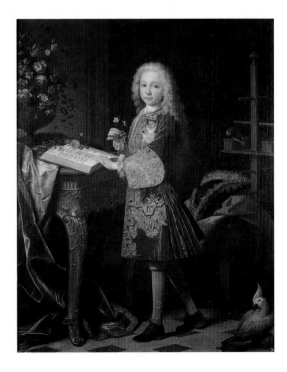

84. JEAN RANC
Carlos III, c. 1723. Oil on canvas, 4'8" x 3'9¼" (1.4 x 1.1 m), Museo del Prado, Madrid.

The sitter is the son of Philip V and his second wife, Elizabeth Farnese. Philip V would rule as king of Naples before becoming king of Spain (r. 1759-88) upon the premature death of Ferdinand VI. In Madrid, he oversaw a variety of enlightened initiatives to modernize the city, and introduced projects to enhance scientific learning – a natural history museum, a botanical garden, and an observatory.

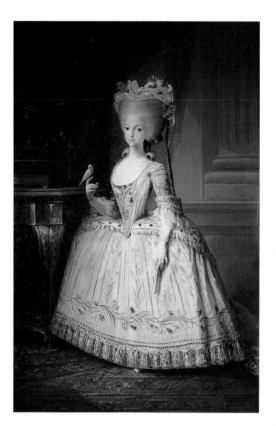

85. Mariano Maella
Retrato (Portrait) de Carlota Joaquina, 1785. Oil on canvas, 5′9¹/₂ ″ x 3′9¹/₂ ″ (1.77 x 1.16 m), Museo del Prado, Madrid.

The daughter of María Luisa and Carlos IV, Carlota Joaquina is here portrayed upon the occasion of her marriage to Juan VI of Portugal, Prince of Brazil.

gave his saintname to the Royal Academy of San Fernando, founded during his reign, Ferdinand is best remembered for the spectacular productions arranged in the opera house of the Buen Retiro by the Neapolitan castrato Carlos Broschi (1705-82), also known as Farinelli. It was apparently Farinelli who arranged an appointment at court for Amigoni, whose intended role in creating ceiling frescoes for the new royal palace in Madrid was cut short by his death in 1752. After Ferdinand's death in 1759 the decoration of the royal palace fell mainly to his successor, Carlos III.

Carlos III arrived in Spain in 1760, having reigned as king of Naples during the previous twenty-five years. His predilection for things Italian is reflected by the artists he brought to court: Anton Raphael Mengs (1728-79), a Bohemian resident in Rome, and Giambattista Tiepolo (1696-1770). Shortly after arriving at court, Mengs painted the king's new daughter-in-law, the fourteen-year-old María Luisa of Parma (FIG. 80, page 119) in a portrait usually dated to 1765, the year of her marriage to the future Carlos IV. The background of the portrait – alluding to the gardens of Aranjuez, which became the future queen's preferred residence – sets off the youthful beauty of María Luisa. Rejecting the refined accessories that surround the sitters in the portraits of Ranc and van Loo, Mengs introduced a new sobriety into portraiture, which would resonate in the works of his successors. The pastel palette, precise rendering of detail, simplicity of setting, and subtle and finished handling are traits of Mengs's style perpetuated by his Spanish followers, as seen in Mariano Maella's (1739-1819) portrait of María Luisa's daughter, the Infanta Carlota Joaquina (FIG. 85). In emulating the style of Mengs, Maella also gives it a harder edge: here, his handling of the Infanta's face becomes more linear, and the contrast of her pink, blue and white dress with the green curtain behind is far harsher than the contrasts seen in Mengs's works.

Despite its shortcomings, Maella's portrait illustrates another important aspect of court portraiture during the last decades of the eighteenth century: that it was executed by a Spanish-born artist. From 1775 onward, Italian and French painters became

increasingly rare at court, as positions and commissions were given to a younger generation of Spaniards, many of whom had trained at the Royal Academy. Members of this generation include Maella, Francisco Bayeu (1734-95) and his well-known brother-in-law, Francisco Goya (1746-1828).

The Rise of the Lesser Genres

Although seventeenth-century genre paintings by Spanish-born artists do survive, they are rare in comparison with the number of portraits and religious compositions. This rarity may in part be attributed to the little value placed upon such scenes, which, often small in scale, could easily be destroyed or lost. At court, the Habsburg monarchs seemed to have been content to get their genre scenes from Flemish artists such as Teniers the Younger (1610-90). As patron of numerous scenes painted in Madrid by the French artist Michel-Ange Houasse, Philip V perpetuated the royal taste for such northern genre scenes – small in scale, highly detailed and

86. MICHEL-ANGE HOUASSE *Tavern Scene*, 1720s. Oil on canvas, 20^1/$_2$ x 24^1/$_2$" (52 x 62 cm), Palace of the Granja, Segovia.

Although brought to the court of Madrid as a portrait painter, Houasse soon turned to a variety of other commissions, including religious works and small genre scenes that suited the new demands of interior decoration, with small private rooms, or cabinets, adorned with small paintings of light-hearted subjects.

87. MICHEL-ANGE HOUASSE
Musical Entertainment,
1720s. Oil on canvas,
20¹/₂ x 24¹/₂″ (52 x 62 cm),
Palace of the Granja,
Segovia.

Again illustrating the shift in
taste under the Habsburgs,
the room is depicted in the
latest French style with
pilasters, intricate moldings,
and a large window that
looks out onto a wood.

with multiple figures involved in daily activities. A variety of
sources and parallels might be cited for Houasse's works, rang-
ing from Dutch and Flemish genre scenes of the seventeenth
century to the works of his French contemporaries, Gillot and
Watteau. *Tavern Scene* (FIG. 86) suggests the influence of Teniers
the Younger, whose works are listed in the 1700 inventory of
the Alcázar and forty-six years later in the collection of Eliza-
beth Farnese in La Granja.

Houasse had arrived at court by about 1715, ostensibly to fill
the post of portrait painter. This role was eventually taken over
by Ranc, leaving Houasse free to paint a wide variety of sub-
jects – religious paintings, scenes of peasants, scenes of court
life, and landscapes. His work remains little known: most of his
paintings were first inventoried in La Granja in 1746, and many
have been lost or destroyed. Still today, his works decorate the
royal residences in Spain, and are rarely seen beyond the Iberian
peninsula. His paintings lack a chronology, and can only be assigned

a date corresponding to Houasse's stay in Madrid, from 1715 to 1730. More insightful than his timeless peasant scenes are Houasse's depictions of contemporary aristocratic manners. The cosmopolitan nature of the court of Madrid is conveyed in *Musical Entertainment* (FIG. 87), where men and women dressed in French fashion perform for a small audience that includes playing children and a flirting couple. Nothing in this work betrays its origin as "Spanish": its language – like that probably spoken by the courtiers portrayed – was French.

Even when he turned to such an icon of Habsburg austerity as the Escorial, Houasse transformed his subject, making the monumental building sympathetic to the nature surrounding it. In portraying the *Jardín de los frailes* ("Garden of the monks"; FIG. 88), he shows only a portion of the building's southern wall, transferring attention to the well-manicured garden and to the mountains behind. Monks look over the garden wall, admiring the view, a gardener carries jugs of water, and a man whose figure might have a fashion plate as its inspiration walks along the central path. The Escorial is brought down to human scale, transformed in Houasse's view from a royal tomb or monastery to a hospitable site for the enjoyment of nature.

The pleasures of comfortable urban life introduced in Houasse's painting also provided subject matter for painters who worked during the reign of Carlos III. Luis Paret y Alcázar (1746-99), the son of a French father and a Spanish mother, traveled to Rome in the 1760s under the patronage of the king's brother, Don Luis. He continued in Don Luis's service after his return, and even assisted in arranging encounters with women for the ostensibly celibate Infante (wrongly destined by his mother, Elizabeth Farnese, for the church). This activity won the painter exile in Puerto Rico from 1775 to 1778, after which he returned to the northern Spanish city of Bilbao. From there he sent a painting of Diogenes to the Royal Academy that won him entry in 1780. After Paret returned to Madrid in 1787, he took an active role in that institution.

Like Houasse, Paret painted a variety of subjects, including portraits, history paintings, port scenes, and scenes of contemporary life. The *Antique Dealer* (FIG. 89), listed in the collec-

88. MICHEL-ANGE HOUASSE
The Jardín de los frailes at the Escorial, 1720s.
Oil on canvas, 20 x 32¼"
(51 x 82 cm), Palacio de la Moncloa, Madrid.

Houasse painted several scenes of royal residences outside Madrid. Here he transforms the Escorial: unconcerned with its symbolism as monastery and dynastic tomb, he turns instead to a study of gardens and surrounding landscape.

89. Luis Paret y Alcázar
The Antique Dealer, c. 1773.
Oil on canvas, 19¹/₂ x
22³/₄″ (50 x 58 cm), Museo
Lázaro Galdiano, Madrid.

This scene suggests the
influence of eighteenth-
century French painting.
A possible source is
Gersaint's Shop-sign by
Antoine Watteau, which
Paret may have known
through an engraving by
Jean de Julienne.

tion of Don Luis and therefore painted before the artist's exile in 1775, ostensibly illustrates the life of an upper-class bourgeois woman in modern Madrid. At center stage, she wears the buck-led satin slippers and lace mantilla that identify her as a *petimetra* (from the French, *petit maître*), a frivolous type satirized in many comic plays of the period. Indeed, she seems far more inter-ested in the comb she considers for purchase than in the child who reaches toward her, left to the care of a nurse. An elegantly dressed man admires the *petimetra* as she in turn admires the comb, while shop assistants busy themselves among the Chinese vases, gilt-framed paintings, books, and collectibles that clutter the shop. High on the wall behind the counter, a painting of the Madonna and Child offers an ironic counterpart to the customer who ignores her maternal duties.

Limited to small canvases in the works of Houasse and Paret, everyday life would achieve a new monumentality when it served as subject matter for designs (or cartoons) to be woven as tapes-tries by the royal tapestry factory of Madrid. During the reign of Carlos III, these tapestries were needed to decorate refurbished rooms in the Pardo Palace (where the court resided annually from early January to the Sunday before Easter), and in the Escorial, used as a residence in the fall. Given the suburban nature of both palaces, their decoration could consist of themes less for-mal than the portraits and history paintings deemed suitable for

the royal palace of Madrid. Francisco Goya was probably the first painter to introduce contemporary subject matter in place of more traditional narrative subjects, and his lead was soon followed by many painters, including his brothers-in-law Francisco and Ramón (1746-93) Bayeu, as well as his contemporary José del Castillo (1737-93).

Castillo enjoyed a brilliant early career, patronized by the government to study in Rome, awarded a first-class prize by the Academy in 1756, and a second scholarship to Rome. He returned to Madrid in 1765 and was assigned by Mengs to paint cartoons for the tapestry factory. Yet his ascent was soon curtailed, to be explained perhaps by the competition from Goya, whose rapid rise in court circles must be at least partly credited to the influence of his brother-in-law and senior court painter, Francisco Bayeu. Many of Castillo's works have been lost: although an early account states that he painted more than one hundred cartoons, only thirty-seven of these are known today. The *Walk in the Retiro Park* (FIG. 90) illustrates his adaptation of contemporary subject matter to the large-scale format of tapestry cartoons. The costume and hairnets worn by the two figures in the left foreground – the man with a broad-brimmed hat and the woman kneeling before him

90. JOSÉ DEL CASTILLO
The Walk in the Retiro Park,
1779. Oil on canvas, 8'8¼"
x 11'11" (2.6 x 3.6 m),
Museo Municipal, Madrid
(on loan from the Prado
Museum).

Painted as a design for a tapestry to be woven at the Royal Tapestry Factory of Santa Bárbara, this work offers a glimpse of leisure in the Madrid of Carlos III. In the park that extended westward from the Buen Retiro palace, a cross-section of Madrid society enjoys the pleasures of nature.

– identify them as *majos*, or the flamboyant types from Madrid's lower class. They are set off against figures in French fashion with powdered wigs and elaborate coiffures, members of the leisured classes, who stroll, scrutinize the bounty of nature through a looking-glass, or admire one of the statues adorning the verdant urban park.

The views of seaports painted by Paret y Alcázar after his return from exile attest the cosmopolitan nature of painting in eighteenth-century Madrid. In 1780, the Príncipe (the future Carlos IV) commissioned from the French landscape painter Claude-Joseph Vernet (1714-89), a series of scenes to decorate a room in a small pleasure house in the grounds of the Escorial. The same prince was also a collector of topographical engravings – including Vernet's engraved works, purchased in 1774. This courtly taste for landscape, as well as the influence of Vernet's series depicting French ports (commissioned by the French king Louis XVI in 1753), may well have inspired Paret to undertake a series of port scenes after his return to Bilbao. Although Paret began painting these subjects independently, by 1786 he had received a royal commission to paint twelve scenes of Spanish ports. One of these was the *View of La Concha de San Sebastián* (FIG. 91), which shows the town in the right-hand distance, at the foot of Monte Urgell. Our perspective is that of the pleasure-seeking tourist, as we, like the depicted party on horseback, have climbed the opposite shore of the bay to get a view of the town and the beach that extends toward us.

A second instance of a painter who undertook a series of works in the hope of gaining a royal commission is offered by Luis Meléndez. Despite his auspicious beginning as a prize-winning student of the Academy, Meléndez's artistic career took a turn for the worse when his father, the painter Francisco, argued with the founding committee of the Academy: this led to the expulsion of both father and son in 1748. The young Luis traveled in Italy before returning to Madrid where, in the 1750s, he painted miniatures to decorate choir-books for the royal chapel. With the arrival in Spain of

91. LUIS PARET Y ALCÁZAR *View of La Concha de San Sebastián*, c. 1786. Oil on canvas, 32 x 47" (82 x 120 cm), Palacio de la Zarzuela, Madrid.

Paret's series of Spanish ports reflects the probable influence of Claude-Joseph Vernet, from whom the Prince of Asturias had commissioned a series of landscapes in the early 1780s. Here, the late eighteenth-century penchant for the picturesque is answered by the inclusion of peasants, cattle, and sheep that populate the hillside.

Carlos III, Meléndez solicited a position as court painter in 1760, but was refused.

It was at about this time that he undertook a series of still-life paintings in which the precise technique he had developed as a miniature painter came to maturity. By the early 1770s, he had a stock of several paintings in his studio, which he took to show the Prince and Princess of Asturias (the future Carlos IV and his consort, Maria Luisa). This resulted in a commission for paintings to decorate a "Natural History cabinet." Although that cabinet might be identified with a natural history collection then housed on the second floor of the building occupied by the Royal Academy, the paintings never reached that destination, and are listed in the 1818 inventory of the Palace of Aranjuez. The early still lifes painted by Meléndez show simple arrangements of common subjects and kitchen wares, but once he had royal backing his compositions became more elaborate. In *Still Life: Cantaloupe, Figs, a Basket, and a Leather Wine Bag* (FIG. 92), fruit is endowed with a new luxuriance, as the textures of ripened figs and split cantaloupes lying in the landscape are set off by leather, cloth, and the coarse basket.

92. LUIS MELÉNDEZ
Still life: Cantaloupe, Figs, a Basket, and a Leather Wine Bag, c. 1771.
Oil on canvas, 24³/4″ x 33″ (63 x 84 cm), Museo del Prado, Madrid.

In their sensual evocation of the tactile, the still-life paintings of Luis Meléndez present the bounty of nature to an enlightened eighteenth-century world fascinated by natural history. His works are characterized by rich color harmonies, as objects resonate the tonality of their setting, whether a wooden table or a landscape.

The Royal Academy and the Grand Tradition

The Royal Academy of Fine Arts of San Fernando was founded officially in 1752, but we know from the award of a prize to Luis Meléndez seven years earlier that it was functioning by the 1740s as arbiter of artistic taste at court. Encompassing painting, sculpture, architecture, and engraving, its goal was to elevate the quality of the arts through instruction. From the beginning, contests and prizes were intended to spur young artists to greater heights. Yet many artists who won these competitions are today unknown to us, whereas Goya competed unsuccessfully in 1763 and 1766. The academic career of young painters was continually hindered by the great number of students and inadequate facilities – of which several professors complained. If a student did advance there was little chance of finding patronage outside the court.

Within the Academy, the highest level of painting competition involved the conceptualization and execution of an assigned subject, usually drawn from Spanish history, the Old Testament of the Bible, or mythology. The *Tyranny of Gerion* (FIG. 93), submitted in 1758 by the twenty-four-year-old Francisco Bayeu, is a competition piece showing the cruelty of the Spanish king as related in Padre Mariana's *History of Spain* (1592-1601), the text of which is cited at the lower margin of the work. According to an account that Bayeu subsequently offered, he submitted the work from Saragossa. In spite of a pastel palette that seems at odds with its theme of cruelty, when Bayeu's painting was seen by other artists upon its arrival in Madrid in 1758, they judged

93. FRANCISCO BAYEU
The Tyranny of Gerion,
1758. Oil on copper,
16¹/₂ x 24³/₄" (42 x 63 cm),
Museo de la Real Academia
de San Fernando, Madrid.

The historical subject of this work typifies the kind of topic assigned in the competitions sponsored by the Royal Academy. Yet academically trained history painters found little demand for such compositions outside the Academy competitions.

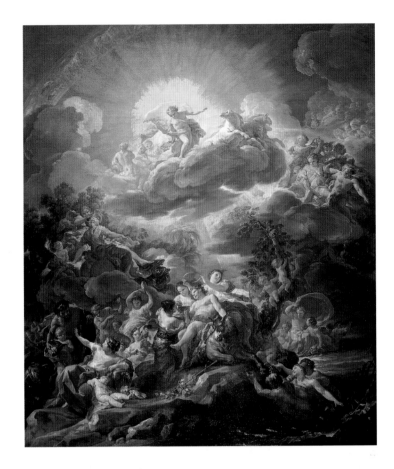

94. CORRADO GIAQUINTO
*Sketch for The Birth of the
Sun and the Triumph of
Bacchus*, c. 1760.
Oil on canvas, 5'6" x 4'7"
(1.68 x 1.4 m), Museo del
Prado, Madrid.

In this sketch for a ceiling
fresco for the newly built
royal palace of Madrid,
Apollo rises on a golden
cloud against a halo of light
and surrounded by signs of
the zodiac. He is contrasted
with the more earthly
deities cavorting below,
including Mars, Venus, and
Diana, who celebrate the
pleasures of Bacchus.

it so superior to their own efforts that they chose not to compete.
By default, Bayeu won a pension to study at the Academy.

Bayeu's subsequent career illustrates the gap between his
academic training and the opportunities for recognized artists. His
career at court, which spanned four decades until his death in 1795,
entailed painting allegorical frescoes for ceilings in the royal palace,
religious subjects, and even tapestry cartoons illustrating scenes of
contemporary life in Madrid. The limits of patronage distin-
guish eighteenth-century Spain from France, where the king com-
missioned paintings of secular history, and where artists vied for
public recognition in the Salon. In Spain, it was not until the 1790s
that the Academy began to sponsor annual exhibitions: then, with-
out a cultivated public, or a tradition of art criticism, there was
little response to this initiative. The sparse surviving documen-
tation for these exhibitions – manuscript lists of exhibited works
– suggests that few artists took them seriously. Although Goya
exhibited regularly, most other exhibitors were students or ama-
teurs, whose work is today unknown. Well into the 1830s, aes-

95. ANTON RAPHAEL MENGS
Sketch for Aurora, c. 1764.
Oil on canvas, 38 x 38"
(98 x 98 cm), Private
Collection.

Dawn in her chariot,
surrounded by a variety
of allegorical figures whose
relation to the main action
is not clear, expels the
fleeing figure of Night.
With its clear delineation
of figures and controlled
illusionism, Mengs's fresco
marks a turn from the more
open and coloristic style of
Luca Giordano and Corrado
Giaquinto, the Italians who
had preceded him at court.

thetes complain of the low quality of exhibited works, and of the need for a more selective inclusion.

During the 1760s, a talented painter would probably be recruited for a major undertaking already under way: painting allegorical frescoes to decorate the grand rooms of the newly finished royal palace. During the previous decade, the Neapolitan painter Corrado Giaquinto (1703–66) had been invited to Spain to take up this project after Amigoni's death in 1752. He completed three frescoes for the royal palace, including that for the Salón de Columnas (Hall of Columns) depicting the Birth of the Sun and the Triumph of Bacchus. A sketch (FIG. 94) shows Giaquinto's colorism and painterly handling. Apollo is portrayed as the Sun God, reiterating a theme represented by the exterior sculptural program of the palace, derived from Ovid's description of the "Palace of the Sun" in Book II of his *Metamorphoses*.

In 1761, Mengs arrived at the Spanish court, as previously noted, having negotiated for himself the title of first Court Painter. This title still belonged to Giaquinto, and even though the Neapolitan painter left Madrid in 1762 because of ill-health, Mengs had to wait until Giaquinto died in 1766 before assuming the title. Mengs's duties at the Spanish court were varied, encompassing portraiture, fresco decoration, and religious paintings, which seemed especially to appeal to Carlos III. He also supervised the production of the royal tapestry factory. A sketch for the fresco *Aurora* (FIG. 95), intended to decorate a compartment in the rooms of the queen, Maria Amalia of Saxony (who died before inhabiting them), illustrates Mengs's style. Although less rigid in composition than Mengs's well-known fresco *Parnassus* in the Villa Albani in Rome, the sketch is still highly classical in its emphasis on clearly delineated human figures perched on lithic clouds. This classical orientation in ceiling decoration was continued to the end of the century by Mengs's Spanish followers Francisco Bayeu and Mariano Maella, who became the leading painters for the royal residences and pleasure houses.

Mengs's influence may also be detected in Bayeu's 1764 ceiling depiction of the *Fall of the Giants* (FIG. 96), painted for an antechamber in the suite of rooms occupied by the Prince and Princess of Asturias. The subject is the rebellion of the Titans against Jupiter and the gods on Olympus, suppressed with the aid of Hercules. As a subject for the royal palace, it perhaps alludes to the consequences to be expected by those who rise up against right-

ful authority. There is a new emphasis on the weighty and muscular human forms that occupy the borders of the composition. The deployment of the figures along the periphery, inspired by Mengs, became a common trait of the frescoes painted for the royal residences during the final decades of the eighteenth century, and undermines the Baroque opening of space still present in Giaquinto's *Birth of the Sun*.

Historical accounts of Mengs's rivalry with Giambattista Tiepolo (1692-1770), who arrived in Madrid in 1762, have been exaggerated. There was little reason for rivalry, since Mengs came to fulfill the role of first Court Painter, while Tiepolo came to court to paint a single fresco for the throne room of the royal palace. Upon completion of that commission he was assigned two other rooms, the Saleta (Small Hall) and the Guard Room. Tiepolo's accomplishment in the throne room is difficult to judge, given the vastness of the room and difficulty of viewing his fresco, which because of its unwieldy proportions is usually represented only by a preliminary sketch (in the National Gallery of Art, Washington, D.C.). Perhaps the most compositionally accomplished fresco of the three executed by Tiepolo is that of the Saleta, the *Apotheosis of the Spanish Monarchy* (FIG. 97). The airiness and lightness of Tiepolo's conception is notable in contrast with the style of Mengs and his followers. Two sketches for the project show that the inclusion of the almost nude figure of Apollo, standing to the upper right of Spain, was an afterthought – perhaps requested by the king. The inclusion of the heroic and idealized god harks

96. FRANCISCO BAYEU
Sketch for the Fall of the Giants, 1764. Oil on canvas, 24½" x 25" (62 x 63 cm), Museo del Prado, Madrid.

The influence of Mengs is suggested by this sketch, in which Bayeu uses a far more classicizing style than that seen in the *Tyranny of Gerion*, painted six years earlier.

back to the imagery of Giaquinto's fresco, and to the exterior sculptural program of the palace.

The meaning of the palace frescos was soon lost. In the mid-1770s, Antonio Ponz (1725-92), secretary of the Royal Academy, referred to them in the description of the royal palace included in his *Journey in Spain* (*Viaje de España*). He complained that they remained enigmatic to most viewers: although their general theme was the glory of the Spanish monarchy, the meaning of the various figures remained unclear. We might ask if all the figures in these compositions had a precise role, or if the artist subordinated thematic coherency to the demands of the vast spaces of the palace ceilings, filling them with figures extraneous to the theme at hand.

In an address offered to the Royal Academy in 1781, the writer and reforming politician Gaspar Melchor de Jovellanos (1744-1811) took as his theme the history of the arts in Spain. Starting with the art of antiquity, Jovellanos praised the accomplishment of Velázquez above all others, saving second place for Murillo. In his opinion, the glorious age of Spanish painting ended with the arrival of Luca Giordano, whose works betrayed an affectation and artifice at odds with the naturalism inherent in the works of Spain's greatest painters. Jovellanos criticized the tastes of modern patrons, who encouraged a fashionable triviality at the expense of artistic glory. The only artist he mentioned after Giordano is Mengs, whom he considered essential to the revival of the arts in Spain.

Jovellanos's condemnation of the eighteenth century is echoed in art historical tradition, that usually jumps from Carreño to Goya. Such exclusion of the foreign artists working at the court of Madrid from the canon of Spanish painting leaves us with a very selective notion of painting in Spain. Like the Habsburgs before them, the Bourbon dynasty in Spain in fact sought art of the highest quality, bringing well-reputed artists to Spain to work on a variety of projects. That these artists were not born in Spain seems secondary. Rather than being associated with the demise of painting in Spain, the eighteenth-century Bourbons might well be credited with its survival, since the artists they brought to court introduced new ideas that inspired Spanish-born artists who worked later in the century. After 1750, foreign artists such as Giaquinto, Mengs, and Tiepolo either taught Spanish-born painters or, in the case of Tiepolo, offered models for a younger generation of Spanish-born artists.

Among those younger artists was Francisco Goya y Lucientes (1746-1828), whose œuvre must be understood in the light of the accomplishments of his predecessors at the Bourbon court.

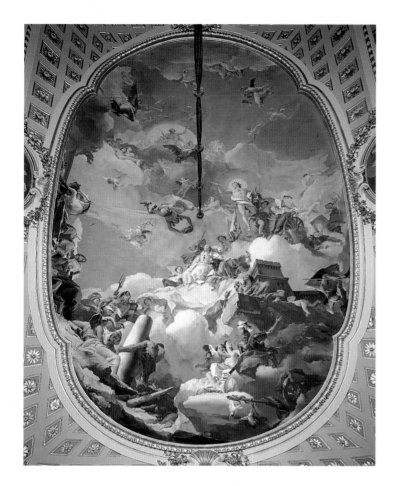

97. GIAMBATTISTA TIEPOLO
The Apotheosis of the Spanish Monarchy, 1764. Fresco, Saleta, Royal Palace, Madrid.

Jupiter and his eagle preside over the scene opening beneath them, as Mercury flies in to crown the personification of the Spanish monarchy, hailed by trumpeting figures of fame, and accompanied by Neptune and Hercules in the lower left.

Aspiring to a position at court, Goya aimed at proving his capacity to paint a variety of subjects in a wide range of media: portraits, genre scenes, history paintings, and religious subjects, created in media ranging from oil on canvas and oil on copper, to fresco. There is no space here to offer a detailed analysis of Goya's sources, but the parallels between his genre scenes and those of Houasse, and between his early portraits and the tradition of Mengs cannot be denied. It may well have been the etchings of Tiepolo that inspired Goya's essay in the medium. His efforts were rewarded ultimately with the position of first Court Painter, granted to him in 1799 by Carlos IV.

Goya's art also marked an alternative to the world of the court artist: during the later part of his career he began to experiment in drawings, etchings and small paintings, depicting subjects for which, in his own words, there was no place in commissioned works. It is this experimental aspect of Goya's art that has led many to consider him as the first of the moderns.

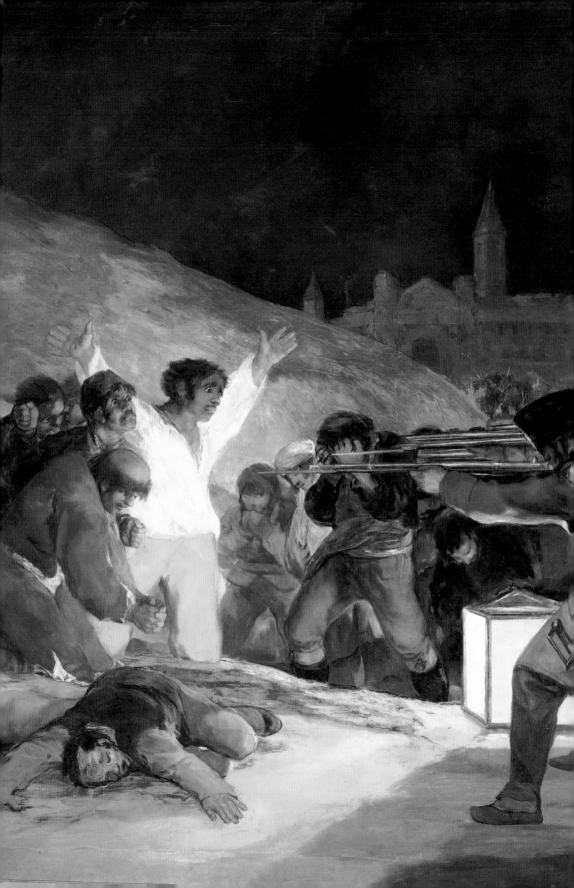

Goya's Modernity

A recent study of the "pictorial intelligence" of Tiepolo cites a common comparison of the Venetian painter with Francisco Goya. The comparison, the study says, tends to oversimplify Tiepolo, who is "cast in the role of the old-time believer in heavenly illusions that are no longer supportable by Goya, the representative of a new modern world." The analysis of Tiepolo's paintings that is the book's main subject shows us how wrong such an oversimplification can be.

But oversimplification works both ways. Tiepolo is not the embodiment of an old-world visual innocence. But neither does Goya mark the sudden beginning of the modern fall from grace. If Goya is presented as the first modern, he has also been considered as the last of the "Old Masters." Although popularly equated with the peculiarity of the *Naked Maja* (see FIG. 106), the fatalism of the *Second of May 1808* (see FIG. 109), or the weirdness of the late "black" paintings (see FIGS 115-117), Goya's art is in fact far more complex. To study his oeuvre, comprising almost 2000 paintings, drawings, engravings, and lithographs, is to examine one artist's evolution from a style conventionally considered late Baroque to the "modern."

What do we mean in using the term "modern" in relation to Goya? To an age of art history in which modern begins with Manet, Goya's modernity has been identified, in hindsight, with two traits of his painting which critics of Manet's day consid-

98. FRANCISCO GOYA
The Third of May, 1808
(detail), 1814. Oil on
canvas, 8'9¹/₂" x 11'4¹/₂"
(2.7 x 3.5 m), Museo del
Prado, Madrid.

ered as sources for the French painter. These are his portrayal of everyday subjects – from bullfights to Spanish ladies with *mantillas* (lace veils) – and his broad application of paint. Although this orthodoxy is still taught in many courses on nineteenth-century painting, it is difficult to substantiate. As Houasse shows us, everyday subjects were hardly new with Goya, and as for his application of paint, examination of his works reveals that it was carefully nuanced, artfully blended, very different from Manet's boldness of touch. For these reasons, Goya's modernity will here be defined by considering his work as a reaction to the preceding traditions, which entailed both a departure from traditional pictorial narrative and the creation of meaning through the reformulation of specific images.

Goya, Tapestry Painter

Goya's concern with narrative is apparent in the earliest paintings executed after his arrival in Madrid from his native Saragossa in 1775. Apparently through the connections of his new brother-in-law, the court painter Francisco Bayeu, Goya began painting cartoons for the royal tapestry factory of Santa Bárbara. The tapestry cartoons were commissioned as groups of scenes intended to decorate a single room: the appropriate measurements were given to the painters, who then did preliminary sketches to be submitted for the patron's initial approval. Until Goya's day, artists

99. FRANCISCO GOYA
The Blind Guitarist, 1778.
Oil on canvas, 8'6¼" x
10'2½" (2.6 x 3.1 m),
Museo del Prado, Madrid.

Taking full advantage of the large scale required, Goya here sets the stage for the smaller scenes to follow, introducing a cast that includes characters from all levels of Madrid society.

100. Francisco Goya
The Fair of Madrid, 1778.
Oil on canvas, 8'5¹/₂" x
7'1³/₄" (2.6 x 2.2 m),
Museo del Prado, Madrid.

Painted for the Prince and
Princess of Asturias, to
be woven as tapestries to
adorn their rooms in the
Pardo or Escorial palaces,
Goya's tableaux of popular
pastimes and street life in
Madrid offered his patrons
a glimpse of a world from
which they were excluded
by court etiquette.

had painted cartoons illustrating a series of events from a single story, or a common theme, such as the four seasons. A painter like Houasse created scenes with a generic similarity defined by pastoral, peasant, or aristocratic subject matter. But Goya rethought this model, choosing as his subject matter contemporary life in late eighteenth-century Madrid, and juxtaposing scenes to give us a view that incorporates characters from all classes, and even from other regions and countries.

One theme, developed for a series of tapestries to decorate the bedchamber of the Prince and Princess of Asturias, was the annual September fair of Madrid. The stage is set with a scene of a blind guitarist (FIG. 99), a common figure on Madrid streets, who sang ballads often narrating recent events. In his invoice for this cartoon, Goya identified its characters, some of whom recur in the paintings of Castillo and Paret. They include men of the lower classes (known as *majos*), identified by their dark capes; their female counterparts, or *majas*, wearing mantillas and brightly colored costumes; the richly dressed man with

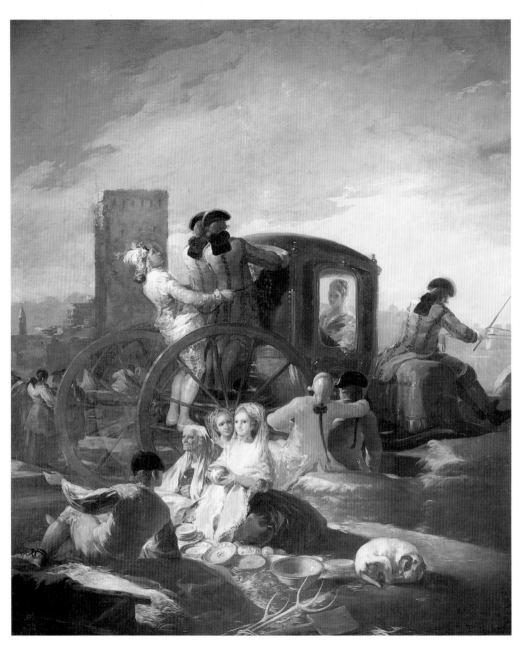

101. Francisco Goya
The Crockery Vendor, 1778. Oil on canvas, 8'6"
x 7'2¹/₂" (2.6 x 2.2 m), Museo del Prado, Madrid.

hand in coat (identified in Goya's invoice as a foreigner); the black waterseller; and behind, the fruitseller.

Once the stage is set, Goya looks more closely at particular interactions. *The Fair of Madrid* (FIG. 100) shows a well-to-do man (a possible companion to the foreigner listening to the blind guitarist) beseeched by a seller of second-hand wares. To one side stands a *petimetra* (a frivolous type, according to the common satire) reminiscent of the woman in Paret's *Antique Dealer* (see FIG. 89, page 128); to the other side is an elegantly dressed fop who seems to look through his monocle at the portrait hung high on the dealer's stand. Behind, we see the crowd of *majos* in their dark capes, and in the distance, the dome of San Francisco el Grande, a church recently built in Madrid under royal patronage.

In the complementary *Crockery Vendor* (FIG. 101), women no longer have the pretenses of the *petimetra*, but sit on the ground with the Valencian (identified by his loose white pants and rope-soled shoes) who attempts to sell them his glazed earthenware. But a closer look at the interaction suggests that the vendor might be making other overtures to his pretty customer, as he points off-stage and she follows the direction of his gesture. Such flirtation between seller and customer would not be tolerated by the

102. FRANCISCO GOYA *The Wedding*, 1791-92. Oil on canvas, 8′9″ x 9′7¹/₄″ (2.6 x 2.9 m), Museo del Prado, Madrid.

In this scene, which presents a marriage for financial interest rather than for love, Goya implies a cynicism about the relationship between the sexes that was to be more fully developed in the etchings of *Los Caprichos*.

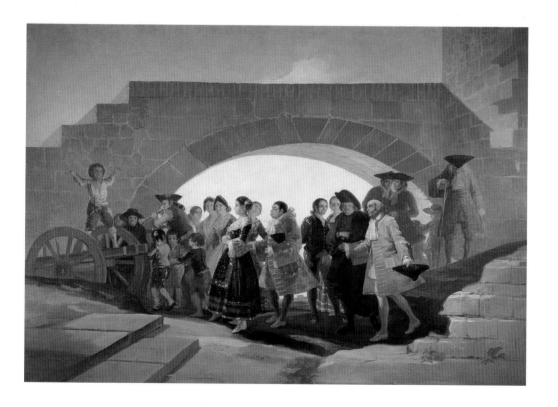

more genteel clientele of the *Fair of Madrid*, and suggests a certain overt promiscuity to be identified with the lower classes. The class of the crockery vendor's customers is emphasized by juxtaposition (within the cartoon) to the woman who rides behind, enframed in the window of a well-appointed carriage, and admired by two men whose dress suggests their bourgeois status.

Each of these images might stand independently as a separate scene within an overall theme of the fair of Madrid. However, juxtaposition to the other five scenes of the series greatly enhances their individual narrative. Goya thinks beyond the single frame, and even at this early point in his career conceives narrative in terms of the multi-imaged series. This, of course, had been done before: we might think of an eighteenth-century precedent in such series as the English artist William Hogarth's (1697-1764) *Rake's Progress* or *Marriage á la Mode*. But in contrast to Hogarth's series, Goya's tapestry series do not follow a specific temporal sequence: Goya offers a kaleidoscopic view of Madrid life, recreated for his royal patrons.

Goya continued to paint tapestries until 1792, when he suffered a severe illness that weakened him and left him deaf for life. In the two years preceding this illness, he had already expressed his dissatisfaction with the lowly assignment of painting tapestries. Having been appointed court painter in 1789, and having established himself as a portraitist of Madrid society during the 1780s, he clearly thought that he deserved more respectable commissions, such as portraits or history painting. Perhaps as a result of his disappointment, the last tapestry cartoons he painted imply a more cynical outlook than expressed in his earlier fair scenes.

An emergent theme is the insincere relations between sexes. The *Wedding* (FIG. 102) features an apparently well-to-do groom, whose facial features might suggest his mixed race. A possible conclusion is that this *mestizo* (that is, a person of mixed race) has returned from the New World to his ancestral village, where his wealth buys him a pretty bride. Who is the beneficiary of such arrangements? This is hard to tell, for although we might think that the bride here is sacrificed, golden-age literature offers models of the pretty young bride who betrays her less than desirable husband. The vanity of their preoccupations are emphasized as both form part of a procession from youth (represented by the children on the left) to old age, that inevitably leads to death. This allusion is clearly intended, since Goya's arched bridge finds a source in popular prints illustrating the ten ages of man that often feature beneath the arch a scene illustrating the day of judgment.

103. FRANCISCO GOYA
Sueno 1 (*First Dream*),
1797. Pen and sepia ink,
9³/₄ x 6³/₄" (24.7 x 17.2 cm),
Museo del Prado, Madrid.

Goya's caption to this
preliminary drawing for
the *Caprichos* series'
frontispiece proclaims his
original intent: "The author
dreaming. His only
intention is to undermine
prejudicial vulgarities and
to perpetuate with this
work of caprice, the solid
testimony of the truth."

Los Caprichos

In late 1792, Goya suffered a serious illness that left him deaf
for life, which has often been seen as a turning point in his career.
His personal correspondence and contemporary documents show
that he was seriously weakened by this illness, and clearly inca-
pable of executing large-scale tapestry cartoons. Although after
1793, he would resume his work as a portrait painter of Madrid's
elite, he turned simultaneously to smaller works, paintings, draw-
ings, and eventually etchings. In a letter to the Vice-Protector
of the Royal Academy of January 1794, he writes how such uncom-
missioned works gave him ground for new experimentation –
as illustrated by a series of small paintings that he submitted

104. FRANCISCO GOYA
*Que sacrificio! (What a
Sacrifice!)*, Plate 14 of
Los Caprichos, c. 1797.
Etching with aquatint,
8 x 6" (20.1 x 15.1 cm),
British Museum, London.

Although this image might
invite us to sympathize
with the young woman, the
caption of a preliminary
drawing suggests her plight
is not so dire as it appears:
" ... they are young gentle-
men each richer than the
other and the poor girl
doesn't know which to
choose."

with the letter to the Academy, including *Strolling Players* (today
in the Prado).

These uncommissioned works apparently found buyers, for he
continued to paint smaller works for the rest of his life. In addi-
tion to these paintings, he began to execute highly finished draw-
ings that would eventually form eight albums, executed from
the mid-1790s until his death in 1828. But perhaps the most famous
testimony of this experimentation is Goya's first series of etchings
published in 1799, and described in a newspaper advertisement
of that year as showing "capricious subjects." In this series of eighty
aquatint etchings, Goya introduces the fantastic themes that he
had developed in drawings of the mid-1790s, clearly thinking that
he would find a market for the images reproduced as multiples.
These etchings, probably undertaken around 1796, reveal Goya's

interest in an interplay of multiple and often seemingly disparate themes that justifies the title of *Los Caprichos* ("The Caprices") by which the work has become universally known.

The first subjects developed by Goya for the series seem to have been scenes of social satire and witchcraft, both of which serve as models of superstitious and unenlightened behavior (FIG. 103). Originally, the intention of these etchings was to teach through negative example: by satirizing imagined witches or social foibles, they warned the enlightened reader what to avoid. *Que Sacrificio* (*What a Sacrifice!*; FIG. 104), plate 14 of the published series, picks up the theme of relationships between the sexes introduced in Goya's last tapestry cartoons. Again, a young lady is ogled by prospective undesirable suitors, inspiring the viewer with pity for her plight. Yet according to contemporary satires, young women often married only to find a new freedom that allowed them to go without a chaperone and enjoy the company of a male escort other than their husband. In light of this, we sense the irony of Goya's title, an irony underscored by the melodramatic exclamation point.

The variety of themes and characters introduced in *Los Caprichos* – from pretty young things to witches – and their highly experimental variations in technique test the limits of what a "series" might be. That breadth of technique is seen by comparing *Que Sacrificio*, with its very linear rendering, with *Buen Viage* (FIG. 105), which differs radically not only in subject but also in the use of a dark, granular aquatint that creates the illusion of goblins in flight, glimpsed as they emerge into moonlight. Goya's will to explore new paths, seen first in the uncommissioned works of the 1790s, soon infused his commissioned paintings with a newly confident sense of experimentation.

105. FRANCISCO GOYA *Buen viage!* (*Bon Voyage!*), Plate 64 of *Los Caprichos*, c. 1798. Etching with aquatint, 8¹/₂ x 6″ (21.8 x 15.2 cm), British Museum, London.

With its reliance on a granular aquatint burnished to suggests volumes and highlights, this etching proves the mastery of the aquatint technique that Goya had acquired in the process of etching *Los Caprichos*.

Traditions Revisited

An example of Goya's experimentation with traditional subjects is offered by the *Naked Maja* (FIG. 106), apparently painted as he was working on *Los Caprichos*, and inventoried in the collection of the queen's favorite, Manuel Godoy, in 1800. Godoy, who began his career as a member of the royal guard, soon rose to the position of royal favorite, and was appointed prime minister in 1792. Although he would relinquish this position six years later, he remained a close confidant of the monarchs, and a powerful – and fairly progressive – figure in Spanish government. As court painter (and after October 1799, as first Court Painter), Goya painted several works for Godoy before the favorite's final downfall in 1808, brought about by an angry mob that viewed Godoy as an evil influence on the Spanish monarchy.

106. FRANCISCO GOYA
Naked Maja, c. 1796-1800.
Oil on canvas, 38" x 7'2¾"
(97 x 190 cm), Museo del
Prado, Madrid.

Inventoried in Godoy's
collection in 1800, this
painting was probably
commissioned by the royal
favorite to complement the
collection of paintings of
female nudes that hung in
a separate cabinet within
his palace.

The *Naked Maja* hung in a special cabinet in Godoy's collection apparently reserved for paintings of nudes: the star of the collection was undoubtedly the *Venus and Cupid* by Velázquez (see FIG. 68, page 99). In many ways, Goya seems to paint against Velázquez, intentionally opposing the subtlety of his elegant nude. Although placed deep in the pictorial space and thus removed from the viewer, the *Naked Maja* confronts us with a straightforward gaze that broaches the distance created. The contact between Goya's nude and the viewer is not through touch, but through the nude's confrontational gaze. Velázquez's form is elongated and curvaceous; Goya's is awkward and angular. If Velázquez's nude is satin, Goya's approaches stone. Other paintings by Goya of reclining

women (such as those in the National Gallery of Ireland or in the MacCrohan Collection, Madrid) suggest that Goya was capable of painting a nude much more in character with that by Velázquez, but that he wanted to emphasize the difference that becomes so apparent in comparing the works. Why? One explanation is that he wanted to create an image of the modern nude. For, by the late eighteenth century, contemporary commentators were lamenting that the fashionable woman had rejected the shy, reclusive, and modest character of her grandmother: they remarked upon her confrontational quality, identified as *marcialidad*. This trait defines Goya's nude as indisputably modern.

Goya further enriched the *Naked Maja* by creating a pendant, today known as the *Clothed Maja* (FIG. 107). The original manner in which these paintings were hung is not known: according to one nineteenth-century account, the *Clothed Maja* hung over the *Naked Maja*, covering it but allowing the owner to reveal the *Naked Maja* with the pull of a cord. It is thus possible that the paintings were meant to be seen in succession, rather than side by side as they are today in the Prado Museum. This would help to explain the inconsistency in scale, as the *Clothed Maja* seems to press boldly against the confines of her frame. Ironically, the brazen and made-up clothed *maja* makes the naked *maja* seem timid in comparison. Her presence also makes it clear that the *Naked Maja* is not a mythological Venus, but a woman without clothes. Those clothes define her modernity, and possibly her marginalized position in society, since the 1808 inventory of Godoy's collection identifies her as a "gypsy" – only seven years later, when

107. FRANCISCO GOYA *Clothed Maja*, c. 1805. Oil on canvas, 37½ x 7'2¾" (95 x 190 cm), Museo del Prado, Madrid.

The more highly keyed color of this painting, its looser handling, as well as the fact that it was not included in the inventory of 1800 where the *Naked Maja* is first mentioned, suggests that it was painted five to ten years after its pendant. It was inventoried in Godoy's collection by 1808.

the canvas was sequestered by a renewed Inquisition, was she identified as a *maja*.

Another painting to proclaim its contemporaneity by contrast to its model is the *Family of Carlos IV* (FIG. 108) painted in 1800, the year after Goya attained the highest rank at court, first Court Painter. Three figures are emphasized: Queen María Luisa stands at center; Ferdinand, the crown prince and future King Ferdinand VII of Spain, stands on the left in a blue suit, and the king Carlos IV on the right. Although a formal portrait, the scene betrays a familiar intimacy as the queen María Luisa holds the hand of her youngest child, and the family gathers in an unidentified room of the palace. In this, the scene departs from the ostentation seen in Louis-Michel van Loo's portrait of the family of Carlos IV's grandfather, Philip V, almost sixty years earlier (see FIG. 2, page 12). If a model is to be found, it is Velázquez's *Las Meninas* (see FIG. 70, page 103).

Why did Goya choose to look to Velázquez? At first, the choice seems natural – one Spanish painter looking back to another. But for Goya, the choice was not so obvious. By 1800, the concept of "Spanish" painting, and the history of painting in Spain, was only beginning to be defined. Painting for Bourbon monarchs, Goya may well have turned to the tradition of Bourbon portraiture illustrated by van Loo's *Family of Philip V*. One reason for which he chose Velázquez may have to do with the tumultuous politics in Spain in 1800, and indeed of the whole era. It was eleven years after the French Revolution – the fall of the Bastille in Paris – and seven years after the king of France, Louis XVI – cousin to Spain's Carlos IV – met his end at the guillotine. The Bourbon monarchy was no longer French, for in France, the general Napoleon Bonaparte (1769-1821) had assumed power as first Consul in 1799. It was time for the Spanish Bourbon monarchy to define its unique image – and this image was to be purely "Spanish" – without van Loo's cosmopolitan trappings.

Although the general positioning of his sitters and the inclusion of his own self-portrait standing before an easel in the murky left-hand background are clearly indebted to Velázquez, Goya transforms his model. In *Las Meninas*, Velázquez implies a narrative of servants waiting on the princess, of the king and queen standing in (or possibly entering into) the room, of the artist painting. In contrast, narrative is denied by Goya. There is no story told here: this is a painting of people posing. This might suggest that the theme is the artist painting, but this is hard to support, given his relegation to the murky shadows. In contrast to Velázquez, Goya does not wish to paint a perspectival *tour de force* or nar-

rative conundrum: he paints a modern group portrait.

Coronation robes and ermine are absent in this revolutionary age, where the fashionably dressed family is identified as royal only by the decorations and orders worn by its members. It shows the monarchy modernized, steadfast in familial strength, even in these troubled times. It is also an idealized image of familial solidarity, since the young Ferdinand forced his parents to abdicate eight years later, to become himself king of Spain in March 1808. Ferdinand's power, however, was shortlived. Two months later his parents, their favorite Manuel Godoy, and Ferdinand himself joined Napoleon in the southern French town of Bayonne. There Ferdinand was invited to abdicate in favor of his parents, who in turn handed the crown to Napoleon. Napoleon proclaimed his brother, Joseph Bonaparte (1768–1844), king of Spain.

As the remaining members of the royal family were about to be escorted from Madrid, the populace rose in rebellion on 2 May 1808. The insurrection against the French forces began at the royal palace, but soon spread throughout the city. Records from

108. FRANCISCO GOYA
The Family of Carlos IV,
1800-01. Oil on canvas,
9′2″ x 11′ (2.8 x 3.3 m),
Museo del Prado, Madrid.

Although this portrait has been interpreted as a satire of the royal family, there is no reason to believe that Goya, recently promoted to First Court Painter, would intentionally make fun of his most important patrons.

1808 suggest that the insurgents were from the lowest levels of the town's population, and may even have included prisoners escaped from the city jail. Their rebellion was put down by the combined efforts of French soldiers and the Madrid police. Yet historical memory transformed this event, that within two years was seen by Spanish patriots as the call to rise up against Napoleonic oppression. The rabble insurgents were soon celebrated as national heroes – and 2 May was celebrated annually in Spanish towns not yet occupied by the French. The War of Independence against Napoleon continued until 1813, when Spanish forces, ably assisted by the English under the Duke of Wellington, expelled the French. Ferdinand VII, who had spent the war in comfortable exile in France, returned in May 1814 to assume the Spanish throne.

In March of that year, three months before the return of the monarch, Goya offered his services to the interim government "to perpetuate with his brush the most notable and heroic actions or scenes of our glorious insurrection against the tyrant of Europe." He was awarded a monthly stipend as well as funds to cover the cost of materials. No other documents survive to explain the origin of two of Goya's most famous paintings: the *Second of May* and the *Third of May, 1808* (FIGS. 109 and 110). They are next mentioned in storage at the Royal Museum twenty years later in 1834. Unless evidence of their original function comes to light, any assumptions remain highly conjectural.

With the pairing of these works, Goya again goes beyond the single frame to create a narrative. The *Second of May* shows

109. Francisco Goya
The Second of May, 1808, 1814. Oil on canvas, 8′9¹/₂″ x 11′4¹/₂″ (2.7 x 3.5 m), Museo del Prado, Madrid.

Painted six years after the event, Goya's paintings of the *Second* and *Third of May* commemorate an uprising that marked the beginning of open resistance to the French forces occupying Madrid.

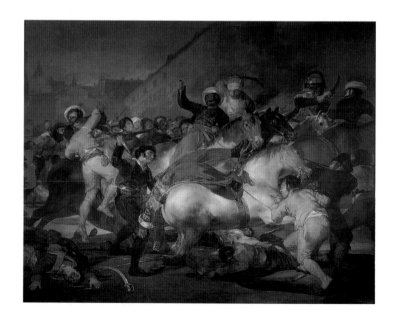

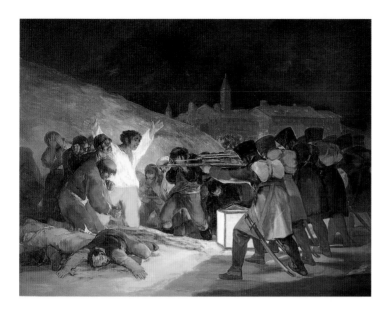

110. FRANCISCO GOYA
The Third of May, 1808,
1814. Oil on canvas,
8′9¹/₂″ x 11′4¹/₂″ (2.7 x
3.5 m), Museo del Prado,
Madrid.

The original function of this image, and of the *Second of May* is unknown. A plausible suggestion is that they were intended to decorate a triumphal arch erected to celebrate Ferdinand VII's return to Madrid; another possiblity is that they hung as decorations when 2 May was finally celebrated in a liberated Madrid in 1814.

the uprising against Napoleon's forces – French soldiers as well as Mamluk mercenaries (originally members of a Turkish military caste who had ruled Egypt prior to Napoleon's 1798 conquest) are on horseback against the disadvantaged Spanish patriots. An interesting detail is the emphasis that Goya places on the Mamluks. Other representations of the event might include one or two such figures, but they do not dominate. Perhaps Goya refers to tradition in order to convey the atrocity of the event, as his melee undoes the archetypal image of righteous conquest, *St. James at the Battle of Clavijo* (see FIG. 36, page 62). As seen in Ribalta's image (and also in a version by Carreño), the white-skinned St. James triumphs over the turbaned Moors. In contrast, Goya's *Second of May* turns this image on its head and it is now the Moor who seems to have the upper hand. This inversion of the traditional imagery of the victorious St. James may well have appealed to an early nineteenth-century Spaniard as a travesty against all that is right, and perhaps even have awakened deep-seated prejudices against the Moors. Such insinuations endowed the image with a power perhaps lost on the modern viewer.

Popularization of 2 May 1808 transformed the uprising into a struggle of patriots versus foreign invaders. That clear, binary opposition is beautifully distilled in Goya's painting of the *Third of May*, which shows the executions that took place during the early morning of the day following the uprising. In contrast to the confusion of the *Second of May*, stillness reigns, as the black sky weighs down on the scene, and the small hill in the

left-hand middle-distance blocks any route of escape. The dominant tones of grays and browns, relieved only by the spilled red blood and the bright white and yellow worn by the figure with arms spread, emphasize the grimness of the event. As in the *Second of May*, the appeal to traditional religious imagery express-es the triumph of evil: the figure with open arms shows the stig-mata in his hands, clarifying his role as a modern Christ-like mar-tyr sacrificed for a greater glory, the salvation of the Spanish people.

Restoration and Exile

In the *Family of Carlos IV*, the *Naked Maja*, and the *Second* and *Third of May*, Goya refers to tradition only to undo it: the result is the creation of an image – of royalty, or of womanhood, or of atrocity – that stakes its own claim within tradition. In the years following the Napoleonic Wars, the appeal to tradition became less evident, or disappeared altogether in a break that might itself parallel the death of the old world order often identified with the French Revolution. Although the monarchy was restored in Spain in 1814, its power was never fully regained. Deviating from the liberal course expected of him, Ferdinand VII depend-ed on specific conservative factions to maintain his power: these were the Church, the Inquisition, and the xenophobic masses, who blamed the nefarious influence of foreign, especially French, Enlight-enment for the tragedy of the Napoleonic Wars.

It is often assumed that the author of the enlightened *Capri-chos* and portraitist of progressive politicians could only abhor the restored regime. In fact, it is difficult to say what Goya's feel-ings towards Ferdinand VII were: he certainly kept them to himself, since he was restored to his position as court painter, and continued to collect a regular salary and even a pension after his retirement in 1826. But if he did not express a great animosity toward the king, the deterioration he sensed in the soci-ety around him apparently inspired a series of four paintings: *Tri-bunal of the Inquisition, Procession, Bullfight in a Village*, and the *Madhouse* (FIGS 4 and 111-113).

Although their subjects seem disparate, their similarity in size and in medium link these works, and lead us to consider their thematic juxtapositions. The *Procession* shows members of a confraternity who flagellate themselves. Although this type of procession did take place in early nineteenth-century Spain, the participation of the flagellants had long been prohibited, since it was thought that their semi-nudity often led to lascivious behav-

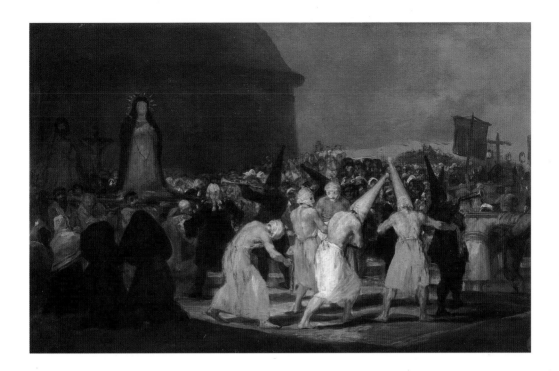

ior and unholy thoughts. The flagellants of the *Procession* bear a marked resemblance to the accused who sit in the foreground of the *Tribunal of the Inquisition* (see FIG. 4, page 19). Both wear conical hats and are bowed in penitence. In the *Tribunal*, however, the figures are accused by the crowd of monks surrounding, in contrast to the penitents whose punishment is self-imposed. Despite these differences, both show the power of the institutionalized church to cow strong men into subservience. Painted during the reign of Ferdinand VII, both of the works might allude to the willingness of the largely conservative populace to accept the yoke imposed by the king and the church that supported him. The third scene in this group is the *Bullfight in a Village*, whose thematic relation to the other two scenes of religious authority is not readily apparent. However, the insistence in all these paintings on crowds comprised of figures with averted or unrecognizable faces betrays a world where heroes have been replaced by actors and crowds of spectators, all of whom fulfill a banal role. The bullfight becomes a thematic counterpart to the spectacle of the Inquisition or the procession: it keeps the masses entertained and also in their place.

In the *Madhouse*, all of the featured lunatics assume the attributes of authority seen in other paintings. In fact, what defines their madness is that they refuse subservience to monarchy, church, and

111. FRANCISCO GOYA
The Procession, c. 1816.
Oil on panel, 18 x 28¾ ″
(46 x 73 cm), Royal
Academy of San Fernando,
Madrid.

The procession includes a man bearing a cross (on the far right) and others carrying floats with religious effigies. Contrary to interpretations of the scene as one of contemporary life in Goya's Spain, it is in fact an invention that recalls rituals long outmoded.

112. Francisco Goya
The Bullfight c. 1816. Oil on panel, 17³/4 x 28¹/4" (45 x 72 cm), Royal Academy of San Fernando, Madrid.

The masses crowd around the popular spectacle, criticized in Spain by many progressives. Within the crowd, the passive individual is subsumed, and there is no room for heroism. Even the *picador* who faces the bull remains anonymous.

the bullfight spectacle: instead they *become* the king, the pope, the bull. Such subversive impudence must be hidden from view: left to inspire others it would undermine the order of the restoration regime. Once again, Goya uses the series of paintings to create juxtapositions that invite the viewer to interpret – he does not paint for the passive spectator. As so often in Goya's works, the viewer is called upon to become an accomplice in the production of meaning.

For whom were these paintings intended? In 1839, they were given to the Royal Academy of San Fernando by Manuel García de la Prada. A successful businessman and friend of the politically progressive writer Leandro Fernández de Moratín, himself a friend of Goya, García de la Prada was known for his progressive leanings and had supported the French government of Spain during the Napoleonic Wars. If he were the original owner of these paintings, he would clearly understand the insinuated criticism of the masses, who blindly allow themselves to be repressed by backward authority.

Another trait seen in the *Madhouse* is the disjointed nature of its narrative: each man is absorbed within his own thoughts and there is no connection, no overall reason for what goes on. This disjointedness defines madness. But what happens when that lack of connection becomes endemic to the world at large? This, I believe, is essential to the uniqueness of a series of etchings probably

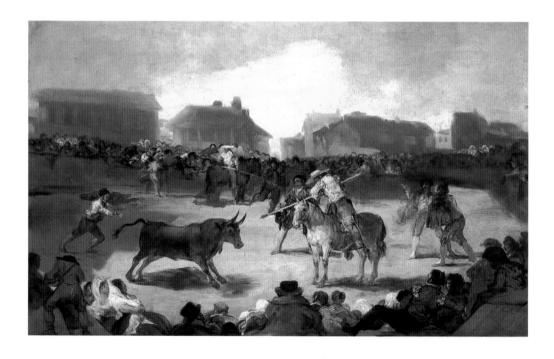

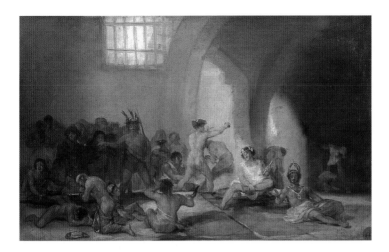

113. FRANCISCO GOYA
The Madhouse, c. 1816.
Oil on panel, 17³/4 x 28¹/4"
(45 x 72 cm), Royal
Academy of San Fernando,
Madrid.

A naked man sits with his back to us, trying on the horns of a bull: in his delusion he becomes the animal. Following the sequence clockwise, power becomes overt as another man subdues an opponent with what seems to be a blow-gun. The monarchy is invoked by a man wearing a crown of feathers, who extends his hand to be kissed by a shrouded figure – a lunatic re-creation of the court ceremony known as the *besamanos*, or hand-kissing. A heroic nude with a tricorne hat appears to fire a make-believe rifle; another wears a crown of cards and holds an improvised scepter; and finally, a man sitting on the ground wears a crown surmounted by a cross and extends his arm in a gesture of blessing.

done from about 1816 to 1819 and published posthumously in 1864 under the title of *Proverbs*. The early twentieth century brought to light early impressions of these plates that bore manuscript captions beginning with the Spanish word "Disparate" (folly), giving the series the title by which it is today known.

These etchings reject the notion that the painter's subject approaches the literary, or even has a verbal explanation. They are haunting images, but any attempt to explain what is going on leads inevitably to simple description. In *Disorderly Folly* (also known as *Matrimonial Folly*; FIG. 114), man and woman have become one to such an extent that the toes on either end of their feet allow them to walk forward whether man or woman leads. At this point, the man seems to be getting the better of things, pointing and pulling in his direction as she screams. But in the end, they don't seem to be going anywhere. They remain immobile, offering a spectacle to a motley crowd that reacts with a variety of expressions ranging from awe, to consternation, to reverence. That varied reaction confuses our own: are we to be offended or awed? Goya offers no hints.

Goya was in his seventies when he created the *Disparates*, as well as what might be his most popular works, the so-called "Black Paintings." In 1819, Goya purchased a two-storey country house, or *quinta*, on the outskirts of Madrid across the Manzanares River from the royal palace. On each floor two smaller rooms flanked a main room measuring about 15 by 30 feet (4.5 by 9 meters). It was in the larger rooms that Goya painted directly upon the plaster walls fourteen oil paintings. Although visitors to the Museo del Prado today see these "Black Paintings" in a rather stark exhibition, photographs taken in the 1860s show that the paintings were framed and set against a decorative wallpaper. If such a domes-

114. FRANCISCO GOYA
Disparate desordenado
(*Disorderly Folly*) from
Los Disparates, c. 1816-19.
Etching, aquatint, and
drypoint, 9¹/₂ x 13³/₄″
(24.5 x 35 cm), British
Museum, London.

These plates were
published posthumously
in 1864 by the Royal
Academy of San Fernando,
under the title of *Los
Proverbios*, at which point
a Spanish proverb was
attached to each image.
This in fact seems to
counter Goya's intent,
which appears to have
been to create enigmatic
images that defy verbal
explanation.

tic setting is in fact contemporary with the paintings, it would seem to counter the initial reaction to these works as the outpouring of a tortured and isolated aging man: in fact, they were part of a decorative scheme of a country villa – as if painting now replaced the tapestries once woven after Goya's designs.

Their imagery recaptures themes seen earlier in Goya's work and also in the etchings of the *Disparates*, but now magnified in scale. Early photographs of *Witches' Sabbath* (FIG. 115) show that its composition originally extended about 3 feet (1 meter) to the right of the onlooker, who today appears on the right edge of the painting. Imagining that compositional extension, we see a shift in the focus of the painting: the center is given over not to the devil, but to his followers – and to their expressions. Thus, the viewer of the painting becomes a witness to the witnesses, and is able to study at first hand the psychology of the crowd. Even though there is, ostensibly, a narrative represented – the witches' sabbath – it is used by Goya only as a pretense to examine human behavior. The faces of the crowd find

no verbal counterpart as, once again, Goya uses painting to exceed verbal narrative.

A comparison of another "Black Painting" with an early small sketch illustrates the triumph of the visual over narrative in these late works (FIGS 116 and 117). The sketch, from 1787, shows the pilgrimage to the shrine of St. Isidore, patron saint of Madrid. The small white hermitage is readily identifiable and Goya takes pains to distinguish the participants by their costumes: we spy the capes and broad-brimmed hats of the *majos*, the white veils of the *petimetras*. The later "Black Painting" was posthumously given the title of *The Pilgrimage to St. Isidore* – but such a title only attests the will to impose word over image. The comparison with the earlier scene shows how inappropriate the title is: nothing in the landscape can be identified as the shrine of St. Isidore, and if there is a shrine to be found, the pilgrims seem to be walking away from it. Their goal lies outside of the painting: they do not walk toward anything, but toward the viewer. The reason for the painting seems to be to make these figures visible – to present them to the viewer. Just as two decades earlier Goya had painted the royal family with no pretense except that of posing for the painter, so now the subject of his painting becomes that of giving form to the faces emerging from the darkened depths of the painted world.

What makes Goya so modern? Certainly, one aspect of his

115. FRANCISCO GOYA *Witches' Sabbath*, c. 1819-23. Oil on plaster transferred to canvas, 4'7" x 14'4¹/₂" (1.4 x 4.4 m), Museo del Prado, Madrid.

Although the theme of this work might at first seem to recall earlier scenes of witchcraft (such as those in *Los Caprichos*), Goya's subject has in fact shifted from the he-devil to the awed expressions of the crowd of worshipers.

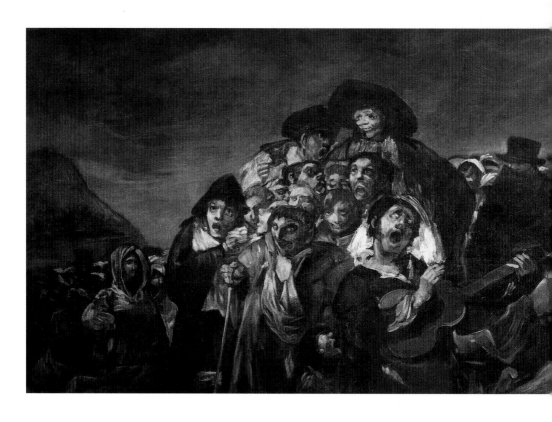

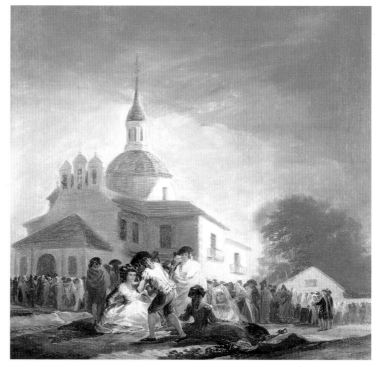

116. Francisco Goya
*The Hermitage of St.
Isidore*, 1787. Oil on
canvas, 16¹/₂ x 17¹/₄″
(42 x 44 cm), Museo
del Prado, Madrid.

Painted as a small-scale
preliminary sketch for
a tapestry cartoon, the
subject of this scene is
the annual pilgrimage
to the shrine of Madrid's
patron saint.

Goya's Modernity

modernity is an expansion of visual narrative that leads ultimately to the emancipation of image from word. We might read a history of 2 and 3 May 1808, but Goya's evocation of the events through the transformation of traditional religious imagery endows his scenes with a uniquely visual meaning. When he introduces narrative in the paintings of the *Inquisition*, the *Bullfight*, the *Procession* and the *Madhouse*, he forces the viewer beyond the single narrative. Visual clues – a madman with the horns of a bull, an inquisitional victim that looks like a processional penitent – force us to read the juxtapositions and the images' ulterior meanings. The result is a collage-like view of the world that approximates human experience.

And when narrative is absent or secondary – as in the "Black Paintings," the *Majas*, and Goya's portraits – the relation of subject to viewer is confrontational. His painted effigies refuse to be mythologized or explained away: one can walk away, but these figures linger as after-images that attest to the power of the purely visual.

117. Francisco Goya
Pilgrimage to St. Isidore,
c. 18ı9-23. Oil on plaster
transferred to canvas, 4′7″
x 14′4¹/₂″ (1.4 x 4.4 m),
Museo del Prado, Madrid.

Like the other "Black Paintings," this image has been restored following its removal from the walls of what was once Goya's suburban house, or "quinta," across the Manzanares River from the royal palace. Its title was likewise given posthumously. Any specific interpretation of its intended subject must remain tentative.

Conclusion

The story of painting in Spain cannot be reduced to the history of Spanish painting, since some of the painting, and many critical influences, were the work of artists with no claim to the title of "Spanish." Insistence on such a framework results in a very schematic view of artistic activity and even presents its own inherent contradictions – such as the unproblematic qualification of Ribera as a "Spanish" painter. It is also an anachronistic view, which imposes on a brilliant history of art and patronage a nineteenth-century conception of a homogeneous national character.

It is historically inaccurate to see the patronage of the kings of Spain as national. Certainly, the Habsburg kings – patrons of Titian, El Greco, Rubens, and Luca Giordano – were not concerned in any way with supporting a "national" school of art. Limiting discussion of their patronage to Velázquez and Coello is a misrepresentation. While the patronage of the Bourbon kings has usually been seen as a departure from the Spanish patronage of the Habsburgs, it was, in fact, only a continuation of a royal search for the best artists, or the best paintings, available.

Nor should we lose sight of the historical distinction between regions: political rebellions aside, we cannot speak of an artistically unified territory: patronage in Seville, for example, was very different from that at court. It was largely dependent upon the church, but artists also found clients among the international body of merchants, attracted to Seville by her role in New World trade. Early documentation suggests that Murillo's scenes of urchins and children were probably painted for Flemish patrons. To under-

score the difference between Seville and Madrid, we might note that, by 1700, not a single work by Murillo was to be found in the Madrid Alcázar: it was in fact the Italian queen of Philip V, Elizabeth Farnese, who brought paintings by Murillo to the court, reflecting the international prestige the artist had gained by the mid-eighteenth century.

Not until the late eighteenth century did writers attempt to construct their national schools from the works of art that were gradually leaving royal or private collections to be exhibited in public galleries. A major catalyst for the Spaniards' own construction of a "national school" was the Napoleonic War. During the occupation of Spain, art works were removed from churches, put in storage and readied for possible export from Spain to the Musée Napoléon in Paris. This threat was not forgotten by the restoration government of Ferdinand VII, responsible for the formation of a Royal Museum – the forerunner of the Prado. The museum opened in 1819, with an exhibition of works of the Spanish school: during the next nine years, other sections would be added – Italian, German, Flemish, and some French. But the museum upheld the fiction of a national school – unique and neatly isolated from other paintings. Thus, an artist such as Titian, whose influence is visible throughout the seventeenth century, was segregated from those non-Italian artists so obviously inspired by his work. The national emphasis also largely erased the historical distinctions among regional schools. It was a neat construction – sure to appeal to the museum-going public that identified themselves as belonging to a certain nation. What is surprising is that such constructions continue to dictate art historical practise.

Because of such conventions, art historians often focus on artists whose work fits well within the concept of the national school, overlooking – or classifying as secondary – those that elude such classifications. As a result it was only in 1994 that a book-length monograph in English on the painters of the Escorial finally appeared. Recent exhibitions have focused on eighteenth-century painting in Spain, and it can only be hoped that these might inspire further consideration of the subject. And even though Goya is the subject of numerous studies, his contemporaries, who worked in a neoclassical style learned in Parisian studios, before returning to paint for the restoration regime of Ferdinand VII, are regarded as unworthy of study. Can we really understand Goya – or any artist working in Spain – without an eye to a broader, supranational context? This book is written with the hope of encouraging that broader view.

Politics and Religion

1481 First *Auto-da-fé* by Spanish Inquisition in Seville, 2 January 1492: Christian forces of Ferdinand and Isabella, king and queen of Aragon and Castile, conquer Granada from the Muslim rulers, the Moors
1492 Expulsion of Jews from Spain (31 March)
1492 Title of *Reyes católicos* (Catholic king and queen) granted to Ferdinand and Isabella by Pope Alexander VI
1502 Royal decree ordering Moors to convert or leave Spain
1506 Charles of Ghent inherits the Low Countries and Franche-Comté ("free county" of Burgundy) upon death of his father, Philip the Handsome
1516 Charles of Ghent inherits throne of Spain as Charles I upon death of his grandfather, Ferdinand
1519 Charles I inherits Austrian duchies (Habsburg empire) upon death of his grandfather, Maximilian I, Holy Roman Emperor, and is elected Emperor as Charles V
1545-63 Meetings of the Council of Trent, among Roman Catholic reformers and papal legates, in response to spread of Protestantism and need for reform

1556 Charles V abdicates from Spanish throne, Philip II comes to power
1557-58 Discovery of Protestant sects in Seville and Valladolid galvanizes Inquisition
1559 Peace of Cateau-Cambrésis ends war between France and Spain
1561 Philip II proclaims Madrid as capital
1564 Decrees of the Council of Trent published
1571 Don John of Austria commands Spanish, Roman, and Venetian fleet in victory over Turks at the Bay of Lepanto
1580 Union of Spain with Portugal under common sovereign
1588 Defeat of Spanish "Invincible" Armada by English forces
1598 Philip II dies, Philip III comes to power
1604 Peace with England signed
1609 Twelve years' truce with United Provinces of the Netherlands
1609-14 Expulsion of the *moriscos* (converted Moors) proclaimed and put into effect
1612-16 Habsburg court and government staff moved from Prague to Vienna
1618 Spanish royal favorite, Duke of Lerma, falls from power

1621 Philip III dies, Philip IV comes to power
1640 Portugal and Catalonia revolt against monarchy
1643 Count-Duke Olivares falls from power
1648 Peace of Westphalia signed with Dutch, recognizing the independence and sovereignty of the United Provinces; Austrian Hapsburgs make separate peace with France
1649 Plague devastates Seville
1659 Treaty of the Pyrenees concludes war with France
1665 Death of Philip IV begins ten-year regency of Mariana of Austria
1673-78 Spain again at war with France, and loses Franche-Comté
1675 Carlos II assumes throne
1689-97 War with France

Literature

1499 Fernando de Rojas (1465?-1541?) writes *La Celestina*

1535 St. Ignatius Loyola (1449/95-1556), founder of the Jesuit order, completes *The Spiritual Exercises*

1543 Posthumous publication of poems by Juan Boscán and Garcilaso de la Vega

1554 Publication of anonymous *Lazarillo de Tormes*, the first novel to feature as protagonist the *pícaro* (the young rogue who survives by his wits)

1565 St. Teresa of Avila (1515-82) completes *Story of My Life*, written at the request of her confessors

1577 Earliest dated copy of St. Teresa of Avila's *Interior Castle*

1599 Mateo Alemán's (1547-1614?) *Guzmán de Alfarache* extends the genre of the picaresque novel

1605 Miguel de Cervantes Saavedra (1547-1616) publishes *Don Quijote*, part I

1613 Cervantes, *Novelas ejemplares* (*Exemplary Novels*)

1614 Cervantes, *Don Quijote*, part II

1619 The playwright Lope de Vega (1562-1635) publishes the three-act play *Fuente Ovejuna* in which the righteous villagers assert their rights before the cruel noble lord

1627 Francisco de Quevedo (1580-1635) publishes the satirical *Sueños y Discursos*, written 1608-22, translated in 1640 as *Visions, Or, Hels kingdome, and the worlds follies and abuses*

1630 Tirso de Molina (1584?-1648) writes *Burlador de Sevilla* (*The Charlatan of Seville*), introducing the legendary character of Don Juan

c. 1636 The dramatist Pedro Calderón de la Barca (1600-81) publishes *La Vida es sueño* (*Life is a Dream*)

1649 The artist and writer on art Francisco Pacheco (1564-1654) publishes *Arte de la pintura* (*Art of Painting*)

Politics and Religion

1700 Carlos II, last Spanish Habsburg, dies without male heir. Philip V, the Bourbon Duke of Anjou and grandson of the French king Louis XIV, comes to the Spanish throne 1702-13: War of the Spanish Succession waged in dispute of Bourbon claim to Spanish throne

1705 Catalonia joins war in support of Austrian candidate to the throne

1713 Treaty of Utrecht ends war: Spanish territories in the Netherlands go to Austria; England is given Gibraltar and Minorca

1746 On Philip V's death, his son Ferdinand VI assumes Spanish throne

1759 Following Ferdinand's premature death, Carlos III, son of Elizabeth Farnese and Philip V and king of Naples, becomes king of Spain

1765 Carlos III expels Jesuits from Spain

1766 The Mutiny of Esquilache pits the Spanish lower classes against the largely foreign government of Carlos III, particularly the Marqués of Squilacci

1788 Carlos III dies, Carlos IV succeeds to the throne

1789 Fall of the Bastille, Paris, to revolutionaries (14 July)

1793 Louis XVI of France, cousin of Carlos IV, guillotined; Spain declares war on Revolutionary France

1795 Treaty of Basel signed with France and Prussia

1799 Napoleon Bonaparte becomes First Consul of France in *coup d'état*

1805 Battle of Trafalgar (21 October), in which English defeat Spanish and French, causing huge losses to the Spanish treasury

1808 Uprising at Aranjuez forces the abdication of Carlos IV and María Luisa and the flight of the queen's favorite, Manuel Godoy; Ferdinand VII assumes throne; Napoleon persuades Ferdinand to abdicate in favor of his parents, who in turn abdicate in favor of Napoleon, who gives Spanish throne to his brother, Joseph Bonaparte; Uprising against French in Madrid, starting the War of Independence

1812 The Spanish Cortes (parliament) in the southern city of Cadiz ratifies the Constitution

1813 The English general Wellington's forces allied with the Spanish, expel the French from the Peninsula

1814 Ferdinand VII returns to power, to head a conservative restoration regime

1820 Liberal coup overthrows Ferdinand VII

1823 With the help of an international force representing conservative European monarchies, Ferdinand VII is restored to power

1833 Death of Ferdinand VII and dispute over succession leads to first Carlist war (1833-40)

Literature

1713 Real Academia Española (Royal Spanish Academy) founded

1715-24 The painter Antonio Palomino de Castro y Velasco (1655-1726) publishes his three-volume *El Museo pictórico y escala óptica* (*The pictorial museum and optical scale*)

1726-39 Fray Benito Jerónimo Feíjoo (1676-1764) writes series of satirical essays and enlightened commentary *Teatro crítico universal* (*Universal Critical Theater*)

c. 1743 Updating Quevedo's satirical *Dreams* Diego de Torres y Villaroel publishes *Sueños morales, visiones y visitas de Torres con d. Francisco de Quevedo por Madrid* (*Moralizing Dreams, Visions and Visits of Torres in Madrid with Don Francisco de Quevedo*)

1781 Gaspar Melchor de Jovellanos (1744-1811), statesman and liberal politician, addresses the Royal Academy of San Fernando, "Elogio de la Bellas Artes" (Eulogy on the Fine Arts)

1790-1801 Jovellanos, *Diarios*

c. 1800 Leandro Fernández de Moratín (1760-1828) publishes *El Sí de la Niñas*

1800 Juan Agustín Cean Bermúdez (1749-1829), *Diccionario histórico de los más ilustres profesores de las bellas artes en España* (*Historical Dictionary of the most illustrious practitioners of the Fine Arts in Spain*)

1810 Blanco-White, to become one of Spain's best known expatriate writers, settles in London

1823 With restoration of Ferdinand VII after the brief constitution interim (1820-23), periodical press in Madrid limited to the *Diario de Madrid* and the *Gaceta*; liberal emigrés settle in London to form an important community of expatriate writers

1824-29 Literary journal *No me olivides* published in London

1828 Expatriate Alcalá Galiano named first professor of Spanish at University of London

1832-33 Mariano José de Larra (1809-37) publishes series of articles on Spanish politics and customs in the satirical review *Pobrecito hablador* (*The Poor Little Speaker*)

Painting

Architecture, Sculpture and Graphic Arts

1479-88 The Flemish-born architect Juan Guas (d. 1496) undertakes the Late Gothic San Juan de los Reyes, Toledo

1514-17 The Florentine Domenico Fancelli (1469-1518) sculpts tomb of Ferdinand and Isabella for the Royal Chapel, Granada

1519-23 Diego de Siloe (1495-1563) builds the *Escalera Dorada* (Golden Staircase) in Burgos Cathedral

1525 The Italian Pietro Torrigiani (1472-1528) working in Seville executes polychrome terracotta figure of *St. Jerome* (today Seville, Museum of Fine Arts)

1527-68 Construction of the Italianate Palace of Charles V after designs by Pedro Machuca (d. 1550) in the complex of the Alhambra, Granada

1528 Diego de Siloe begins Granada Cathedral (built 1528-63)

1537 Alonso de Covarrubias (1488-1570) designs the Alcázar at Toledo

1539-43 Alonso Berruguete, choir stalls for Toledo Cathedral

1559-64 Antonio Sillero and Juan Bautista Toledo (d. 1567), Convent of the Descalzas Reales, Madrid

1563-84 Juan Bautista Toledo and Juan de Herrera (1530-97), the Escorial palace and monastery

1603-06 The Sevillian sculptor Juan Martínez Montañés (1568-1649) executes polychrome wood sculpture of the *Christ of Clemency*

1611-16 Juan Gómez de Mora (1586-1648), Convent of the Encarnación, Madrid

1614 Gregorio Fernández (1576-1636) sculpts for Philip III a *Cristo yacente* – Christ taken down from the cross, lying on his shroud.

1617 Juan Gómez Mora builds the *Plaza Mayor*, the central square of Habsburg Madrid, including a market hall supported by pillars inspired by fifteenth-century Flemish and Italian models

1632-40 Alonso Carbonell (active from 1620, d. 1660), designs and builds Buen Retiro Palace, Madrid

1640-50 Velázquez in charge of works to complete the Pantheon of the Escorial, and rehangs its collection of paintings

1658 Completion of high altar for the convent of San Plácido in Madrid, in full Baroque style, by Pedro de la Torre (d. 1677) and his brother José (d. 1661)

1664 Alonso Cano designs facade of Granada Cathedral with characteristic Spanish-Baroque surface decoration

1670-75 Pedro Roldán (1624-99) sculpts the *Entombment* for the Church of the Hospital de la Caridad in Seville. The elaborate altar (1670-73) is the work of Bernardo Simón de Pineda, who combined architectural forms with illusionistic perspectives, a form emulated throughout Spain

1693 José de Churriguera (1665-1725), sculpts high altar for San Esteban, Salamanca, in highly ornamental style that would become synonymous with his name

Painting

1715-30 Michel-Ange Houasse paints genre scenes and views of royal residences for the new Bourbon court

1743 Louis-Michel van Loo, *The Family of Philip V*

1752 Founding of the Royal Academy of Fine Arts of San Fernando

1761 Anton Raphael Mengs arrives at Spanish court

1762-70 Giambattista Tiepolo at Spanish court

1775 Francisco Goya arrives at the court of Madrid

1794 While recuperating from a serious illness, Goya paints a series of cabinet paintings – his first documented uncommissioned works – which he presents to colleagues at the Royal Academy

1800 Goya's *Naked Maja* documented in collection of royal favorite, Manuel Godoy

1800-01 Goya, *Family of Carlos IV*

1814 Goya, *Second* and *Third of May, 1808*

1815 Vicente López (1772-1850) appointed First Court Painter

1819 The Royal Museum (today the Prado Museum) opened to the public with an exhibition of the paintings of the Spanish school

1819-23 Goya paints the so-called "Black Paintings" on the walls of his country house, the Quinta del Sordo (House of the Deaf Man)

1824 Goya leaves Madrid and after a visit to Paris settles in Bordeaux

1828 Goya dies

Architecture, Sculpture and Graphic Arts

1721-23 Teodoro Ardemans (d. 1726) builds palace of the Grania to be decorated after his death by Italian artists

1721-32 Narciso Tomé (d. 1742) executes in Toledo Cathedral the Transparente, a massive architectural-sculptural ensemble illustrating the complexity of the late Baroque

1722 Pedro de Ribera (c. 1683-1742) executes in a Churrigueresque style the portal of the hospice of San Fernando (today, the Museo Municipal) in Madrid

1734 Fire destroys the Alcázar palace fortress in Madrid, rebuilt over the next two decades by Filippo Juvarra (1678-1736) and his student Giovanni Battista Sacchetti

1769-78 Francisco Sabatini builds the neoclassical arch Puerta de Alcalá marking entry to Madrid from the west

1775-82 José de Hermosilla and Ventura Rodríguez (1717-85) with several sculptors redesign the Salón del Prado, at junction of the Calle de Alcalá and the Calle San Jerónimo, Madrid

February 1799: Francisco Goya announces publication of *Los Caprichos* in the *Diario de Madrid*

1785-1808 Juan de Villanueva (1739-1811) designs and builds in Madrid the Natural History museum (to become the Museo del Prado after 1819) in Neoclassical style

1810-1818 Goya etches the *Disasters of War* and *Caprichos enfaticos* (*Emphatic Caprices*), published posthumously in 1863

1816 Goya publishes the *Tauromaquia* (Bullfight)

c. 1817-20 Goya etches the *Disparates* (Follies), published posthumously in 1864 under the title *Proverbios* (Proverbs)

1825 Goya publishes a series of four lithographs, *Bulls of Bordeaux*

Bibliography

The most important early sources for painting in Spain are: FRANCISCO PACHECO (ed. F. J. Sánchez Cantón), *Arte de la pintura*, (Madrid: Instituto de Valencia de Don Juan, 1956); ANTONIO PALOMINO (trans. and ed. Nina Ayala Mallory), *Lives of the Eminent Spanish Painters and Sculptors* (Cambridge and New York: Cambridge University Press, 1987); and JUAN AGUSTÍN CEAN BERMÚDEZ, *Diccionario histórico de los más ilustres profesores de las Bellas Artes en España* (Madrid: Viuda de Ibarra, 1800). More recent general studies for the painting and history of Spain are JONATHAN BROWN, *The Golden Age of Painting in Spain* (London and New Haven: Yale University Press, 1990); ALFONSO E. PÉREZ SÁNCHEZ, *Pintura barroca en España 1600-1750* (Madrid: Ediciones Cátedra, S.A., 1992); J. H. ELLIOTT, *Imperial Spain 1469-1716* (New York: 1963; London: Penguin 1990); J. H. ELLIOTT, *Spain and its World 1500-1700* (New Haven and London: Yale University Press, 1989); and HENRY KAMEN, *Inquisition and Society in Spain in the Sixteenth and Seventeenth Centuries* (Bloomington: Indiana University Press, 1985).

CHAPTER ONE: *Painting at the Court of Philip II*
For an entertaining and informative biography of Philip II see GEOFFREY PARKER, *Philip II* (Chicago and LaSalle, Ill.: Open court, 1995). For a summary of arguments on why the Court was moved to Madrid, see: ALFREDO ALVAR EZQUERRA, *Felipe II, la corte y Madrid en 1561* (Madrid: CSIC, 1985). The standard work on the architecture of the Escorial is GEORGE KUBLER, *Building the Escorial* (Princeton: Princeton University Press, 1982); the essential study of its decoration which has served as a basis to this chapter is the excellent study by ROSEMARIE MULCAHY, *The Decoration and Royal Basilica of El Escorial* (Cambridge and New York: Cambridge University Press, 1994). There currently exists no major study of Sánchez Coello in English, and the most up to date source remains the catalogue of a Prado exhibition, *Alonso Sánchez Coello y el retrato en la corte de Felipe II* (Madrid: Museo del Prado, 1990).

CHAPTER TWO: *The Toledo of El Greco*
Wittkower's summary of the principles of Tridentine art is cited from *Art and Architecture in Italy 1600-1750* (Middlesex: Penguin, 1958; rev. 1985 pp. 21-2). The translation of Paravicino's homage to El Greco is cited from ANTONIO PALOMINO (trans. and ed. Nina Ayala Mallory), *Lives of the Eminent Spanish Painters and Sculptors* (Cambridge and New York: Cambridge University Press 1987, p. 86, no. 20). Although there exist many monographic studies on El Greco, the most informative and concise introduction to the artist and his context in English is the catalogue to the 1982 exhibition, *El Greco of Toledo* (Museo del Prado, Madrid; National Gallery of Art, Washington;

Museum of Fine Arts, Dallas, Boston: Little, Brown, 1982). Those interested in studies of individual works may consult the essays in *Figures of Thought: El Greco as Interpreter of History, Tradition, and Ideas*, ed. JONATHAN BROWN, *Studies in the History of Art*, vol. 11 (Washington, D.C.: National Gallery of Art, 1982). The fundamental study of El Greco's aesthetic ideas remains FERNANDO MARÍAS and AGUSTIN BUSTAMENTE, *Las Ideas artísticas de El Greco* (Madrid: Ensayos Arte Catedra, 1981). An in-depth study of El Greco's work in relation to patronage is RICHARD G. MANN, *El Greco and His Patrons: Three Major Projects* (Cambridge and New York: Cambridge University Press, 1985). The works of Sánchez Cotán have been presented in several exhibitions of Spanish still-life painting since the 1970s: in English, see WILLIAM B. JORDAN and PETER CHERRY, *Spanish Still-Life from Velázquez to Goya* (London: National Gallery Publications, 1995), and WILLIAM B. JORDAN, *Spanish Still-Life of the Golden Age 1600-1650* (Fort Worth: Kimball Art Museum, 1985). For an interpretation of Sánchez Cotán's still-life paintings in relation to Spanish mysticism, see: NORMAN BRYSON, *Looking at the Overlooked* (Cambridge, MA: Harvard University Press, 1984), Ch. II.

CHAPTER THREE: *Ribalta in Valencia and Painting in Seventeenth-Century Seville*
The most complete and accessible sources in English on painting in Valencia and Seville are generally the catalogs of recent exhibitions. These include FERNANDO BENITO DOMENECH, *The Paintings of Ribalta 1565-1628* (New York: The Spanish Institute, 1988); *Jusepe de Ribera lo Spagnoletto* (Fort Worth: Kimball Art Museum, 1982); *Jusepe de Ribera 1591-1652* (New York: Metropolitan Museum of Art, 1992); *Zurbarán* (New York: Metropolitan Museum of Art, 1987); and *Bartolomé Esteban Murillo*, (London: Royal Academy of Art, 1982). On Ribalta, see also DAVID KOWAL, *The Life and Art of Francisco Ribalta (1565-1628)* (unpublished doctoral thesis, Ann Arbor, Michigan, 1981). On Valdés Leal, see ELIZABETH DE GUÉ TRAPIER, *Valdés Leal: Spanish Baroque Painter* (New York: Hispanic Society of America, 1960), as well as the essay "Hieroglyphs of Death and Salvation: The Decoration of the Church of the Hermandad de la Caridad, Seville," in JONATHAN BROWN, *Images and Ideas in Seventeenth-Century Spanish Painting* (Princeton: Princeton University Press 1978). The bibliography on Sevillian painters in Spanish is extensive; especially important is the work of ENRIQUE DE VALDIVIESO, which includes a monograph on Juan de Roelas and another on Valdés Leal. Exhibition catalogues published by the Museo del Prado offer another important source: these include *Zurbarán* (1988) and *Valdés Leal* (1991). The exhibition catalog *Velázquez in Seville* (Edinburgh: National Gallery of Scotland, 1996) was published as this work went to press.

CHAPTER FOUR: *The Habsburg Court: 1598-1655*
Quotations are taken from J. H. ELLIOTT, "The Court
of the Spanish Hapsburgs: a peculiar institution?" in
his *Spain and its World 1500-1700* (New Haven and
London: Yale University Press, 1989, p. 154).

The essential introduction to Velázquez is JONATHAN
BROWN, *Velázquez: Painter and Courtier* (New Haven
and London: Yale University Press, 1986); JONATHAN
BROWN and J. H. ELLIOTT, *A Palace for a King* (New
Haven and London: Yale University Press, 1980),
provides a thorough examination of the Buen Retiro
Palace, and of the scenes commissioned for the Hall
of the Realms. Other studies influential in developing
this chapter are: MARY CRAWFORD VOLK, "Rubens
in Madrid and the Decoration of the Salón Nuevo in
the Palace," *Burlington Magazine* 122 (1980): pp. 168-
80; EMILY UMBERGER, "Velázquez and Naturalism I:
Interpreting *Los Borrachos*," RES 24 (Autumn 1993):
pp. 21-42; EDWARD L. GOLDBERG, "Velázquez in
Italy: Painters, Spies and Low Spaniards," *Art Bulletin*
74, no. 3 (September 1992): pp. 453-56; GRIDLEY
McKIM-SMITH, GRETA ANDERSEN BERGDOLL, and
RICHARD NEWMAN, *Examining Velázquez* (New
Haven and London: Yale University Press, 1988);
and CARMEN GARRIDO PÉREZ, *Velázquez: Técnica y
evolución* (Madrid: Museo del Prado, 1992).

CHAPTER FIVE: *Painting at Court 1655-1700*
A summary of the scholarship on the *Fable of
Arachne* and *Las Meninas* is found in JONATHAN
BROWN, *Velázquez: Painter and Courtier* (New
Haven and London: Yale University Press, 1986). In
addition to Brown, two articles contribute particularly
insightful contemplations on the painting: LEO
STEINBERG, "Velázquez' *Las Meninas*," *October* (19),
1981, pp. 45-54, and SVETLANA ALPERS, "Interpretation
without Representation, or, The Viewing of Las
Meninas," *Representations* 1, no. 1 (February 1983),
pp. 31-42.

On painting in the second half of the century the
essential study is EDWARD SULLIVAN, *Baroque Painting
in Madrid: The Contribution of Claudio Coello, with a
Catalogue Raisonnée of his Works* (Columbia: University
of Missouri Press, 1986); see also EDWARD SULLIVAN,
"Politics and Propaganda in the *Sagrada Forma* by
Claudio Coello," *Art Bulletin* 67, no. 2 (1985), pp.
243-59, the source for the contextual study of the
Sagrada Forma offered here. EDWARD SULLIVAN and
NINA MALLORY, *Painting in Spain 1650-1700 from
North American Collections* (exh. cat.; (Princeton:
Museum of Art, 1982), and the proceedings of a
symposium with contributions by various authors in
the *Record of the Art Museum of Princeton University*
41, no. 2 (1982), offer important material. Essential
to a study of Carreño is ALFONSO E. PÉREZ SÁNCHEZ,
Juan Carreño de la Miranda (Aviles: Ayuntamiento,
1985).

CHAPTER SIX: *Painting under the Bourbon
Monarchy 1700-70*
Overviews of painting at the Bourbon court include
YVES BOTTINEAU, *L'Art de cour dans l'Espagne de
Philippe V 1700-1746* (Bordeaux: Féret, 1962); *El Arte
europeo en la Corte de España* (Madrid: Ministerio de
Cultura, 1980); and MICHAEL HELSTON, *Painting in
Spain during the Later Eighteenth Century* (London:
National Gallery, 1989). The major monographs include
J. J. LUNA, *Miguel Angel Houasse 1680-1730* (Madrid:
Museo Municipal, 1981); OSIRIS DELGADO, *Luis Paret
y Alcázar* (Madrid: C.S.I.C. 1957); *Luis Paret y
Alcázar* (exh. cat.; Bilbao: Gobierno Vasco, 1992);
ELEANOR TUFTS, *Luis Meléndez: Eighteenth Century
Master of the Spanish Still Life* (Columbia: University
of Missouri Press, 1985); JANIS TOMLINSON, "The
Provenance and Patronage of Luis Meléndez's
Aranjuez Still Lifes," *Burlington Magazine* 132
(February 1990), pp. 84-89; JOSÉ LUIS MORALES Y
MARÍN, *Francisco Bayeu* (Saragossa: Ediciones
Moncayo, 1995); CATHERINE WHISTLER, "G.B.
Tiepolo at the Court of Charles III," *Burlington
Magazine* 128 (1986), pp. 199-203; and JUTTA HELD,
*Die Genrebilder des Madrider Teppichmanufaktur und
die Anfänge Goyas*, (Berlin: Mann Verlag, 1971). A
new study and catalog by JOSÉ LUIS MORALES Y
MARÍN, *Mariano Maella* (Saragossa: Moncayo, 1996)
appeared as this study went to press.

CHAPTER SEVEN: *Goya's Modernity*
Quotation is taken from SVETLANA ALPERS and
MICHAEL BAXANDALL, *Tiepolo and the Pictorial
Intelligence* (New Haven and London: Yale University
Press, 1994, p.6). Two catalogs are essential for those
wishing to assess Goya's œuvre: TOMÁS HARRIS,
Goya: Engravings and Lithographs (Oxford: Bruno
Cassirer, 1964), and PIERRE GASSIER and JULIET
WILSON, *The Life and Complete Work of Francisco
Goya* (New York: Morrow, 1971). A good introduction
to his graphic works remains ELEANOR A. SAYRE *et al.*,
The Changing Image: Prints by Francisco Goya (exh.
cat.; Boston: Museum of Fine Arts, 1974).

Many of the ideas presented here have been
developed more fully in my own studies on the artist,
where full bibliographies may also be found: see
*Francisco Goya: The Tapestry Cartoons and Early
Career at the Court of Madrid* (Cambridge and New
York: Cambridge University Press, 1989); *Goya in the
Twilight of Enlightenment* (New Haven and London:
Yale University Press, 1992); *Francisco Goya y Lucientes
1746-1828* (London: Phaidon, 1994).

Picture Credits

Index